Expressionism

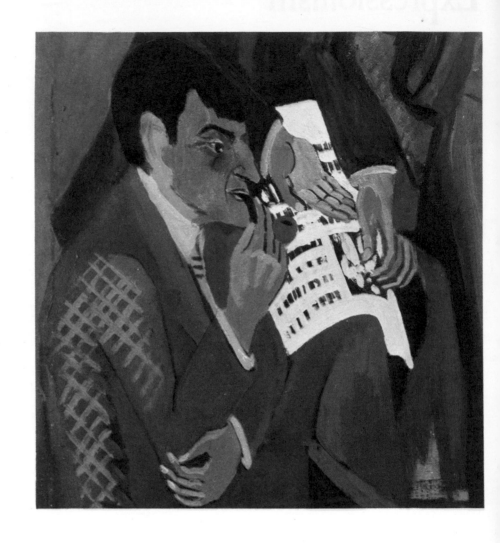

Expressionism

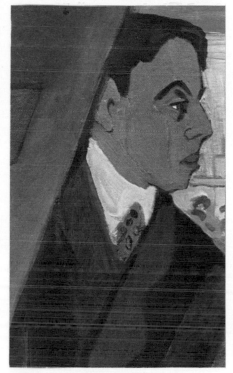

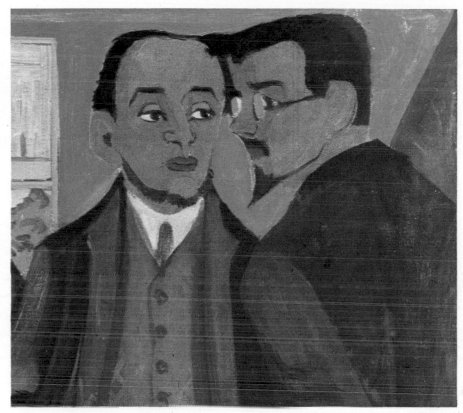

Frank Whitford

Movements of
Modern Art
General Editor:
Trewin Copplestone

Hamlyn
London. New York.
Sydney. Toronto.

Front endpapers colour illustration:
1. Emil Nolde *Steamer Belching Smoke*
(detail), 1910, oil on canvas,
22.37 × 28.12 in. (56.8 × 71.4 cm.),
Ada and Emil Nolde Foundation, Seebüll

Half-title illustration: see fig. 41
Title-page illustrations:
details of fig. 146
Contents pages illustrations:
see figs. 28 and 79
Back endpapers: see fig. 45

71 – 576704

Published by
THE HAMLYN PUBLISHING GROUP
LIMITED
LONDON · NEW YORK · SYDNEY ·
TORONTO
Hamlyn House, Feltham, Middlesex,
England
© Copyright 1970
The Hamlyn Publishing Group Limited
I.S.B.N. O 600 02639 6
Printed in Hong Kong by
Toppan Printing Company (H.K.) Limited

Contents

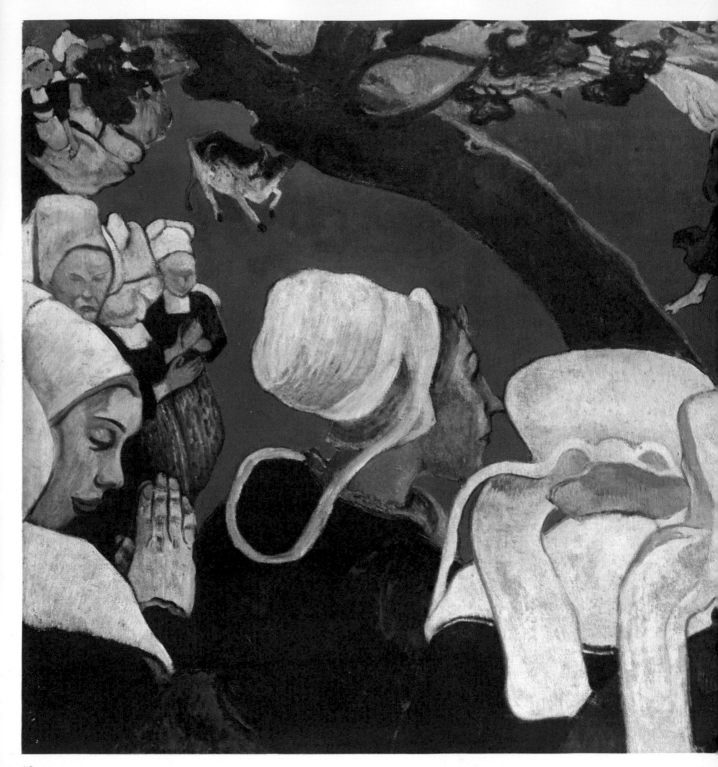

Introduction

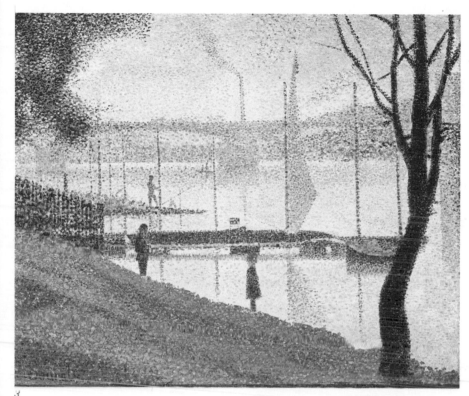

2. *Paul Gauguin* Vision after the Sermon, 1888, oil, 29.75 × 36.25 in. (75.6 × 92 cm.), National Gallery of Scotland, Edinburgh

3. *Georges Seurat*
The Bridge at Courbevoie, 1886,
oil on canvas, Courtauld Gallery, London

What is Expressionism?

The word 'Expressionism' gained general currency during the First World War and was coined to describe those forms of modern painting which were reacting against Impressionism. The Impressionists had painted light and atmosphere and attempted to reproduce the image of Nature that was reflected on the retina of their eye. Expressionism was therefore a term applied to the work of those artists who believed there was much more to the world than simply what their eyes saw.

For many years the word was applied much more widely and indiscriminately than it is today. Germans referred to artists as different as Picasso and Chagall as Expressionists, and the artists themselves disliked having the term applied to their work.

Nevertheless, 'Expressionism', as a word to describe an artistic style and even a philosophy, was there to stay, and continued for many years to have the general meaning of 'anti-Impressionist and therefore radically modern'.

If we search for the first person to give the term wide currency, we find that it was neither a critic nor an artist but Herwarth Walden, editor of the newspaper *Der Sturm* and an impresario and publicist of great foresight and business acumen. For him, Expressionism was less the precise description of an artistic style than a catch-phrase, a banner beneath which he and his artists might march out to meet the masses and make money. In Walden's terms it was much easier to publicise a movement with a programme than it was to bring a number of difficult and dissimilar artists to the attention of the public. Although the term was invented and circulated by others, the Expressionist movement as such, the notion that there were artists with a definite programme, was Walden's invention. It is an achievement which brought him infinitely more financial profit than it brings us enlightenment.

Today the meaning of Expressionism has crystallised. The term is generally applied to German literature and painting between, roughly, 1905 and 1918. Some writers, while agreeing that the most distinguished modern manifestation of the Expressionist style appeared before and after the First World War, nevertheless use the word in a much broader way. For them, Expressionism is one type of representation, typical for so-called Germanic countries, which reappears throughout history and always at moments of great spiritual and social crisis. In other words, Expressionism becomes one of the basic art-historical blanket terms,

meaning all things to all men and equally applicable to the art of the fourteenth, eighteenth and twentieth centuries, so that although the term is today used in a much more precise way than it was fifty years ago, it remains somewhat vague and contradictory.

What follows treats Expressionism as a limited phenomenon. It concerns itself above all with German painting and graphic art from 1905 to 1919. The characteristics of Expressionist literature, music, architecture and cinema of roughly the same period will also be discussed towards the end of this account.

The Political Background

Shortly before the outbreak of the 1914–18 war, Kaiser Wilhelm the Second announced that he no longer recognised political parties, only Germans. Fifty years earlier, such a proclamation would have been impossible. In 1860 the King of Prussia was not Emperor of Germany and Germany only existed as a loose confederation of states, each with a different ruler. The country was unified only inasmuch as there was a common language and culture.

Of all the states Prussia was by far the strongest. Its King was autocratic and the mentality of his subjects essentially feudal. High in the social order was the military: no-one was respected more than an officer and no qualities were admired more than the military virtues of obedience to authority and self-discipline.

Otto von Bismarck, Minister President from 1862, was convinced that Germany should be unified and sure that Prussia should take the initiative. Put simply, Bismarck thought that this could be achieved most efficiently by a series of wars.

Wars against Denmark, the Austro-Hungarian Empire and France were arranged, all with the aim of regaining lost territories, thus bringing all the German states together to fight for a common cause under the leadership of Prussia. On January 18th, 1871, Wilhelm the First of Prussia was proclaimed Emperor of all Germany. Bismarck had succeeded in convincing all the German Dukes, Princes and even the intransigent King of Bavaria, the second largest State, that union was in their best interests. The new Reich was nominally a federal system with the greatest power situated with the Emperor in Berlin and a modicum of internal self-determination in the regional capitals. It was Prussia writ large.

Immediately Germany underwent a belated but thorough Industrial Revolution. This was carried out with characteristic Prussian

4

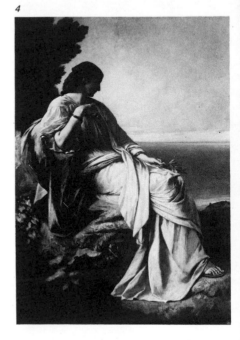

4. *Anselm Feuerbach* Iphigenia, 1860s, *oil on canvas, Hessisches Landesmuseum, Darmstadt*

5. *Front page of the weekly paper Die Aktion, no. 35/36, 6th Year, special Egon Schiele issue*

6. *Arnold Böcklin* The Plague, *1898, tempera on wood, 58.87 × 41.12 in. (149.5 × 104.5 cm.), Kunstsammlung, Basel*

Die Aktíon

WOCHENSCHRIFT FÜR POLITIK, LITERATUR, KUNST

VI. JAHR.HERAUSGEGEBEN VON FRANZ PFEMFERT NR. 35/36

EGON SCHIELE-HEFT. INHALT: Egon Schiele: Selbstporträt (Titelzeichnung) / Professor G. F. Nicolai: Der Kampf ums Dasein / F. A. Harta: Porträt des Egon Schiele / Victor Fraenkl: Von dem Budha zu Mach / Ein unveröffentlichter Brief von Elisée Reclus / Egon Schiele: Studie / Alfred Wolfenstein: Neue Gedichte / Egon Schiele: Das Kind; Mutter und Kind (zwei Federzeichnungen) / Egon Schiele: Abendlandschaft / Wilhelm Klemm: Entsagung / Kurd Adler: Mai-Phantasie 1916 / Anton Sova: Pastorale / Egon Schiele: Studie / Arturo M. Giovannitti: Der Käfig / Egon Schiele: Bild des Malers Harta / Ulrik Brendel und Heinrich Nowak: Ueber Egon Schiele / Ich schneide die Zeit aus / Kleiner Briefkasten / Schiele: Holzschnitt

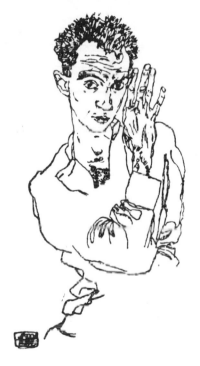

6

VERLAG · DIE AKTION · BERLIN · WILMERSDORF

SONDER-NUMMER

HEFT 50 PFG.

5

7. *Edvard Munch,* By the Death-bed, *1895,*
oil on canvas,
35.5 × 47.5 in. (90.2 × 120.5 cm.),
Rasmus Meyer Collection, Bergen

8. *Henri van de Velde* Engelswachen, *1891,*
appliqué, 55 × 91.75 in. (139 × 233 cm.),
Kunstgewerbe Museum, Zurich

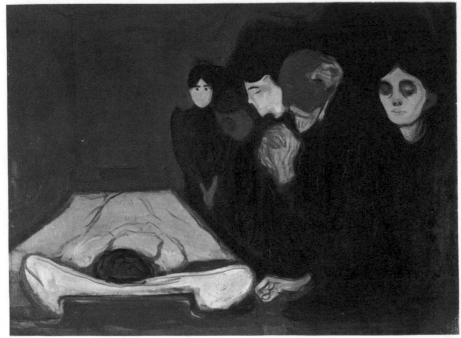

7

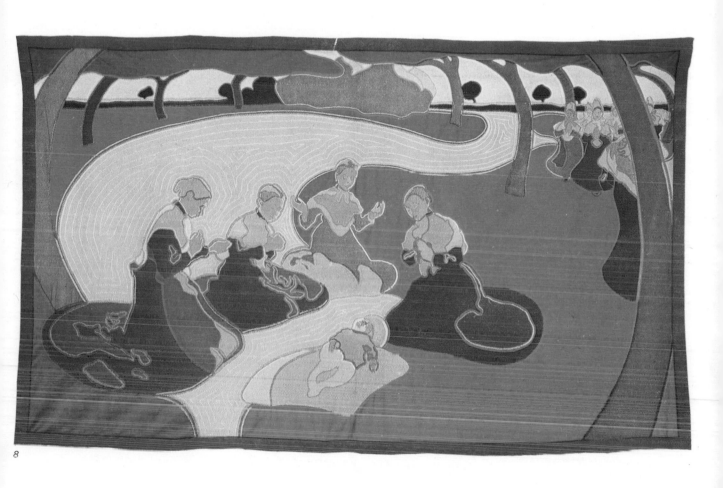

8

speed and efficiency so that by the turn of the century a country which had been predominantly agricultural had become second only to England as a world trading nation. German engineers and advisors were building railways, factories and schools and giving lavish financial aid from Asia to South America.

Economic strength was reflected in the military budget. The race was on with Britain for the greatest navy in the world and Germany's army, based on the Prussian model, was by far the largest in Europe. Much of the scene for the outbreak of hostilities had been set.

Patronage and Provincialism

The rapid growth of Germany to a position of world importance greatly influenced the development of German art during the period.

The lack of a real capital had profound effects on artistic events. Although Berlin, the largest city in Germany, became the official capital in 1871 and was unrivalled in industrial and financial matters, it was by no means recognised as the country's cultural and spiritual centre.

Indeed, for many German-speaking artists and intellectuals, Vienna and Prague had everything that Berlin lacked: tradition, beauty and the atmosphere that was thought necessary for creativity. Moreover, even the smallest provincial capital had for years encouraged art by patronage. Each court employed its painters, composers, writers and philosophers. It was a practice which had proved very beneficial to the Bachs, Mozart and Goethe. To work in the comparative isolation of a small provincial capital was to the advantage of writers, thinkers and all those who preferred solitude to café society. But visual artists appear to need to remain open to all sorts of outside influences if their work is to mature, and part of the trouble with painting in nineteenth-century Germany was doubtless due to the lack of one great spiritual and cultural centre where artists might congregate.

In the nineteenth century, the most exciting things in art were happening in France, and that, of course, meant Paris. Berlin had nothing like the same significance. In spite of the Kaiser's city-planning—the new boulevards, triumphal arches and parks in conscious imitation of the French capital—the Berlin artists were as provincial as they were elsewhere in Germany, and those painters shrewd enough to recognise their situation looked for their capital elsewhere, either in France, or Italy.

Consequently, artistic developments in one centre, like Munich, for example, were, and

9

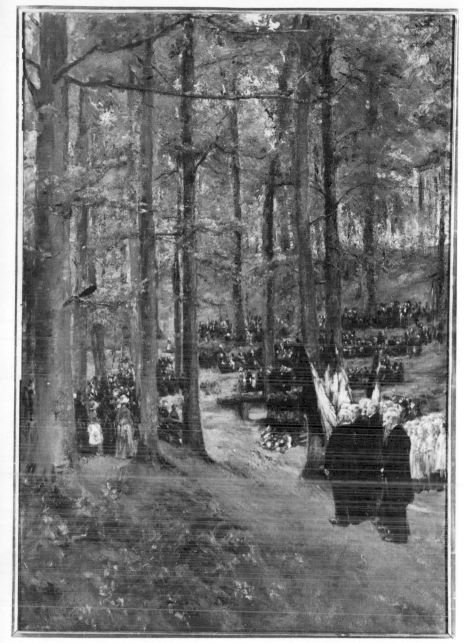

9. *Max Liebermann* Self-portrait, *c 1920, pen and ink*

10. *Max Liebermann* Memorial Service for Kaiser Friedrich at Kosen, *1888, Tate Gallery, London*

10

17

continue to be, very different from those in another, such as Berlin. The two most successful Expressionist groups were *Die Brücke* and *Der Blaue Reiter* in Dresden and Munich, but, again, these were quite independent of each other and totally different in outlook. Later, some of the artists went to Berlin, where yet another kind of Expressionism was then created. And developments here were in contrast to those in Leipzig, Breslau and Cologne. It was an essentially provincial situation, unparalleled elsewhere in Europe, and the direct result of history. It makes any consideration of Expressionism as complicated as it is fascinating.

A Generation of Protest

It has been said that Expressionism is a 'revelation of the profoundly problematic condition of Europe at the turn of the century'. Although the reunification of Germany had brought many material benefits, the speed with which events took place and the way in which Prussia had imposed her will resulted in profoundly problematic social conditions throughout the country. An awareness of these conditions and an attempt to do something about them is one of the strongest links between all the Expressionist artists.

The sub-title of Bernard Myers's book on Expressionist painting is 'A Generation in Revolt', and indeed, the one aspect common to all Expressionist work in every medium was that it was revolutionary—and not revolutionary simply in aesthetic terms. That art in Germany was changed aesthetically beyond recognition and almost overnight is obvious enough. But the Expressionists were politically engaged. For them there was no difference between art and society. Art was pointless unless it had a revolutionary effect on society.

To be an Expressionist was to be young in an old and tired world. It was to believe in the bankruptcy of society, the idiocy of the masses and the falseness of the generally held picture of the world. It was to believe in communal activity and above all in communal action. There was no point in working alone in a Bohemian attic studio. You had to bring about change, to take art out on to the streets and undertake cultural cavalry charges against the entrenched and undiscriminating middle classes. The names of the Expressionist broadsheets and newspapers are evidence enough: *The Cry, The Storm, The Torch* and *The Action.* (5) The heroes were Nietzsche and Marx. As the writer, Iwan Goll, put it: 'We no longer paint for the sake of art, but for the sake of people'.

11. *Adolf von Menzel, Berlin Potsdam Railway, 1847, oil on canvas, 17 × 20.5 in. (43 × 52 cm.), National Gallery, Berlin*

12. *Lovis Corinth* Walchensee Landscape, *1920s*

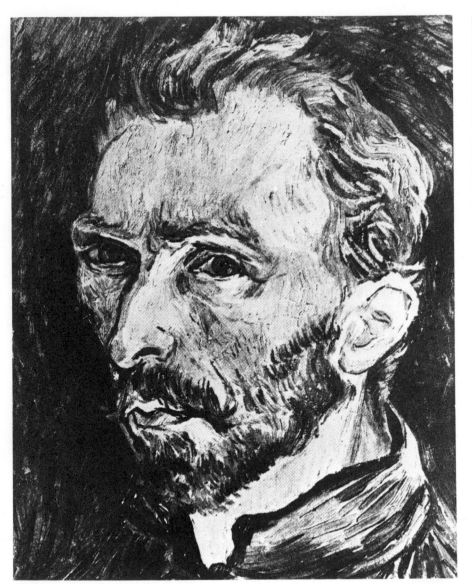

13

14

13. *Vincent van Gogh*
Self-portrait, *1889*

14. *Paul Gauguin* Self-portrait, *1888*,
M. Denis Collection, St Germain-en-Laye

15. *Edvard Munch* Self-portrait, *1895*,
Oslo Kommunes Kunstsamlinger

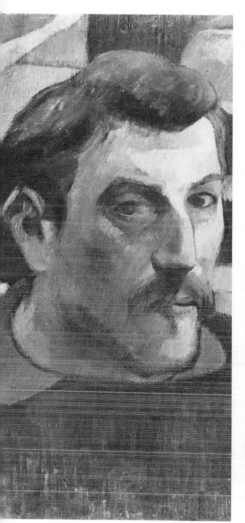

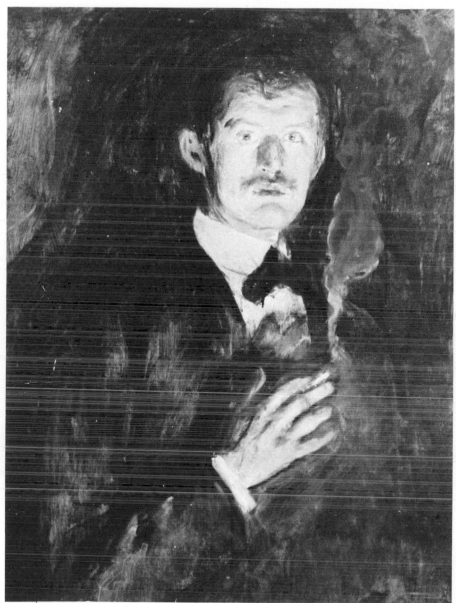

15

The Expressionists grew up in and reacted violently against the self-satisfied world of the materialistic burgher during the grand period of the German Empire, a world perfectly and horrifyingly described by Heinrich Mann in his novel *Der Untertan* (*The Loyal Subject*). Almost without exception, the Expressionists came from middle-class homes and they all despised their own origins. At the time there were so many stage plays dealing with the conflict between father and son that it almost became a genre in its own right. Dissatisfaction with family and society expressed itself in other, often tragic ways. The poet, Georg Trakl, took drugs, slept with his sister and finally did away with himself in a field hospital in Cracow during the war. His was an extreme case but he was only one of many suicides. Oskar Kokoschka, the great Austrian Expressionist, preferred to be anti-social in public, having a life-size doll made, living with it and taking it to the opera, simply because he was deeply committed to the idea of social outrage.

For Kasimir Edschmidt, himself an Expressionist poet and author of *Living Expressionism*, the movement was 'the first great upheaval brought about by the youth of Germany since Romanticism'. It was a revolution before which 'there was practically nothing but Naturalism, and after which a multitude of schools and tendencies unthinkable without Expressionism.' Whether the young Expressionists read Rousseau, Marx or Nietzsche, they believed that a new order would displace the old, that the course of man's development must be redirected, his essential nature revealed to him and put to work. They believed that only a thorough-going revolution would make their ideas reality.

The art of the pre-war years is distinguished by its visions, some of a Utopian existence, beyond conventional society, and others of the disasters that were to come. They are both sides of the same coin and bear witness to the sensitivity of the Expressionists to the prevailing social and political atmosphere. While many Germans welcomed war, believing it would assert their nation's greatness, most of the Expressionists were filled with horror. Those poets and painters who joined the army with light hearts did so because they saw the war, with its extremes of suffering and passion, as the liberation of society from its stifling mediocrity.

Nineteenth-Century Attitudes: Naturalism and Romanticism

There were two dominant strains in German

16

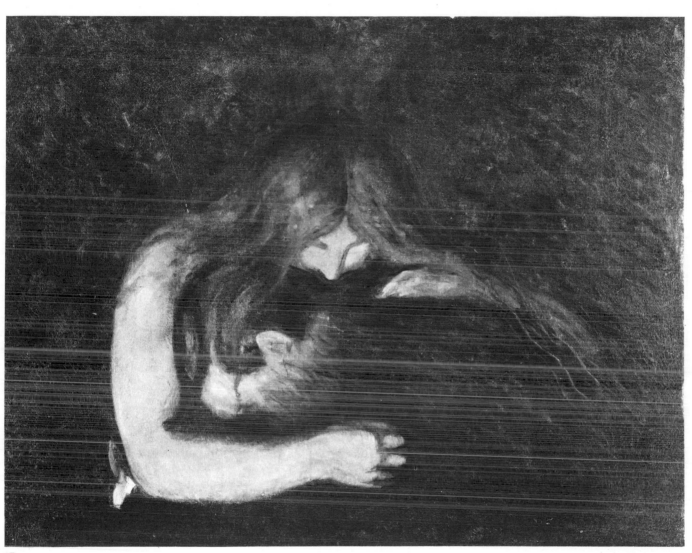

17

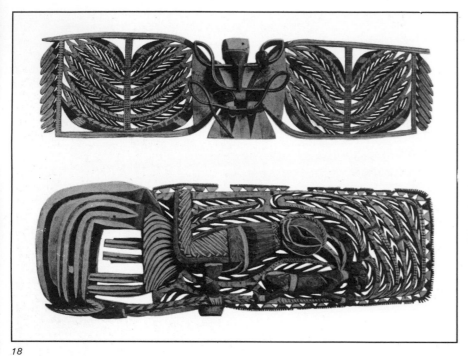

18

19

18. *Primitive house decorations
(woodcarvings) from the Bismarck Islands,
acquired 1895, Königliches
Ethnographisches Museum, Dresden*

19. *Edvard Munch* Primitive Man, *1905,
woodcut*

20. *Primitive painted woodcarving from
the Bismarck Islands,
British Museum, London*

painting during the second half of the nineteenth century: Romanticism and Naturalism. Romanticism was the preferred manner of able and original artists long after it had passed on to second-rate imitators elsewhere in Europe.

Anselm Feuerbach (1829–1880) spent most of his life in Italy and preferred Renaissance models, painting classical subjects in a clear and disciplined style. (4) His work was never as popular as that of the Swiss, Arnold Böcklin (1827–1901), whose highly inventive mythological subjects had no direct parallel in the work of any of his contemporaries. Böcklin, who spent thirty years in Rome, created a world of strange (6) creatures and uncanny atmospheres which were appreciated by many artists and by the German public, who, towards the end of Böcklin's life, accorded him nothing short of hero worship. In fact, Böcklin, for all his outlandish subject-matter and unmodish style, later influenced Emil Nolde and Giorgio de Chirico.

Hans von Marées (1837–1887), like Böcklin and Feuerbach, spent many years in Italy, and although a painter of great natural ability, nevertheless exerted great influence with his interest in plastic form and precisely calculated composition. Marées, virtually unknown in his lifetime, was, like Böcklin, appreciated by many younger artists. Franz Marc, for example, admired his work greatly.

Naturalist and Realist painters reached maturity at approximately the same time as the Romantics. The most important of these, Adolf von Menzel, spent years of his life chronicling the life and times of Frederick the Great in a series of large canvases describing the Prussian court of the 'alter Fritz' in all its aspects. He also painted many landscapes and some of the first pictures anywhere to include industrial subjects. (11) His Iron Foundry of 1875, for example, is something of a tour de force. When he died in 1905, the true extent of his achievement was revealed. Hundreds of sketches and oils which he had never exhibited were seen for the first time. In their freedom of handling and interest in light, these were essentially Impressionist and included some of the most successful paintings produced in Germany that century.

When Impressionism arrived in Germany, it was as much a development of the Realism of Menzel as it was an imitation of French models. Many of the German Impressionists, were concerned with social problems which were at their most acute in Berlin and created visual equivalents of the working-class

20

25

21

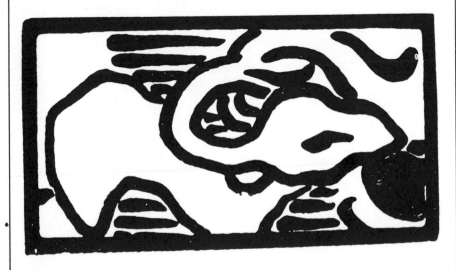

dramas of Gerhart Hauptmann and the
politically committed lyric poetry of
Arno Holz.

By and large, and taken in the European
context, German art in the nineteenth
century was dull and boring. The extreme
view of one critic was that it was more than
disappointing: it was terrifying. The most
advanced art of the period originated in
France; Germany lagged behind by the space
of at least a generation.

Impressionism

At the turn of the century, the two German
cities most advanced in artistic matters were
Munich and Berlin. Munich had never taken
completely to atmospheric Naturalism and
two gifted artists who had begun to develop
an interest in French Impressionism in
Munich, Lovis Corinth and Max Slevogt,
left for the capital where the dealers had
introduced Impressionism to the public with
some success.

These two artists gravitated to the most
brilliant Impressionist in Berlin, Max
Liebermann, a man known for his urbane and
caustic wit and the brilliance of his style. (9)
Liebermann's work was never whole-
heartedly Impressionist. It retains much of
the careful feeling for composition and
colours in the earth range which the French
masters were so anxious to expel from their
canvases. His sense of light was never as
pure as the French, he never completely
eradicated black from his palette and was
never courageous enough to do entirely
without literary and allegorical subject-
matter. (10)

Lovis Corinth's roots were even deeper in
tradition than were Liebermann's. Influenced
by Flemish art and particularly by Rubens,
he continued to paint historical subjects
long after they had ceased to be fashionable
elsewhere and cultivated a baroque feeling
for the dramatic contrasts of chiaroscuro,
for the bloom on naked flesh and for
sensual forms and colours.

At first, the Berlin Impressionists were
regarded as very avant-garde. Politicians and
academicians alike, succumbing to
Nationalism, reviled them as pro-French and
therefore anti-German. They were, however,
eventually very successful and there was no
doubt that, until the arrival of the
Expressionists, their work was the most
advanced the capital had seen.

Their greatest service was to make the
Berlin public aware of the modern artistic
movement and to create an atmosphere in
which their successors might prosper.
One aspect of German Impressionism which
is often overlooked and which distinguishes

it from the French version is the painters' emotionalism. Their colours and handling of paint betrays a deep personal involvement with the subject, at variance with the objectivity and impersonality which was the aim of the French. In the 1920s, Corinth produced a series of landscapes which are closer to Kokoschka than anything by Monet or Pisarro. The unforced transition from quasi-Impressionism to a form of embryonic Expressionism in these canvases emphasises the gulf between German and French Impressionism. (12)

Neo-Impressionism

The brightness and new approach to colour of the French Post- and Neo-Impressionists appealed to Expressionist artists because emotions could be communicated by means of colour. Using paint direct from the tube, unmixed, they applied colour emotionally, arbitrarily, and found that the Neo-Impressionist juxtaposition of small dots of colour made their hues more brilliant. They briefly adopted the style, in fact, for completely opposite ends from those of Signac or Seurat whose objective was a more scientific representation of nature. (3) A more profound and far-reaching influence was Symbolism and its expression in the work of Gauguin and Van Gogh. (13, 14)

Symbolism

Recently it has been maintained with increasing emphasis that the nineteenth century is the least-known of all periods, in spite of its comparative nearness to us. One of its aspects which is still unclear, particularly with regard to the extent of its influence on Expressionism and related movements, is Symbolism.

The Symbolist movement began with a group of French poets around Mallarmé, Verlaine and Rimbaud who attempted to write verse which evoked, suggested and implied rather than directly stated. Their subjects were fleeting and imprecise things. Ultimately, they were interested in the secrets of life, particularly of the inner life of the emotions. 'To *name* an object', wrote Mallarmé, 'is to suppress three quarters of the poem's pleasure . . . to *suggest* it, that is the dream'. In other words the reader had to be stimulated and brought subtly to states of mind with the aid of symbols, metaphors or 'hieroglyphs', which acted on two levels: as images in their own right and as keys to the poem's inner meaning.

The Expressionists not only adopted the idea but also the terminology. Thus Kirchner writes about making 'mystery visible in an *inner picture* . . . The hieroglyph, this inner picture, is not formed in terms of nature . . .

22

but derives from optical laws which have not been used in the visual arts until now' and Kandinsky observed: 'To speak mysteriously of the mysterious. Is this not the content [of the work of art] ?'.

The two artists who, in certain periods of their work, had applied these Symbolist ideas to painting in the most impressive way were Van Gogh and Gauguin. Gauguin asserted that the artist should create 'a veiled picture of limitless mystery'. Van Gogh, in a celebrated passage from a letter to his brother, describes a technique which summarises one of the key methods to be adopted by the German artists in working towards Symbolist and Expressionist ends: 'Instead of trying to render exactly what I have before my eyes, I use colour more arbitrarily in order to express myself more powerfully'. Other, equally well-known passages show that the artist was aiming at a use of colour diametrically opposed to the 'Realist' method of the Impressionists. Colour for him was the best way of expressing abstract ideas, emotions, powerful inward feelings. Instead of depicting the world objectively as it was reflected on the retina of his eye, he was trying to express visually the effect of a landscape or café-scene on his innermost self. (16)

Gauguin, too, was concerned with an arbitrary, that is a non-realistic use of colour. From his time in Britanny to his last days on Tahiti, he searched for correlatives between colour and emotions. His *Vision after the Sermon*, for example, depicts what a group of Breton peasants saw after a church sermon. To heighten the unreality of the atmosphere the picture's colours are not naturalistic. The ground is bright red. He believed that the artist should 'paint dreams and always remain on the search for the absolute'. (2)

Gauguin also believed in the symbolic power of line: '. . . there are noble lines, deceitful lines etc. A straight line signifies the infinite, the curve limits creation . . . colours are even more indicative . . . there are noble tones, others that are commonplace, tranquil harmonies, consoling ones, and others that excite you by their boldness'.

To read Kandinsky's theoretical statements is to realise how close Expressionist ideas are to those of Gauguin and Van Gogh, and how much the Expressionists owed to them. Their achievement in making the 'invisible visible' impressed the Expressionist generation who also believed that they should be laying bare their souls, interpreting the secrets of Nature, describing their feelings and clothing abstract ideas with

tangible forms. Pechstein said: 'Van Gogh is the father of us all'.

One other artist made a crucial impact on the work of the young German painters. The Norwegian, Edvard Munch, who lived in Germany for many years had succeeded in his own way and largely independent of other artists in painting intangible subjects and extreme states of mind. Munch might almost be described as the Sigmund Freud of painting for, in his early work especially, he analysed anxieties and feelings with a penetration and insight that has never been surpassed. His attitude to sex, and particularly his pessimistic view of woman as the devourer of man are summed up by *The Vampire* and his ability to express emotions visually can be seen in *Jealousy* where the facial expressions, the colour and the space between the figures create a visual tension parallel to the picture's emotional content. (15, 7, 17, 126, 152)

Like Gauguin, Munch relied on the symbolic power of colour and line to communicate emotional states. In his most famous painting, *The Cry*, the composition, the distortion of space, the contours and the harsh colour, all express the title of the work without resorting to any of the traditional means of telling a story in pictures.

Strindberg, also from Scandinavia, made the same impact on German audiences as Munch, doing for the theatre what Munch did for painting. Strindberg realised that human motivation was by no means as easy to determine as traditional dramatists had claimed. Miss Julie goes berserk for any number of reasons; few of them can be analysed. (120)

The Primitive

The discovery of the primitive became one of the keystones of much Expressionist endeavour. Modern man was no longer capable of emotion and it was emotion, the more powerful and direct the better, that proved you were alive. (19)

Gauguin was influential in this respect. (35) Sure that modern man had lost his way, and his soul in the process, he searched for man's true nature in primitive societies which, as he believed, were untouched by the stain of Western civilisation and were in consequence more completely human. This belief in 'Natural Man' and the 'Glorious Savage' led him first to the peasants of Britanny and then to the South Seas where he sought to embody the ideal state, man at one with nature, in canvases based on native legends and others which pay homage to the unselfconscious beauty of the inhabitants of Tahiti.

Kirchner, also, 'discovered' primitive art in 1904 and this was of great importance for the development of the *Brücke* style. The South Sea Island carving that Kirchner saw (18) was probably from the German dependencies near New Guinea and although the Bismarck archipelago style is quite different from that which inspired Gauguin and absolutely unlike the African sculpture that so impressed Matisse and Picasso, the basic characteristics were the same: its symbolic quality and (20) directness of statement. For the South Sea Islanders, art was magic, meant to reveal mysteries visually. This explains the distortions, the strangeness and often comic qualities of primitive wood-carving. In this way, it tied in closely with the aim of making the mysteries of life visible.

Art Nouveau and Jugendstil

An off-shoot of Symbolism at the turn of the century was the international movement known as *Art Nouveau*. The German version was called *Jugendstil*. Although this movement pivoted on problems of practical design, the style, which was essentially derived from abstracted natural forms, extended from the applied arts like glass and furniture, to painting and graphics, and also to architecture.

Until recently the movement was regarded as a sterile and precious manner, incapable of development and interesting only as an eccentric curiosity. Recently its theories have been more deeply investigated and *Art Nouveau* has emerged not only as an important manifestation of Symbolism but as one of the richest sources of modernism in the arts. For most of the *Art Nouveau* artists, their curvilinear forms were much more than stylistic devices. Van de Velde, (8) for example, one of the most brilliant *Art* (21) *Nouveau* artists, believed that there was a direct relationship between forms and emotions, a view which relates directly to Symbolist theory, and that certain forms could stimulate definite feelings in those who looked at them. When the Munich Jugendstil architect, August Endell, wrote, as early as 1898: 'We stand at the threshold of an altogether new art, an art with forms which mean or represent nothing, recall nothing, yet which can stimulate our souls as deeply as only the tones of music have been able to do', he was doing nothing short of announcing abstract painting.

In Germany, *Jugendstil* was most successful in Munich. Here the 7th International Art Exhibition in 1897 gave as much space and importance to arts and crafts as to fine art. The name itself was taken from a Munich art magazine, *Jugend*

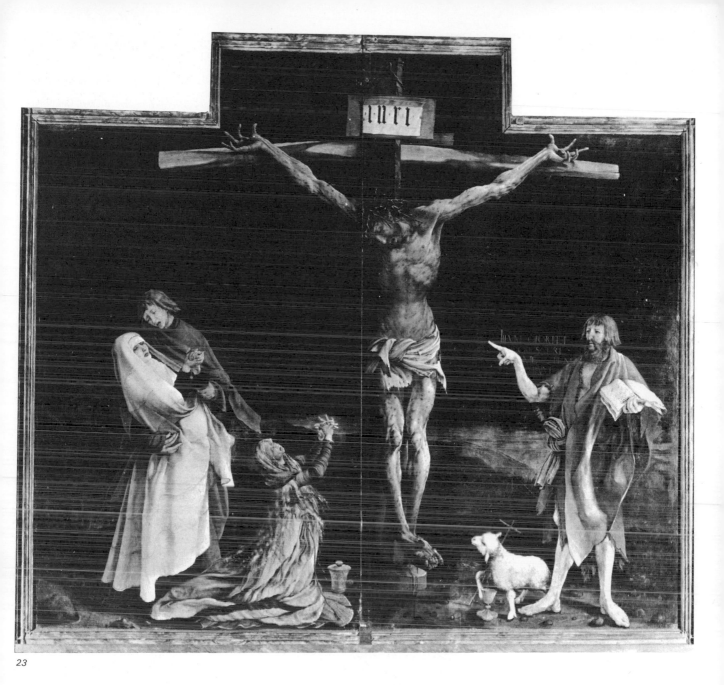

23

23. *Mathis Grünewald* Isenheim Altarpiece,
c. 1515, Musée Unterlinden, Colmar

(*Youth*), which was the semi-official organ of the new style. A Munich designer called Schmidt-Hals produced a series of compositions based on whirlpools and other natural forces in which no recognisable object can be seen, bearing out Gabriele Münter's observation that in Munich in 1901 'Jugendstil was attacking the old Naturalism and cultivating the qualities of pure line'.

The style became fashionable throughout Germany. The *Kurfürstendamm* in the West of Berlin was redesigned and the houses given *Jugendstil* façades; there was a *Jugendstil* artists' colony under Royal patronage in Darmstadt and Henri van de Velde became the first director of an art school based on *Jugendstil* ideas in Weimar. But the centre of the movement was still in Munich.

The influence of the style on those artists who were to become Expressionists was crucial; almost all of them went through a period of experimentation with *Jugendstil*. All over Europe the same thing was going on. Picasso's Blue Period, for example, derives from his knowledge of *Art Nouveau* in Barcelona. Kandinsky, working in Munich, produced paintings and woodcuts clearly influenced by *Jugendstil* for a time and the theoretical pronouncements of Munich artists like Obrist and Endell reappear later, in modified form, in Kandinsky's justification of abstract art, *Concerning the Spiritual in Art*.

The interest in the woodcut and the first woodcuts produced by Kirchner in Dresden comes as much from the *Brücke* artists' knowledge of *Jugendstil* as from their desire to emulate medieval German artists. The first things done by Kirchner, Heckel and (22) Schmidt-Rottluff all bear witness to the fact, as does their enthusiasm for magazines like *Jugend*, *Pan* and the English *Studio*. Far from being a precious, essentially sterile movement, *Jugendstil* was in fact the direct link between the Symbolist and Expressionist generations.

The Gothic and Medievalism
In the years before the foundation of the *Brücke* group, the great area for clarification and revaluation was pre-Renaissance 'Gothic' art in Northern Europe. Throughout the Renaissance, the Gothic was thought to be a primitive and barbaric culture. The major painters of this period—Cranach, Grünewald and the School of Cologne, for example—had for years been regarded as little more than unfortunate. Little by little, however, the Italian Renaissance was no longer regarded as the only possible source

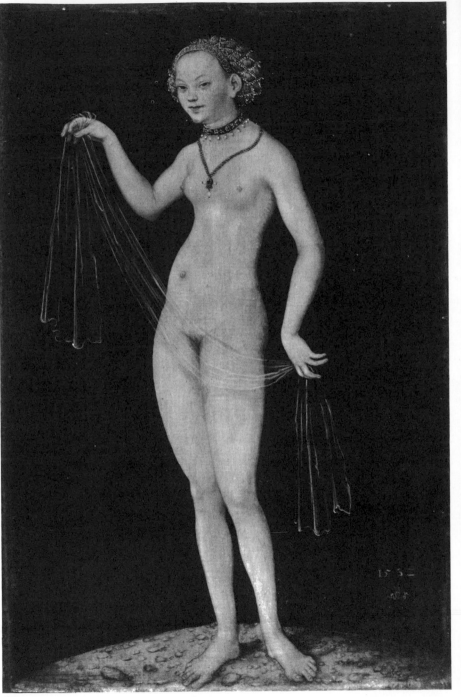

24

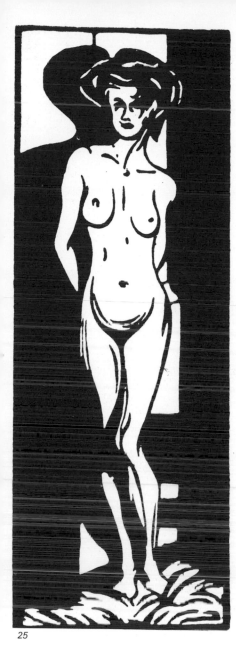

25

for the true and the beautiful and Grünewald's conception of the darker side of existence and his wilful style could at last be appreciated. Grünewald's *Isenheim Altar*, a genuinely visionary synthesis of form and content and one of the most (23) harrowing paintings ever created, became the talisman for the Expressionist generation.

In England, the revaluation of Gothic art resulted in the attitudes of Ruskin and Morris. In Germany the most significant results came later. They were so thorough-going that even the great Classicist, Heinrich Wölfflin, turned to the study of medievalism. In 1912 the shift was marked by a book, *Problems of Form in the Gothic*, by Wilhelm Worringer, who had already laid the foundations for modern art theory with his book, *Abstraction and Empathy* (1910). Although Kirchner's ideas had been developed before Worringer's publication, the climate of opinion which influenced the artist received its fullest expression in Worringer's book.

Worringer claimed that non-classical styles, and particularly the Gothic, had suffered from the Classical scale of values which had predominated for centuries. A new aesthetic was necessary. The classical style had sprung from the feeling that man had understood and mastered his environment. In contrast, Gothic man found himself in a hostile environment which he could neither comprehend nor overcome. The Gothic 'soul' is the result of this predicament when the inner and outer worlds of the artist are not resolved. A religious, mystical, 'inner' style is its expression where the superficial appearance of nature is changed by the temperament of the artist.

For Worringer, the Gothic man is the Northern European, racially speaking, the German strain. The Germans were not the only race to have produced Gothic art but they, and their racial characteristics, were the *sine qua non* of the true Gothic style. The purest form of the Gothic is, therefore, not to be found at Rheims or Chartres, but in the Germanic North. Here the expression of the Gothic 'soul', its awe in the face of an imponderable world, its mysticism, is at its finest.

In Nuremberg, Kirchner had been struck by similar thoughts, reflecting that 'the German creates his form out of fantasy, out of his inner vision and the visible form of nature is a symbol to him...' and that, in establishing the new German art, he must lay bare the universal truths which lie beneath the surface of Nature.

This explains why Kirchner revered medieval artists like Dürer and Cranach. A reproduction of a Cranach hung in his (24) studio and he made several versions of it himself. Of far greater importance than (25) specific visual sources, however, was an attitude of mind, informed and stimulated by what is best described as the atmosphere of Gothic art: its linearity, its distortions and dissonances, and, above all, its expression of the mystical.

Furthermore, during the early years, the *Brücke* group reflected the character of a medieval guild. The names of medieval masons and carvers who produced the great cathedrals are unknown and unimportant. They were members of a guild, working together to create a grand and unified monument to the greater glory of God. These anonymous masters were also versatile. There was no difference between art and craft. It was a time when artist meant artisan. In the same way, living together in Heckel's studio, the *Brücke* artists painted and decorated it with furniture and crudely printed tapestries all made by themselves. They had a sense of vocation, lofty ideals and they also sought a communal style; it is often difficult to distinguish between the work of the individual members at first. The *Brücke's* attitude to communal work is best shown by its graphic work. Its artists believed, like Morris and Ruskin, that in all arts an intimate, craftsmanly relationship must exist between artist and work and that art must speak to the people. Consequently they taught themselves how to print. This was in sharp contrast to current practice, where professional printers were employed. It is no exaggeration to say that the *Brücke*, and Munch, revitalised the art of woodcut in Germany. Not since Dürer had such excellent work, completely in terms of the medium, been produced.

24. *Lucas Cranach the Elder* Venus, *c. 1530, Städelsche Kunstinstitut, Frankfurt am Main*

25. *Ernst Ludwig Kirchner* Standing Nude, *c. 1902, woodcut*

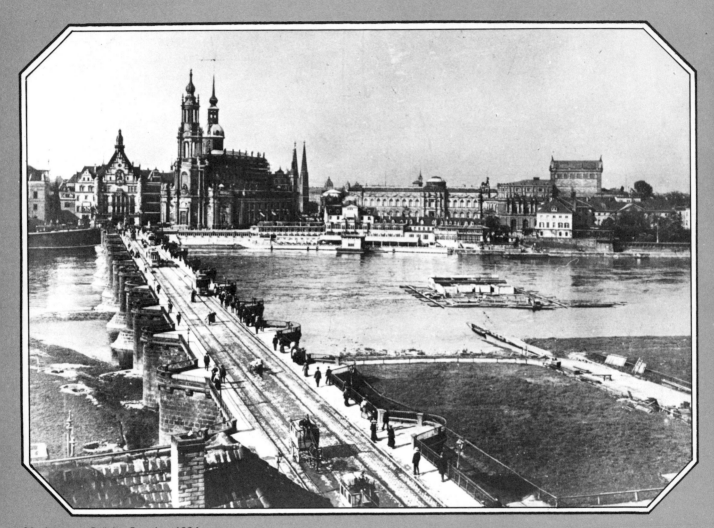

26. *Augustus Brücke, Dresden, 1904*

Dresden

27. Opera House, Dresden

Beginnings of the Brücke

The *Brücke* artists were the first to produce wholly Expressionist work and it was in Dresden in 1905 that their group, *Die Brücke* (The Bridge), was formed. (28)

Dresden was a beautiful city with a long artistic tradition. The capital of Saxony, it possessed one of the richest collections of paintings in the world and its architecture, mostly Baroque, made it one of the (26, 27) highlights of any fashionable Grand Tour. Its theatre was one of the most controversial and courageous on the continent. Plays by Ibsen and Strindberg had first performances here.

Dresden's star first began to rise in the field of modern painting when the exhibition of 1897 was held where Van de Velde, later to have a crucial influence on German art education, was first introduced to the German public. The Academy of Art remained conservative, however, as did the policy of the museums. This was in marked contrast to the views of the private dealers. Galleries like Richter and Arnold were in advance even of Berlin and concentrated on French modernism. Monet and Cézanne were shown as early as 1896. Munch had a show in 1900 and thirty-five Van Goghs were shown in 1905. The modern movement was supported in print by *Kunstwart*, a magazine founded in 1887.

Nevertheless, the circumstances in which the *Brücke* was founded and the extent of its influence was surprising. The four amateur painters Ernst Ludwig Kirchner, Fritz Bleyl, Erich Heckel and Karl Schmidt-Rottluff, who, in 1905, formed this artistic group, were all architectural students, studying at the Technical High School in Dresden. Their professed intention was to revolutionise the course of German art and profoundly to influence the nature of German society.

The *Brücke* may not have changed society but it certainly marks a watershed in the development of German art. With its foundation, Expressionism was given its first coherent form. The *Brücke* turned out to be the first German movement of truly European significance for more than three centuries.

The group had unpromising beginnings. The outlook of its four student members—the youngest was 19, the oldest 25—was decidedly immature. At first, the *Brücke* was more like an undergraduate secret society with vague mystical leanings and enthusiastic but inarticulate political notions. The most revolutionary things they were doing at first were woodcuts in the *Jugendstil*

MIT DEM GLAUBEN AN ENTWICKLUNG AN EINE NEUE GENERATION DER SCHAFFENDEN WIE DER GENIESSENDEN RUFEN WIR ALLE JUGEND ZUSAMMEN UND ALS JUGEND, DIE DIE ZUKUNFT TRÄGT, WOLLEN WIR UNS ARM: UND LEBENSFREIHEIT VERSCHAFFEN GEGENÜBER DEN WOHLANGESESSENEN ÄLTEREN KRÄFTEN. JEDER GEHÖRT ZU UNS, DER UNMITTELBAR UND UNVERFÄLSCHT DAS WIEDERGIEBT, WAS IHN ZUM SCHAFFEN DRÄNGT

28. *Ernst Ludwig Kirchner*
Künstlergruppe Brücke, *1906, woodcut*

29. *Ernst Ludwig Kirchner,*
Manifesto of the Brücke, 1906, woodcut

30. *Ernst Ludwig Kirchner, Caricatures on a postcard sent to Fritz Bleyl, 1904, woodcut, Brücke Museum, West Berlin*

31. *Ernst Ludwig Kirchner, Postcard to Fritz Bleyl from Nuremberg, showing a castle, 1904, ink*

30

31

RNBERG

37

manner. As far as art was concerned, its members hoped to compensate for their lack of training and experience with an excess of zeal.

They began in a spirit of social criticism. The tone of the *Programme of the Brücke*, the group's 'manifesto', cut in wood and in letters recalling Morris, is that of a high-sounding mission: 'With faith in progress and in a new generation of creators and appreciators of art we summon all youth together. As youth, we carry the future with us, and want to establish freedom of life and movement in opposition to the entrenched older forces. Everyone who conveys that which forces him to create directly and with authenticity belongs to us'. Here the generation question and revolutionary intent are perfectly clear. In contrast to other manifestoes of the modern movement, this programme of the *Brücke* sounds almost like a political pamphlet. (29)

Erich Heckel's decision to take a studio in the workers' suburb of Dresden also had political grounds. Kirchner would have us believe that they were on the edge of starvation all the time, that they had to take the cheapest accommodation available and that he, Kirchner, had to black grates at 50 Pfennings a time just to stay alive. All four students were receiving regular financial support from their parents, however, and if they lived cheaply it must have been because they thought it was good for the soul. Heckel says that they were never without wine at meals and that he could have taken a proper studio elsewhere if he had wanted. The decision to rent part of a butcher's shop was therefore partly a declaration of solidarity with the workers, and partly a demonstration of their contempt for the bourgeoisie.

The studio was in a permanent state of disorder: dirty, paint-flecked and the cigarette butts of weeks of excessive smoking piled in the corners. Surroundings which betrayed a studied Bohemianism were complemented by naked girls sitting around for most of the day posing and a diet of tea, cake, tobacco and poetry-readings. Fritz Bleyl records: 'Heckel read us beautiful poems. I can still recall Fontane's *Bridge Over the Tay*, Conrad Ferdinand Meyer's *Feet in the Fire*, Whitman's *Leaves of Grass* and Arno Holz's poetry'. These very Romantic pieces show clearly where the interests of these young students lay.

No-one knows who first thought of the name *Brücke*, or indeed what it was intended to signify. Bleyl wrote that 'the plan was not to appear in public as individuals, but as an artists' association... which would have a definite, strong-sounding name.' It was probably Schmidt-Rottluff who invented the happy title, *Die Künstlervereinigung Brücke* (The Artists' Association Bridge).' Nietzsche, the Group's favourite philosopher, certainly used the bridge as an important symbol in *Thus Spoke Zarathustra*, and this may well have been the source for the Group's name.

The interesting thing is that the young artists got the idea of founding a group with a name and a programme at all, particularly as their art was by no means very advanced at the time. There had been no groups of German artists since the *Deutschrömer* had come together in Italy in the nineteenth century. What bound them together was the fact of their exile and their pursuit of the same historical style in painting. It was probably the *Nabis*, the French group of mystical and religiously inspired artists, which the *Brücke* took as their immediate example. The *Nabis* put the same emphasis on the mystical ('*Nabim*' is the Hebrew word for prophet) and the same belief in group activity. Nevertheless, the *Brücke* turned out to be much more homogeneous than the *Nabis* or any of the other numerous artistic groupings of this century.

Ernst Ludwig Kirchner

Kirchner claimed to have been the leader and initiator of the *Brücke*. If this was not the case (and it is difficult to plot the Group's exact course during the early years), he was certainly the strongest and most egocentric personality of the four. A would-be theoretician, he became the group's most eager explainer. Much of what he wrote, however, is suspect, distorted in the interests of self-glorification.

He was born in 1880 in the small and undistinguished Franconian town, Aschaffenburg. His father, an expert in paper technology, took the family to Saxony, where he had been offered a teaching job. Although he encouraged his son to draw and paint from an early age, he persuaded him to study architecture, a pursuit both more secure and socially acceptable than painting.

According to Kirchner, his first paintings and woodcuts date from childhood. If he did begin to produce work so early, it no longer exists and the earliest things by him that we have are postcards with his own woodcuts printed on them which he sent to his friend, Fritz Bleyl, from Munich. Of these, a series of caricatures is of special interest. They show the influence of Vallotton, the

32. *Gothic figure group, 1200–37, Bamberg Cathedral*

Swiss *Art Nouveau* artist. (30)

Kirchner knew the *Art Nouveau* magazines in Dresden but his contact with the movement was strengthened by a trip to Munich. There he entered the private academy of Wilhelm von Debschitz and Hermann Obrist. Obrist was a *Jugendstil* artist of great originality and perception Primarily a decorator, he investigated the emotional effects of lines and colour. One of his statements is highly relevant in connection with Kirchner. Obrist claimed that the ambition of every modern artist should be 'to replace Impressionism with a heightened expression and intensification of reality' and to treat art as 'exalted poetic life'.

Kirchner returned to Dresden within a year to continue his architectural studies. 'Munich with its *Bierfeste* soon bored me'. he wrote later but Munich had given him more than he admitted. He had seen an exhibition of Neo-Impressionist paintings, studied medieval woodcuts and Flemish etchings in the museums and discovered German Gothic which had found its most perfect expression in South German cities like Nuremberg, Naumberg and Bamberg. Kirchner had also seen an exhibition which included works by Cézanne, Van Gogh and Gauguin. He later claimed that he had not been greatly impressed. '. . . there were several Van Goghs there, but I found his work too excited and fragmented. I couldn't learn much from such people'. The paintings he did during the next three years tell a different story. (31, 32, 46)

Kirchner's painting invariably lagged somewhat behind his theories and he later destroyed his early work, repainting pictures to make it seem as though he had been really modern much earlier, but when the French influence finally asserted itself, in 1906 and 1907, the free brushwork and striking colours recall Van Gogh and are also related to the Neo-Impressionist manner.

But Kirchner was not stimulated by the French alone. He wanted ultimately to create a modern German school. To do this he felt that he needed to isolate the peculiarly German characteristics in art: those qualities which make a German painting German and nothing else. He found what he wanted in Dürer, Cranach and the other German masters who, poised between late Gothic and the Renaissance, were the last standard-bearers of the national culture before it went under in the flood of foreign influences. Again, his interest in the Gothic took some time to manifest itself in his work. When it does appear, it can be discerned in a general

33. *Ernst Ludwig Kirchner,*
Brücke letter head, 1906, woodcut

34. *Ernst Ludwig Kirchner*
Nude in Black Hat, *1909,*
26 × 8.43 in. (66 × 21.5 cm.), woodcut

35. *Ernst Ludwig Kirchner,*
Vignette, woodcut

rather than specific form. He elongates his figures and tends to round out the belly and narrow the legs in a medieval fashion. The stylised facial expressions also owe (33, 34) something to Gothic painting, although so many influences were working on Kirchner at this time that it is often difficult to isolate specific sources for any one picture.

In 1904, Kirchner made another important discovery. Looking at wood-carvings by South Sea Islanders in the ethnological museum in Dresden, he noticed that 'they used in their figures exactly the same formal language that I did . . . and I began to believe that I was on the right track.'

Despite what he says, it is certain that primitive art had no effect on Kirchner's style in 1904. Later, when Kirchner's style matured and he moved away from the free versions of Van Gogh's and Seurat's styles, his line hardened and his approach became more linear, largely because certain (35) primitive influences were breaking through and he often included pieces of primitive wood-carving in his compositions.

The crucial thing—and Kirchner's achievement is to be found here as much as in any of his work—is that he recognised where the true course of modernism lay. Almost overnight, a German artist came abreast of the times, a fact which is all the more amazing because German artists had previously been at least a generation behind. Independent of France, Kirchner recognised for himself precisely what was new and vital: the work of the Neo-Impressionists and so-called 'primitive' art. These were important factors not only in the art of the *Brücke*, but in Fauvism and Cubism as well. Although in 1905 Kirchner's work lagged behind his ambitions, his ideas, developed by two years of intensive thought and fairly serious reading, plus a wealth of visual experiences, were maturing and becoming very definite and he transmitted them to other members of the *Brücke*. They, too, had important ideas to offer. Between them they created the *Brücke* style: revolutionary, independent, the beginnings of Expressionism. In 1937, many years after the event, Kirchner described the situation thus: 'Did you know that as early as 1900, I had the bold idea of revivifying German art? I brought it off, too . . . my aim was always to express feeling and experience through large and simple forms'. The statement is typical. The decision to inject new life into German art cannot have been as early as he claims, nor did he achieve his goal alone.

Fritz Bleyl
Fritz Bleyl, Kirchner's friend at the

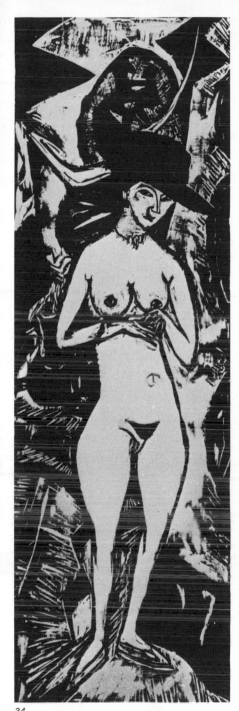

34

Technical High School, was of little importance as an artist, although one of the founder-members of the *Brücke*. (38) Financial difficulties soon forced him to leave the group and practise as an architect. It is one of the ironies of the *Brücke's* history that this one-time revolutionary should later write a doctoral thesis on the mining of ores, in preparation for a staid career as an academic.

Bleyl's recollections of the early formative years of the *Brücke*, however, are of great value. He writes for example of Kirchner's return from Munich 'with heaps of sketches and drawings. . .' and of how they 'kept up-to-date by looking at the few art journals there were at the time, above all the English *Studio* . . .' Elsewhere Bleyl mentions that: 'One day Kirchner brought an illustrated book by Meier-Graefe on the modern French artists from some bookshop. We were thrilled'. This book, *The Development of Modern Art*, by Julius Meier-Graefe, the German art historian, made an impression not only on Kirchner and Bleyl, but on all thinking artists in Germany. It would not be an exaggeration to say that Meier-Graefe was largely responsible for the introduction of French Post-Impressionism to the country. Bleyl continues: 'We got hold of all the then new little books in Richard Muther's series *Die Kunst* (Art). With their help we got to know the work of the great modern painters and graphic artists. Through the monographs by H. Knackfuss, we also became aware of special areas of world art, like poster design and coloured Japanese woodcuts'.

The third German exhibition of arts and crafts in Dresden also surprised and thrilled Bleyl and Kirchner. The French section included 'many large books full of reproductions of the masterpieces of modern French art. We were astonished by these large superb illustrations of Van Gogh and Gauguin, to choose only two of the many great names'.

Erich Heckel

Erich Heckel, from Chemnitz (now Karl-Marx-Stadt) in Saxony, was three years younger than Kirchner and already interested in painting and poetry when he began to study architecture in 1904. (37) According to Kirchner, Heckel soon heard about his talent from friends at the Technical High School and visited him at home. 'Without collar or hat he came up the stairs declaiming passages from Nietzsche's *Zarathustra* . . . and my girl-friend, who was posing for me, almost burst trying not to laugh at this peculiar young man. But she

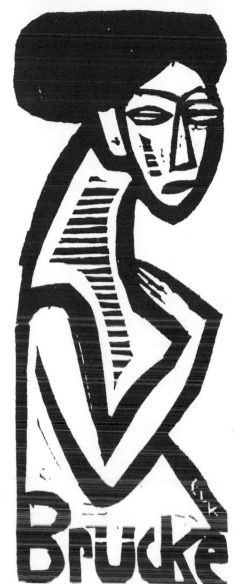

35

41

36. *Erich Heckel* Sitting Woman,
1906, woodcut

37. *Ernst Ludwig Kirchner*
Portrait of Heckel, *1911, oil on canvas,*
76.75 × 25.5 in. (195 × 65 cm.),
Karl-Ernst-Osthaus Museum, Hagen

38. *Fritz Bleyl* Old Houses,
c. 1905, woodcut

36

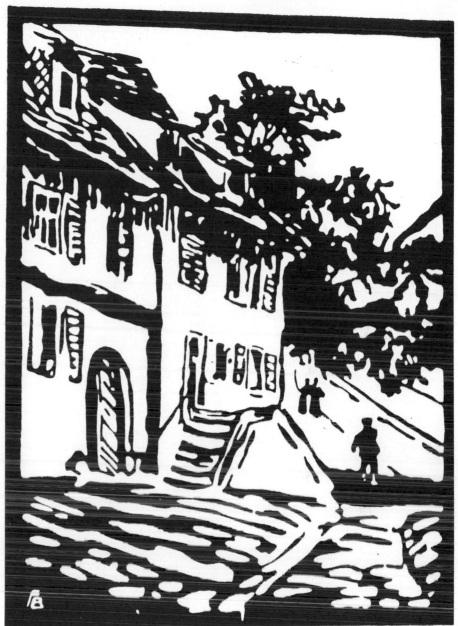

37

38

39

soon realised that he was enthusiastic and noticed how he admired my work . . . Heckel learned quickly'. (36)

Kirchner does not mention that Heckel's own paintings were already quite advanced in his use of colour and that his paintings were generally more courageous than his own. But like Kirchner's, Heckel's work of 1904 and 1905 cannot be described as really advanced. *Flowering Cress*, (48) for example, a remarkable painting from 1907, is still completely under the spell of Van Gogh. Van Gogh's *Meadow with Butterflies* (1890), in particular, is (47) called to mind by *Flowering Cress*, in which the harshness of Heckel's colours, the violence of the handling and the fragmentation of the subject certainly recall Vincent's last period. The subject has been rendered almost unrecognisable, dissolved into a riot of curling brushstrokes which flicker on the surface of the canvas.

The *Brücke* owed much more to Heckel, its most practical and business-like member, than Kirchner was ever prepared to admit. The idea of founding a group appealed to him greatly, and he began to think along the lines of a painters' community, like that which Van Gogh had proposed to Gauguin in Arles. Heckel was the first to find a proper studio and it was there that the others met. It was also Heckel who found the premises for the group's first exhibition, which he organised, to all intents and purposes, alone.

Karl Schmidt-Rottluff

Heckel's best friend was Karl Schmidt who, deciding that his real name was too mundane, added that of his birthplace, Rottluff, a small town near Chemnitz. Schmidt began to paint at school and according to Heckel showed more promise than any of the other future members of the group when he came to study architecture in Dresden in 1905. His colours were apparently brighter even than Heckel's and he had already learned how radically to simplify and express a landscape in terms of its basic elements.

Heckel took his friend, at that time only 19, to see Kirchner, who again relates how much he taught the young man. Schmidt certainly seems to have first applied himself to (41) woodcuts under Kirchner's supervision and made very quick progress. As artists they quickly reached a similar state of (39, 40) development. The group was ready for its official launching.

Emil Nolde

In 1906 the Group felt confident and advanced enough to invite four new painters to join them. The most important of these

39. *Karl Schmidt-Rottluff* Windy Day, *1907, oil on canvas, 27.87 × 35.75 in. (71 × 91 cm.), Dr Paul Rauert, Hamburg*

40. *Karl Schmidt-Rottluff* Still-life with Apples and Yellow Flowers, *1908, oil on canvas, 26 × 18.87 in. (66 × 48 cm.), Wallraf-Richartz Museum, Cologne*

was Emil Nolde, who had exhibited in (42) Dresden in January. At that time, painting in his own, strongly individual version of Impressionism, Nolde had begun to liberate his colours, had gained the strength to begin to free himself from nature, to use discordant and jarring hues and to let colour live for itself. (50)

It was the comparative brightness of his canvases that appealed to the *Brücke*. A painting like *Trollhoisgarten* clearly shows the stage Nolde had reached. A composition without a horizon line, its all-over quality is emphasised by the strength of the colour and the high degree of freedom with which the brush has been handled. It shows that Nolde, like the other members of the group, had been influenced by Van Gogh. Nolde was not, however, from Dresden. He lived in isolation right up in the North of Germany, not far from the Danish border. Schmidt-Rottluff immediately wrote to him, inviting him to join and persuaded Nolde, old enough to be his father, to visit Dresden: 'You will know as little about the *Brücke* as we knew about you before your exhibition . . . now, esteemed Herr Nolde, please consider what your wishes are . . . we want, with this letter, to do honour to your veritable storms of colour'.

In the summer, Schmidt-Rottluff went to visit Nolde who thought at the time that his visitor did not really have much to say for himself. He wanted to talk only about Nietzsche and Kant. Nevertheless, Nolde eventually agreed to join the young artists and lived in Dresden on and off during the next two years. Two pictures painted during this visit are instructive: one is a self-portrait by Schmidt-Rottluff, the other is a portrait of him by Nolde. The Schmidt-Rottluff is the more advanced, completely broken up by long, nervous squiggles of harshly bright (53) paint. The other, also loose and colourful, (54) makes concessions to conventional ideas about introducing light into paintings and the way the brushstrokes are integrated to give the figure rounded form is also less courageous than the Schmidt-Rottluff.

Nolde was one of the strangest and most independent Expressionist figures. Unlike the other members of the *Brücke*, he was a peasant, uncultured and proud of his roots. He loved solitude, was suspicious of other people and hated intellectuals. He was much older than the young *Brücke* painters which also resulted in a difference in outlook, but from their point of view, Nolde's experience was of the greatest benefit. He had been to Paris and many parts of Germany and knew dealers, museum officials and collectors.

40

41. *Karl Schmidt-Rottluff,
Figure group of artists
(Heckel in the centre), c. 1905.*

42. *Emil Nolde* Self-portrait,
c. 1906, woodcut

41

He had had a modest success, exhibiting quite frequently and earning enough from his work to enable him to live.

Nolde was born in 1867 of German-speaking stock but in what was then South Denmark. This partly explains the fervour with which he proclaimed his nationality and the importance he attached to race. Nolde was deeply attached to the landscape from which he came, where harsh winters, mild summers and the frequent fogs which come down to blanket the land, clusters of islands, floods and large clouds scudding across the sky create an atmosphere in which nature seems vast, forbidding and (166) unpredictable. All the people there feel the marked rhythm of the year and have an almost religious relationship with the soil. Theodor Storm, in his short novel, *Der Schimmelreiter (The Rider on the White Horse)*, brilliantly describes the people and the area. The North Germans still believe in the supernatural, and there is no doubt that such factors played a big role in the formation of Nolde's art. Something of his feeling for his environment emerges from his *Steamer Belching Smoke* of 1910, where two ships, both vague and ghostly, battle their way through rough seas on a dismal day. (1 *on front endpapers*)

Although he travelled a great deal, he was never really happy when away from home. A letter written during a visit to Berlin shows this clearly: '. . . I have never been so lonely . . . I long for a life as pure as Nature, for sunshine, for the West wind which whips up the foam and lashes me in the face. I want my clothes to be soaked . . . frosty cold that bites, icicles hanging over my mouth from my moustache. . . . I long for grass and dune-sand, to lie there, dreaming, sleeping— sleeping until I die'.

Nolde's artistic development was unusually slow. He began as a carpenter and joiner. Leaving home, he taught at various schools for the training of craftsmen and eventually decided to become a painter. Refused admission by the Munich Academy, he went to the artists' colony in the countryside nearby, at Dachau. Here Adolf Hoelzel took him under his wing. Hoelzel, still underestimated as an artist and theoretician, was to become the most influential teacher in Germany and made a significant contribution to the creation of abstract art.

In 1899, Nolde went to Paris, where, like so many great painters, he benefited from the lack of proscriptive training at the *Académie Julian*. In Paris he saw work by the Impressionists, of course, whose sweetness he claims to have disliked on

42

43. *Emil Nolde* Big and Little Steamer, *1910, woodcut*

44. *Emil Nolde* Young Girl with Bird, *woodcut*

45. *Emil Nolde* Steamers, *1910, woodcut*

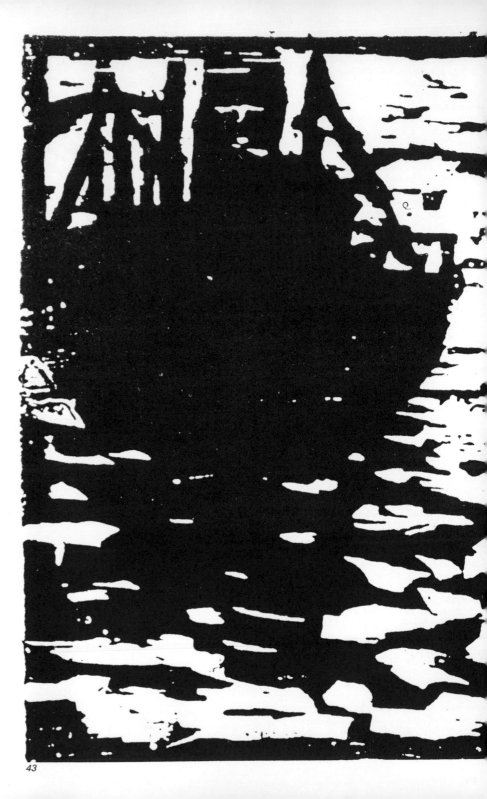

43

44

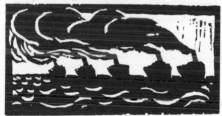

45

49

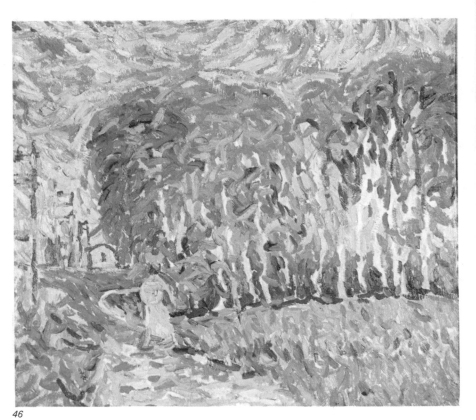

46

48

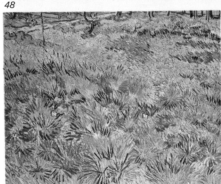

47

46. *Ernst Ludwig Kirchner*
Frau vor Birken, *c. 1906,*
Baron von Thyssen Collection,
(near Lugano), Switzerland

47. *Vincent van Gogh*
Meadow with Butterflies, *1890,*
oil on canvas, Tate Gallery, London

50

49

48. *Erich Heckel* Flowering Cress, *1907,*
oil on canvas,
26.75 × 29.87 in. (68 × 76 cm.),
© *Professor Erich Heckel, Hemmenhofen*

49. *Max Pechstein* River Landscape,
c. 1907, oil on canvas,
20.87 × 26.75 in. (53 × 68 cm.),
Folkwang Museum, Essen

50. *Emil Nolde* Trollhois Garden, *1907,*
oil on canvas,
28.87 × 34.75 in. (73.3 × 88.3 cm.),
Ada and Emil Nolde Foundation, Seebüll

sight. He preferred the Manet and the Rembrandts which he saw in the Louvre. In 1900, back in North Germany, on the island of Alsen, he painted his wife, self-portraits and his immediate environment, most often his garden, in a style derived from the Impressionists. The striking difference between his manner and that of the Impressionists lies in his brighter colours and his freer, thicker handling of paint, the bold qualities which were to attract the *Brücke* painters in 1906.

Nolde resigned from the group in 1907, a mere eighteen months after he joined. He had found the group atmosphere, at times, almost incestuously close, stifling, and had lost patience with the immature way in which the young painters talked philosophy and read poetry aloud. He was reaching a real, if late climax in his work, and felt that he should be recognised as an individual talent and not be made to bask in the reflected glory of a group. 'Intellectuals and learned men call me an Expressionist', he wrote later, 'I do not like this narrow classification. A German artist, that I am'.

He returned once more to solitude on the island of Alsen where he continued to paint the flowers in his garden in riotous colours and to think deeply about religion. One thing that he learned from the *Brücke* was how to make woodcuts and he quickly (43,44) excelled in the technique. Indeed, his woodcuts were far in advance of his (45) paintings, and his later religious compositions, on which his reputation largely rests today, were anticipated by religious subjects cut in wood. We shall return to the climax of Nolde's career later.

Max Pechstein
The other important artist to join the *Brücke* in 1906 was Pechstein, the only trained painter among them. Pechstein had decorated the ceiling of the Saxony hall at the Dresden arts and crafts exhibition. His colours were too bright for the authorities, who had his work overpainted. Heckel, who had seen the ceiling in its original state, sympathised with Pechstein and asked him to join the *Brücke*. We can have no idea of how the ceiling looked but a river scene of 1907 shows that Pechstein was as advanced as any of the other (49) members of the Group. Here the blocks of colour recall Neo-Impressionist painting but go beyond it by being very bright and jarring.

Pechstein was not only the best painter in conventional terms of the group, he was also its most politically active member. He once wrote, for example, that 'art is not a game, but has a responsibility towards the people.

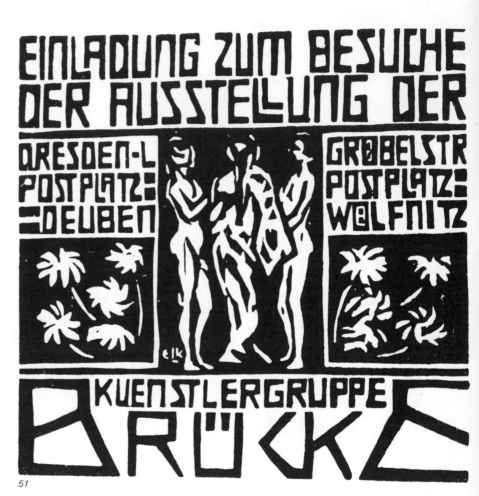

51

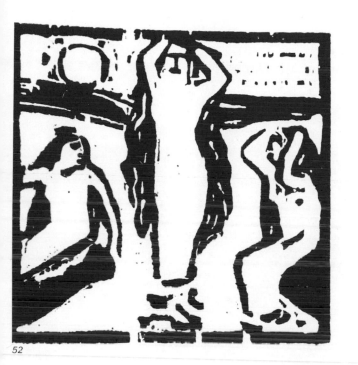

52

51. *Ernst Ludwig Kirchner, Invitation to the 1905 Brücke Exhibition, woodcut*

52. *Brücke membership card, 1909, woodcut*

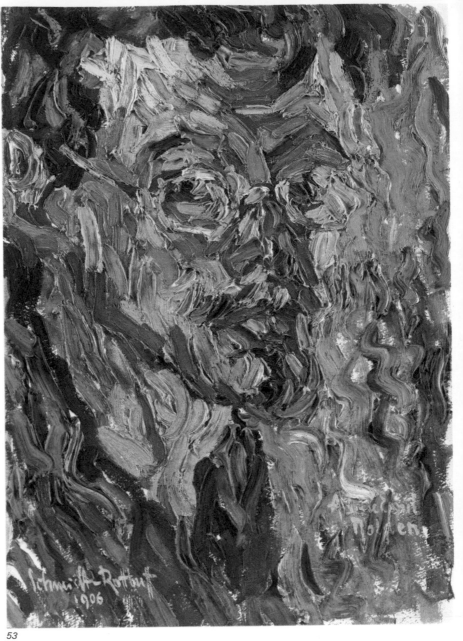

53

53. *Karl Schmidt-Rottluff* Self-portrait,
1906, oil on canvas,
17.25 × 12.5 in. (43.8 × 31.8 cm.),
Ada and Emil Nolde Foundation, Seebüll

54. *Emil Nolde* Portrait of
Schmidt-Rottluff, *1906, oil on canvas,*
20.37 × 14.5 in (52 × 37 cm.),
Ada and Emil Nolde Foundation, Seebüll

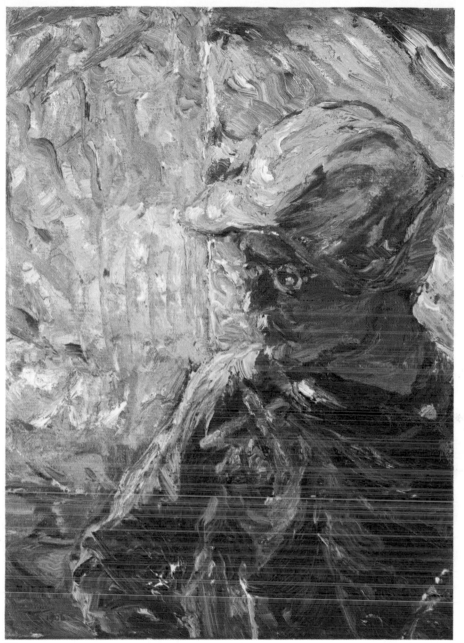

54

Art is a public affair'. Unlike the others, Pechstein had made contact with his contemporaries in France and always recognised his debt to them.

Kirchner was never really fond of him, afraid that he might take over the unofficial leadership of the *Brücke*, as in the eyes of the public Pechstein eventually did. Indeed, Pechstein was the first of the young artists to enjoy real financial and critical success, and much of the success that the *Brücke* later had was due to Pechstein's association with it. For many years he was thought to be the only significant Expressionist from Dresden. For this, Kirchner never forgave him.

Exhibitions

In his letter of invitation to Nolde, Schmidt-Rottluff said that the group arranged several exhibitions annually, and that these travelled throughout Germany. At that time, this was wishful thinking. For one thing the original four members did not have sufficient work to show and none of it was 'surging and revolutionary' enough to give the public even a vague idea of what the group stood for. Now that there were six artists, two experienced and professional, there was more point in an exhibition. The problem was: where?

Not surprisingly, none of the Dresden dealers were prepared to give them wall-space. Heckel, whose contacts were always better than Kirchner's, found a designer of light-fittings in the Löbtau suburb of Dresden who had a showroom and was willing to let the group hang their work there.

In this way, in 1905, the first *Brücke* exhibition was arranged and was especially important for they regarded their first introduction to the public as a group to be of immense significance. Kirchner designed a large, powerful poster (after Bleyl's original design had been banned as obscene by the police) and produced a woodcut for the (51) invitation card. Of course, the surroundings did not make for a suitable atmosphere. The show-room was too far from the city-centre and the decor must have clashed with the work on show. The exhibition was not a success. There was almost no critical comment, and the workers, on whom the group had placed a certain amount of hope, did not come. So the *Brücke's* hopes of making what Kirchner described as 'painting in the home once more the centre of human existence' came to nothing.

The members were probably not surprised by the lack of response. They immediately saw that if the group was to be a success, above all financially, then some sort of publicity was desperately necessary.

Someone had the idea of widening the membership to include non-practising artists, so-called 'passive' members who, for an annual fee, would receive a portfolio of original prints, a membership card and a (52) yearly report. It was an idea of some originality and in keeping with the group-idea to create a real social role for art.

Shortly after the first exhibition the first portfolio appeared with a woodcut each by Bleyl, Heckel and Kirchner, and the portfolios continued to appear sporadically until 1912. They have since become some of the most sought-after examples of modern graphic art. In 1906 the manifesto, or programme of the *Brücke*, also appeared, cut in wood in almost indecipherable letters, by Kirchner. (29)

Early Brücke Style

There was no catalogue of the first exhibition and there is no way of determining exactly what was on show there. Most of the *Brücke* work from this period was unsigned and undated and Kirchner's dated work is in any case highly suspect. We can, however, see what stage the painters had reached from a small number of canvases which are without question dated correctly.

The work of all the artists hovers between a bold, bright version of Impressionism and a sort of painting where subject and style is highly simplified. The paintings of 1906 are invariably bright. Yellows, greens, reds and blues, applied without reference to the (46–9) 'natural' object throb and vibrate. A nude is seen as an unstable arrangement of brilliant complementary colours. The contours, (57) always emphasised, are often in bright red or green and the subject seen against a flat, (59) patterned background. Space is pushed more and more to the surface of the canvas, so that in the most advanced paintings, the entire subject is rendered as a flat, complex pattern which interlocks and covers the entire picture-surface.

Pechstein's colours are less violent than (56) Kirchner's; they are sweeter, more in keeping with what is best described as 'French' taste. Nolde's handling is freer and richer than (54) Pechstein's or Kirchner's. He is still concerned with often extreme effects of light and with the rhythms set up by his (50) brushstrokes on the canvas. Both Schmidt-Rottluff and Heckel were less interested in flat contrasting areas of colour than was Kirchner.

Woodcuts from the same period show the end of the influence of *Jugendstil* and the beginnings of an approach, in which (55) generous areas of black and white contrast strongly and the natural graining of the wood and marks of the tools are exploited to the

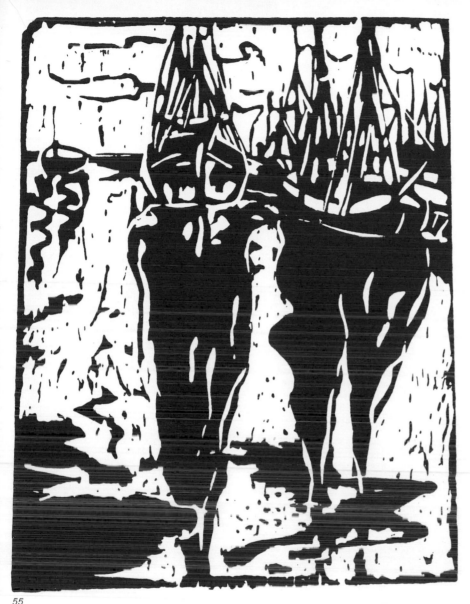

55

full. Nolde, who is said to have been introduced to the technique by Kirchner, took to it from the first. The former carpenter was already very advanced by 1906 and his pieces compare favourably with Kirchner's invitation card for the first exhibition which, in the way it divides the composition into very definite areas, is still close to *Jugendstil* models.

Foreign Members

Pechstein and Nolde were not the only new members to join the group in 1906. At the end of the year a Finn, Axel Gallén-Kallela, and a Swiss, Cuno Amiet, both of Nolde's generation, accepted invitations. Kallela, who was well known in Germany, was a proficient *Jugendstil* painter and designer, but it is difficult to see why he was asked to join. Amiet's importance is clearer, for he had been in Britanny, at Pont-Aven, while Gauguin was there, and had adopted the style which all of the artists there, Emil Bernard and Maurice Denis among them, had taken over from Gauguin. Amiet was therefore a living link with that crucial development in painting, which Gauguin initiated. Neither Kallela nor Amiet lived in Dresden, however, and neither got to know any of the *Brücke* founder-members well. Both corresponded regularly and contributed to the exhibitions and portfolios of graphics.

Plein-Air Painting

When Schmidt-Rottluff had visited Nolde on the island of Alsen, his stay in the country must have impressed him and he must have communicated his enthusiasm to the other members, for the following year they went up to the moors near Oldenburg in North Germany to work in the open air. Till then entirely city-bound, painting models in their studios or working from their imaginations, they now all began to spend a little of each year in the country, together or alone. Kirchner began to frequent Moritzburg, the lake district near Dresden, and Pechstein went North to the East Prussian coast.

This new interest in what the Impressionists called '*plein-air*' ('open air'), working on the subject in the open from start to finish and not in the studio, was not such a departure from *Brücke* ideas as it might at first seem. Around the turn of the century, 'Communion with Nature' was a popular pastime. Encouraged by mystics, new cults and outdoor movements, large sections of the German population began to make the countryside and the idea of returning to Nature a kind of religion. From the Romantic Revival on, with its poems of homeland, fir-trees and mountains, Nature, and a belief in its healing powers, took on a new

55. *Ernst Ludwig Kirchner* Harbour View, *1907, woodcut*

56. *Max Pechstein* Young Girl, *1908,*
oil on canvas,
25.75 × 19.87 in. (65.4 × 50.5 cm.),
National Gallery, Berlin

57. *Ernst Ludwig Kirchner* Nude with Fan,
c.1908, oil on canvas,
24.75 × 31.5 in. (63 × 90 cm.),
Kunsthalle, Bremen

58. *Max Pechstein* Portrait in Red, *1909,*
oil on canvas, 39.75 × 39.75 in. (101 ×
101 cm.) Hessisches Landesmuseum,
Darmstadt

59. *Ernst Ludwig Kirchner*
Girl with Japanese Umbrella, 1909–10,
oil on canvas, 36.12 × 31.5 in.
(92 × 90 cm.), Kunstsammlung
Nordrhein-Westfalen, Düsseldorf

56

57

58

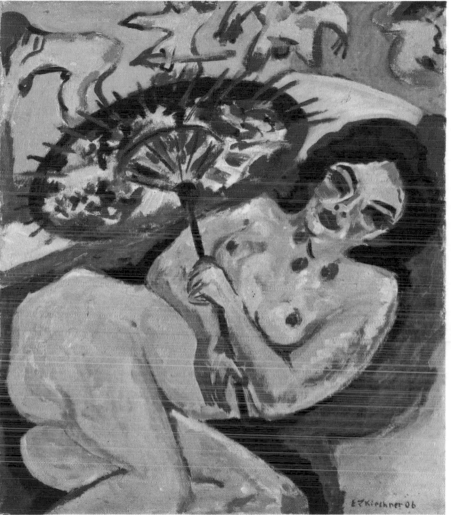

59

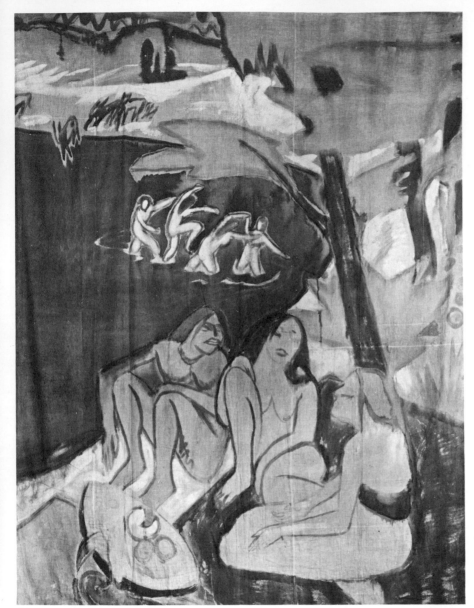

60. *Max Pechstein* By the Lake, *1910–11,*
wall-hanging of unbleached calico
painted with textile colour,
8 ft. 4.38 in. × 6 ft. 6.75 in.
(2.55 × 2 m.), Galerie des 20. Jahrhunderts,
Berlin-Charlottenburg

61. *Photograph of Isadora Duncan*

60

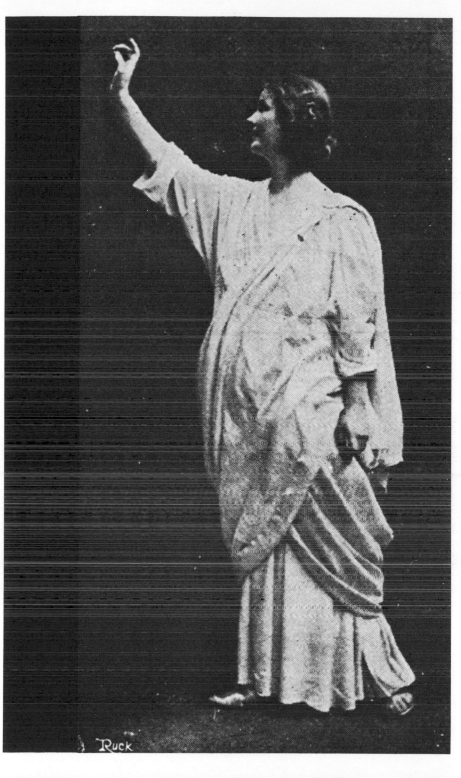

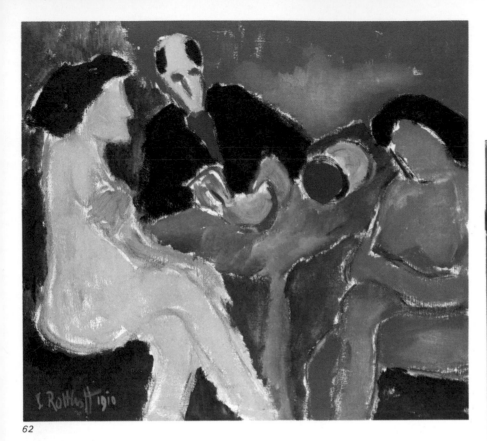

62

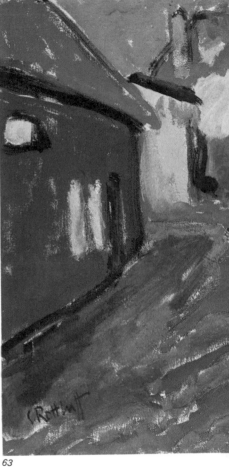

63

62. *Karl Schmidt-Rottluff*
Rest in the Studio, *1910, oil on canvas,*
29.87 × 33.12 in. (76 × 84 cm.),
Kunsthalle, Hamburg

63. *Karl Schmidt-Rottluff*
Farm at Dangast, *1910, oil on canvas,*
33.87 × 37.12 in. (86.5 × 94.5 cm.),
National Gallery, Berlin

64. *Ernst Ludwig Kirchner* Self-portrait
with Model, *c.1910 (redated),*
oil on canvas, 59 × 39.37 in.
(150 × 100 cm.), Kunsthalle, Hamburg

63

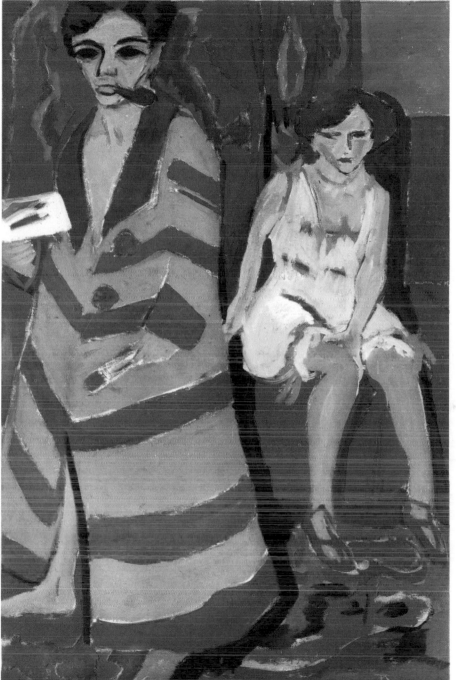

64

significance. Nature became the answer to soul-destroying work in factories and the frustrations of city life and, in the twentieth century, this led to the rise of vegetarianism and all sorts of varieties of physical culture, the mushrooming of the nudist movement and the *Wandervögel*, a national organisation which encouraged communal hikes, including folk-songs and sausages under the stars before going to bed in tents.

The German enthusiasm for the new, free kind of dance created by Mary Wigman and Isadora Duncan was related to the (61) importance attached to unrestricted physical movement and natural grace. The *Brücke* artists were regular visitors to variety halls where they made numerous (121) sketches of dancers and Mary Wigman was later to stay with Kirchner in his studio in Switzerland.

Put simply, the *Brücke's* theme of a naked model seen against a landscape epitomised this interest in Nature. Aesthetically, the (60) paintings resulting from these stays in the country are important for other reasons. Although the Impressionists had emphasised the necessity for working in the open air, they concentrated on the landscape rather than on the human figure and where figures were included in their compositions, they became part of nature, dissolved by the same light and atmosphere that dissolved the landscape. The *Brücke*, like Cézanne, wanted to bring back the naked figure into landscape and create a harmonious composition in which the two merge and man becomes part of nature but with the (68) figure retaining a significant role. They also wanted to evoke the sense of Arcadia, original innocence and natural joy. Unlike Cézanne, however, they made no preliminary studies. They went into the woods or onto the beach with their models and painted them quickly as they walked around or lay in the grass. (129, 130, 133–4, 149) They were interested in Arcadia but not in any Classical or timeless sense; they were after freshness and immediacy.

Development of the Brücke Style
Writing about himself, under a *nom de plume*, of the importance to him of *plein-air* work, Kirchner said that 'he grew to recognise that a new form, created from the intensive study of nature with the aid of the imagination, had a much stronger effect than naturalistic representation. He developed the 'hieroglyph' and enriched modern art with an important means of expression, as Seurat in his time invented his division of colour and Cézanne his system of cylinder, cone and sphere'.

It was in these figure compositions that the *Brücke* style began to change. The (64) application of paint became somewhat more controlled, the brushstrokes longer and more regular and the rhythms they set up in conjunction with the major elements of the composition, are less violent, although as strong as ever. In the work of Kirchner and Heckel a decided angularity creeps in and this is emphasised by straight but broken brushwork. Between 1906 and 1911, Schmidt-Rottluff had escaped completely from the rich, loose brushwork, which ultimately derived from Impressionism, and now composed his pictures in terms of (63) broad, flatter areas of strongly contrasting colour, by and large darker than those used by the others. His figure compositions are the most radically simplified of all *Brücke* (62) work at this time and his harsh contours reveal the impression primitive art had made on him. Pechstein, by contrast, is at once softer and more lyrical. There is a grace about his figures and a sweetness about his colours which are closer to Matisse than (58) Schmidt-Rottluff or Kirchner.

The similarity between Pechstein's work of this period and certain aspects of contemporary French painting was not fortuitous. In 1906 he had won a generous study-grant from the Dresden Academy and spent the money on a trip to Italy and Paris. Although he was impressed by Etruscan art in Italy, the work of the French *Fauve* painters, to which he was introduced by Kees van Dongen in Paris, was a revelation. It was the first time that a member of the *Brücke* had seen the contemporary movement in Paris at first hand, and it had an immediate effect on Pechstein's style and thinking.

The other members of the group resolutely denied having known anything about *Fauve* painting until years later, even though Pechstein must have talked to them about developments in Paris a great deal. Heckel claimed that 'obviously Matisse was not known at that time in the circles into which Pechstein accidentally strayed in Paris; had we known anything about him, we would surely have invited him to join us, although his pictorial intentions had only a few points of contact with ours'. The denial sounds like an attempt in retrospect to prove the group's originality and independence from outside influences. This helps explain why Kirchner shamelessly repainted and redated his pictures to make it look as though his style was more radical earlier than it was, and also the energy with which Schmidt-Rottluff and the others disclaimed all knowledge of Van Gogh until long after they

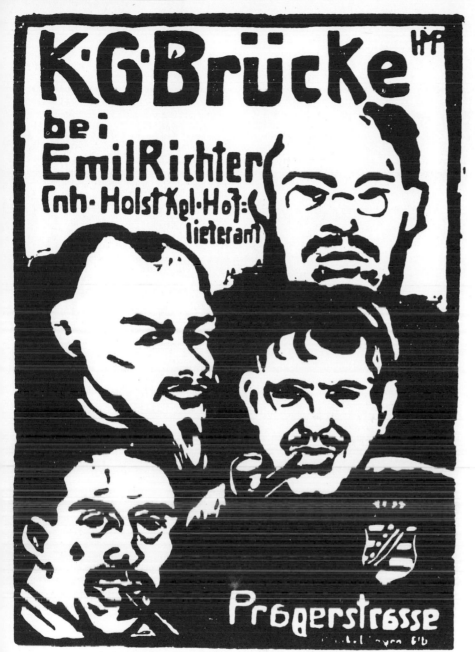

65. *Max Pechstein, Brücke exhibition poster, showing portraits of Schmidt-Rottluff, Heckel, Kirchner and Pechstein, 1909, woodcut*

65

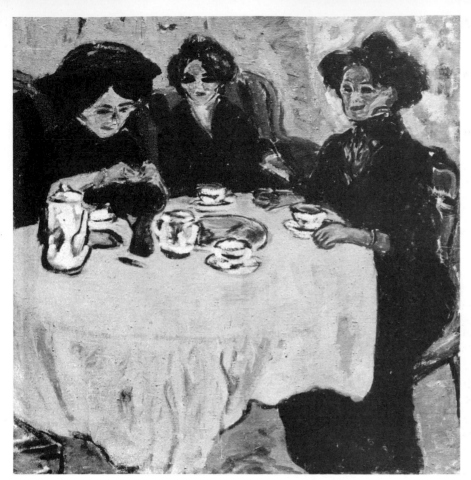

66

67

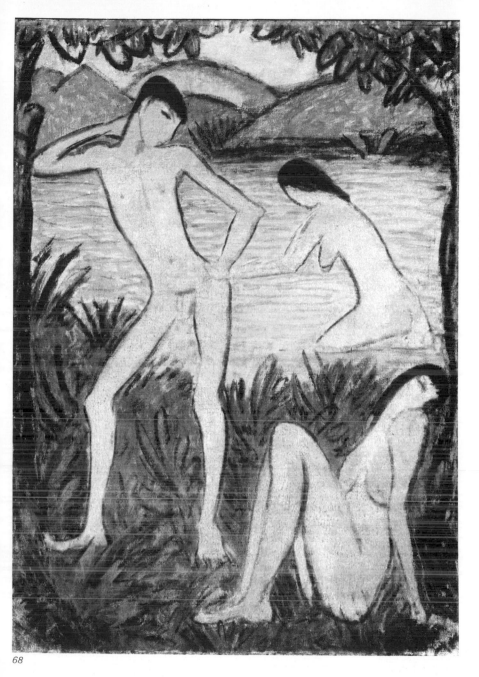

68

66. *Ernst Ludwig Kirchner* At Coffee,
*c.1909, oil on canvas, 43.75 × 44.5 in.
(111 × 113 cm.), Landesmuseum für
Kunst und Kulturgeschichte, Münster*

67. *Erich Heckel (after Kirchner)*
Seated Nude, *1909–10, woodcut,
illustration for the Galerie Arnold
Brücke exhibition catalogue*

68. *Otto Mueller*, Large Bathers,
*1910–14, tempera on canvas,
6ft. × 4ft. 2.5 in. (1.8 × 1.3 m.),
Städtishes Kunsthaus, Bielefeld*

69. *Erich Heckel, Woodcut of painting by Kirchner, 1910, cover illustration for the Galerie Arnold Brücke exhibition catalogue*

70. *Erich Heckel, Cover for the Galerie Arnold Brücke exhibition catalogue, 1910, woodcut*

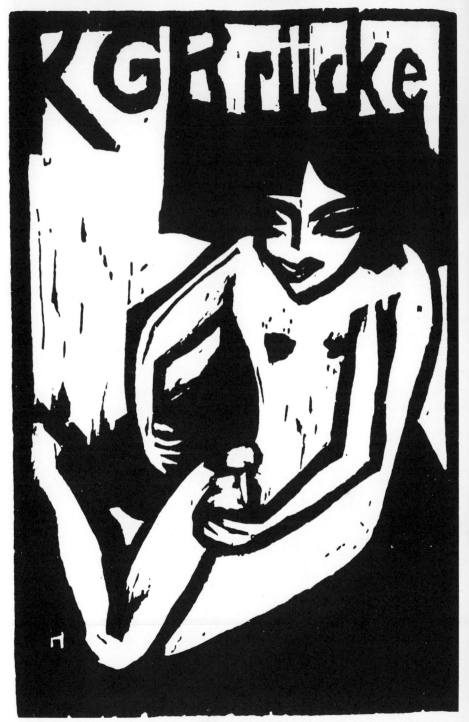

69

had matured as artists. The attitude of the group to Pechstein cooled and Kirchner, much later, went so far as to reject Pechstein as a second-rate artist and 'Matisse imitator'. When Pechstein returned from abroad in 1908, he settled in Berlin although he continued to correspond and exhibit with the other members of the *Brücke* in Dresden. (65)

There is no doubt that *Fauve* painting of the period frequently appears amazingly like *Brücke* work. Matisse's portrait of Derain (1905) for example, comes close to (66) Kirchner's work of two years later, although the Frenchman's colours are sweeter. A Matisse nude of 1907 also shows the influence of the primitive clearly and it is interesting to see how different kinds of primitive art brought Kirchner to a similar conclusion somewhat later. Despite such similarities and Pechstein's contacts with Paris, it seems clear that both styles arose independently from similar sources.
No direct French influence on Kirchner, for example, can be proved.

Otto Mueller
The last painter to join the group was Otto Mueller, an orphan, apparently of Gypsy blood, who had been brought up by the Hauptmann family, the most prominent member of which was Gerhart Hauptmann, the Realist writer. Mueller was in fact the model for the hero of Hauptmann's novel, *Einhart der Lächler* (Einhart the Smiler).

Mueller was by far the most restricted of the *Brücke* artists and his canvases show a continuing but unsuccessful attempt to come to terms with his limited abilities. It has been suggested that Mueller, in essence, painted the same picture over and over again. Whether the subject was bathers, or portraits of Gypsy families (two of his preferred subjects), the melancholy expressions, the long slim and jointed (68) bodies are essentially identical and painted in the same limited range of pastel tones.

He was invited to become a member by Kirchner who found in him a fellow-admirer of Dürer and Cranach and was impressed by Mueller's self-taught distemper technique. This was a kind of water-based tempera, which enabled Mueller to paint large areas of regular, flat colour, quickly. Tempera also dries quickly and immediate overpainting was possible. It was an ideal technique for full-scale compositions in the open air.

Further Exhibitions
In 1910 the first really important *Brücke* exhibition was held at the Galerie Arnold, in Dresden. Arnold was a recognised and respected dealer and his interest in the *Brücke* meant a great deal to the group's members. A catalogue was printed in which all the illustrations and lettering were cut in wood. The group character of the exhibition was emphasised by the fact that the illustration were woodcuts of each other's paintings. (67, 69, 70)

The next, and until then the largest *Brücke* exhibition took place in the Gurlitt Gallery in Berlin. By that time most of the artists had moved there, and it was in the capital that they were to reach the climax of their careers.

**Katalog ——————
zur Ausstellung der K. G.
„Brücke" ——————
in Galerie Arnold ———
Dresden • Schloßstraße
September 1910 ———— 70**

Munich

71. *A Munich beer restaura*

Munich enjoyed a reputation abroad as the foremost artistic city in Europe after Paris. Artists and students were drawn to the Bavarian capital from as far afield as Chicago and Moscow, attracted by what the city had to offer apart from the Academies. Munich, situated near the Alps, was close to several countries and the people there seem to be a mixture of the best of Northern and Southern characteristics. There was also a large artists' quarter, Schwabing, which, not unlike (72) Montmartre, had studios, cafés, bars and (71) variety theatres.

The Munich Secession

As important a cultural centre as Berlin, Munich was the first German city to have a Secessionist organisation. Its first exhibition, in 1893, showed works by Corot, Millet, Courbet, Böcklin and Liebermann. If this was the 'modernism' of the dissenting artistic group, it can be imagined what the accepted, semi-official artists were producing.

The best-known of these was Franz von Lenbach, a painter of State portraits (he even painted Gladstone) who lived like a prince in a large and imposing villa. On the other hand, the Secession can be best represented by the Realist paintings of Wilhelm Leibl, whose chief claim to fame, apart from his studies of Bavarian peasants, was having met Courbet. Leibl had many disciples, among them the landscape painter, Hans Thoma and Wilhelm Trübner, a mannered artist, who cultivated thick and strangely articulated surfaces and delighted in his own highly individual range of greens. The Realists in the Secession also encouraged an interest in Impressionism. Slevogt, Uhde and Corinth, who all came from the Munich area, first exhibited with the Secession.

In spite of the comparative success of the Realists, the Impressionists did not receive the attention that their colleagues in Berlin did, and they all left for the capital around 1910. By that time the direction of art in Munich had radically changed. Realism was no longer the most advanced form of art to be seen in the city; *Jugendstil* had taken its place.

The Munich New Artists' Association

Because the Secession was never as liberal as its name implied, regularly rejected the work of advanced artists and was aloof from any of the radical painting produced abroad, there were *avant-garde* artists in Munich whose work was good but who found it impossible to exhibit with the Secession. In 1909, Wassily Kandinsky, Alexei von Jawlensky, Gabriele Münter, Marianne von Werefkin and Franz Marc were among those forward-looking artists in

73

72. *Studio in Schwabing,*
the artists' quarter of Munich

73. *Gabriele Münter* Kandinsky Painting,
1903, oil on board,
6.62 × 9.86 in. (16.9 × 25 cm.),
Städtische Galerie, Munich

72

73

74

Munich who broke away from the Secession
and founded the New Artists' Association
(*Neue Künstler Vereinigung*) to exhibit work
not accepted by the Secession. The first
exhibition was held in the winter of
1909/10. (73–5, 85–8)

The NKV was not interested in furthering
the aims of its own members alone.
It brought many artists from abroad to the
attention of the Munich public. In its second
exhibition of 1910 it introduced the work of
among others, Picasso, Braque, Derain and
Vlaminck to the Bavarian capital. This
openness, internationalism of the NKV is in
striking contrast to the almost parochial
nationalism, claimed if not real, of the *Brücke*.
For one thing, the leading members of the
association were not even Germans at all,
but Russians, now regarded as members of
a 'German school', simply because it was on
German soil that they came to artistic
maturity, and for another, they regarded the
showing of foreign artists to be a vitally
important part of their activities. Their
horizons were broad; they were constantly
inquisitive and eager to learn.

One of the French artists invited to show at
the 1910 NKV exhibition was Le Fauconnier.
He was a friend of Gleizes and Delaunay and
knew the Futurists well. Le Fauconnier had
developed a version of Cubism quite
different from Picasso's and Braque's. (76)
Put simply, he used Cubist elements angular
planes which cover the picture surface, as an
aid to the creation of greater plasticity and
monumentality. At the same time he
increased the limited colour range of
Picasso's Cubism.

Le Fauconnier's work had an important
effect on the development of the work of
many of the younger Munich artists,
particularly that of Franz Marc who, using
elements derived from Cubism and Futurism,
liberated his painting from the restrictions of
extreme Realism. For Marc, the language of
Cubism promised a visual equivalent
of the spiritual world he was attempting to
describe in his paintings.

Although the members of the NKV were
more advanced in their attitudes than the
Secession, the New Artists' Association was
nevertheless an uneasy compromise from
the first. It embraced artists of widely
divergent views and abilities and, from the
first, two groups or cliques were
immediately apparent. The group around
Kandinsky, which was the more advanced,
began to be unsure of the advantages of
exhibiting with artists they considered less
able. In 1911 a break seemed inevitable, for
the more conservative group was also

75

76

74. *Gabriele Münter* Listening (*portrait of Jawlensky*), 1909, oil on canvas, 19.5 × 27 in. (50 × 69 cm.), Städtische Galerie, Munich

75. *Marianne von Werefkin* Factory, 1910, mixed media, 41.37 × 31.5 in. (105 × 80 cm.), Städtisches Museum, Wiesbaden

76. *Henri le Fauconnier* Portrait of Jean Louve, *Musée d'Art Moderne, Paris*

77

78

77. *Franz Marc* Blue Horses,
c.1911, oil on canvas,
41.25 × 71.5 in. (104.8 × 181.6 cm.),
Walker Art Center, Minneapolis

78. *Franz Marc, Vignette and*
capital letter 'I' from the Almanac of
the Blue Rider, *1912, Indian ink*

79. *Wassily Kandinsky, Cover for the*
Almanac of the Blue Rider, *1912, woodcut*

unhappy about exhibiting with Kandinsky and his friends. Franz Marc wrote that 'Kandinsky and I clearly foresee that the next jury . . . will cause a ghastly controversy'. Indeed the jury of the next NKV exhibition rejected one of Kandinsky's most ambitious paintings and Kandinsky, Marc, Münter and Alfred Kubin promptly resigned. Marc, an energetic organiser, immediately began to make plans for a rival exhibition. *Der Blaue Reiter* (The Blue Rider) was about to be born.

The First Blaue Reiter Exhibition

When Kandinsky and Marc broke away from the New Artists' Association of Munich, Jawlensky at first refused to join them. Marc had the idea of organising an exhibition, to be staged at the same time as the next NKV show and in open competition with it. It opened on the 18th December, 1911, at the Modern Thannhauser Gallery, immediately next door to the NKV exhibition. It was called the exhibition of the *Blaue Reiter*, or Blue Rider.

The *Blaue Reiter* is frequently described as a group of artists, the second great Expressionist artistic grouping after the *Brücke*. Although it can indeed be regarded as a group, it was in no sense as close as was the *Brücke*, nor did its members regard themselves as co-workers in any sort of communal activity.

The *Blaue Reiter* was in fact the name of a publication that Marc and Kandinsky had been planning throughout 1911. It was to be a collection of essays about art with illustrations and written by artists and Marc and Kandinsky hoped it would appear annually, as an almanac. In fact, the *Blue Rider Almanac* only appeared once, in 1912. The two artists already knew what they wanted to call the publication by the time of the exhibition in 1911 and eventually announced that the show was organised by the editors of the almanac. (77—9)

Why the name was chosen is difficult to determine. Blue was a favourite colour of many German Romantic poets, particularly Novalis, and the more mystical of the Expressionists, Kandinsky among them, were often anxious to pay tribute to the Romantics from whom they had learned so much. Moreover, Kandinsky had always been fascinated by riders on horseback. (86) One of his early paintings, called, in fact, *The Blue Rider* (1903) later served as the basis for some of his important non-figurative compositions in which the same motif can dimly be discerned.

The first, and incidentally the most important *Blaue Reiter* exhibition closed in

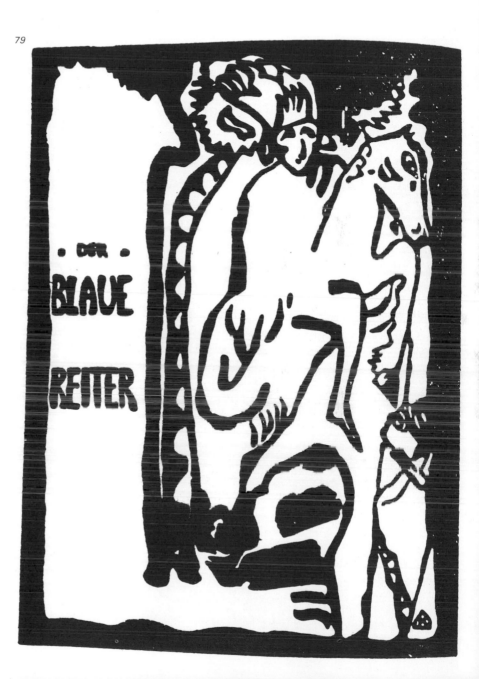

80. *Wassily Kandinsky* Rider and Castle, *c. 1906, woodcut*

81. *Wassily Kandinsky*
Arrival of the Merchants, *1905, woodcut*

82. *Wassily Kandinsky* Monk, *1907, woodcut, 9.5 × 2.5 in. (65 × 24 cm.), Städtische Galerie, Munich*

83. *Photograph of Wassily Kandinsky*

81

84. *Bavarian glass-painting,*
Bayerisches Nationalmuseum, Munich

January, 1912, and then toured Germany. It was shown by Herwarth Walden as the first *Sturm* exhibition ever. Shown there were Kandinsky, Marc, Macke, Münter, the Douanier Rousseau and Delaunay, from whom Marc and Macke particularly had learned so much.

The Almanac of the Blue Rider

The publication which Marc and Kandinsky had been planning for some time was (211) eventually published in 1912. Kandinsky later described it as the result of 'my desire to edit a kind of book (a kind of almanac) in which all the authors would be artists. I thought about painters and musicians in particular. The corrupt distinction between one art-form and another, furthermore between 'folk' art and 'children's' art, between art and 'ethnology', all these well-built walls between forms which in my eyes seem so closely related, and indeed are frequently identical'—these, thought Kandinsky, should be broken down

The book lived up to Kandinsky's ambitions. Reproductions of work by Picasso were published with child and peasant art, with paintings by the Douanier Rousseau, Gothic church sculpture, Bavarian glass-painting and so on. The essays, all of which are well-written, include one on the 'German Fauves' by Marc, an esoteric piece by Kandinsky on the problem of form, an essay on masks by Macke and a musical score and an article on musical composition by Arnold Schoenberg, a friend of Kandinsky and virtually the inventor of twelve-tone music.

What immediately strikes one looking back on this remarkable publication is that it still retains its freshness and is still, in some respects, a valid statement of the avant-garde. The insistence on the universality of art, raised above the restrictions of categories, the similarities between all forms of art and above all the implication that there was as much value in the artistic efforts of children, peasants and idiots are issues which are still relevant today. Moreover, the insistence that artists themselves, and not critics, should write about artistic problems was something new. *The Blue Rider Almanac* gave them the chance to formulate their ideas in print, always a good method of getting one's theories in order.

The publication, brought out by the Munich firm of Piper, was, in terms of such books, an immediate success, selling more than 1,500 copies. Nevertheless, Kandinsky and Marc never managed to bring it out a second time, far less make of it an annual event. Other commitments prevented them.

The Second Exhibition

While Herwarth Walden was staging a *Blue Rider* show in Berlin, in March, 1912, the second was organised in Munich. This was limited to watercolours and graphics and was much broader in its choice of artists than the first. Nolde was represented, for example, as were Kirchner, Heckel and Pechstein. In fact, the other German Expressionists far outnumbered the Munich artists in the show. France was also well represented and the Russian artists, notably Malevich, were also there. Of importance for developments in Munich was the selection of work by Paul Klee, a Swiss artist who had come to the Bavarian capital in 1906.

Kandinsky

In 1896 a number of Russians arrived in Munich to study. One of them, Wassily Kandinsky, was later to become one of the first abstract artists and played a role of unequalled importance in the development of Expressionism. Kandinsky was already 30 when he arrived in the Bavarian capital. Munich impressed him greatly. In his autobiography he speaks of the fairy-tale quality of the city, the quality of light there, the bright colours of the post boxes and trams and the Neo-classical architecture. His grandmother, who had taught him German, had also told him all the German fairy stories when he was a boy. With this early background and because of Munich's reputation in Russia as a city of great artistic importance, it was natural for him to come there when, after a promising career as a lawyer and academic, he had decided that what he really wanted to do was paint and turned down an offer of a Professorship.

On photographs Kandinsky looks (83) more like a scientist than an artist. He in fact commanded knowledge in a number of apparently unrelated fields, had a good grounding in science and in the ethnology of certain parts of Russia. He loved to theorise, was unusually articulate and had the rare ability to find analogies between all those areas of knowledge that he had acquired, between Russian law and Russian folk art, and between modern scientific discoveries and theories of painting, for example. Later he was to write *Concerning the Spiritual in Art*, a justification of abstract art and one of the key works of artistic theory in this century. Even if Kandinsky had never painted one picture, his reputation as a revolutionary art theorist would have been supreme.

Kandinsky also had another rare gift. It is an accepted fact that all the senses are closely related, that certain colours, for example,

85

86

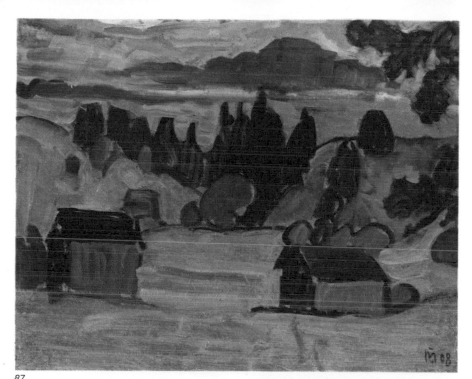

87

88

85. *Marianne von Werefkin* Self portrait,
c.1908, oil on board,
20.12 × 13.37 in. (51 × 34 cm.),
Städtische Galerie, Munich

86. *Wassily Kandinsky* The Blue Rider,
1903, oil on canvas, 20.5 × 21.5 in.
(49 × 52 cm.), Bührle Collection, Zurich

87. *Gabriele Münter* View of
the Murnau Moors, *1908, oil on paper,*
12.87 × 16 in. (32.7 × 40.5 cm.),
Städtische Galerie, Munich

88. *Gabriele Münter* Jawlensky and
Werefkin, *1908—9, oil on cardboard,*
17.75 × 13 in. (54.1 × 33.2 cm.),
Städtische Galerie, Munich

89

90

91

92

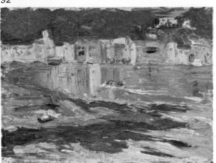

93

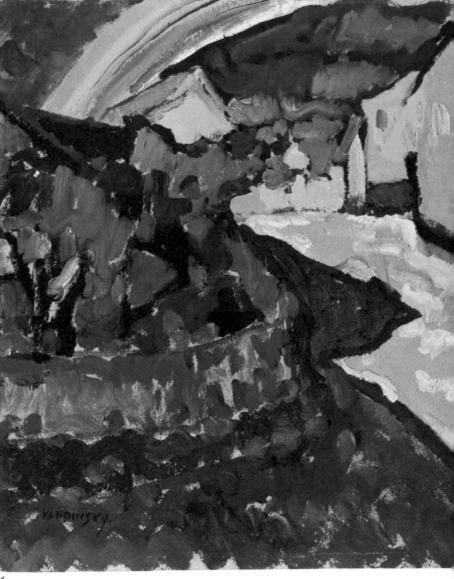

94

95

92. *Wassily Kandinsky*
Russian Beauty in Landscape, *c.1905,*
gouache on black paper,
16.25 × 10.62 in. (41.4 × 27 cm.),
Städtische Galerie, Munich

93. *Wassily Kandinsky* Santa Margherita,
1906, oil on board,
40.75 × 12.87 in. (123.7 × 32.7 cm.),
Städtische Galerie, Munich

94. *Wassily Kandinsky*
Murnau with Rainbow, *1909, oil on board,*
12.87 × 16.87 in. (32.8 × 42.8 cm.),
Städtische Galerie, Munich

95. *Alexei von Jawlensky*
Murnau Landscape, *1909*

96. *Franz Marc* Fighting Forms, *1914, oil on canvas, 35.75 × 51.75 in. (90.8 × 131.4 cm.), Bayerische Staatsgemäldesammlungen, Munich*

97. *Alexei von Jawlensky* Girl with Peonies, *1909, oil on paper on wood, 39.75 × 29.5 in. (101 × 75 cm.), Von der Heydt-Museum, Wuppertal*

stimulate the feelings and that certain lines call forth an emotional response. Blue, for example, is generally considered to be a sadder colour than red; drooping lines arouse different reactions from those produced by straight lines. Kandinsky was highly sensitive in this respect. Colours also made him hear very definite sounds and his autobiography is full of descriptions of colour/sound experiences. These had a decisive effect on the development of his art. Of pictures painted in 1909 for example, he wrote 'within me sounded the memory of early evening in Moscow, before my eyes was the strong colour-saturated scale of the Munich light and atmosphere, which thundered deeply in the shadows'.

The Phalanx

At the Munich Academy Kandinsky learned quickly and soon began to establish a reputation for himself. By 1902 he was already exhibiting at the Berlin Secession and was well known in Munich. He became president of a new group of fairly advanced artists called *Phalanx*, a name which was presumably intended to convey the idea of a solid body of opinion. Its aim was to oppose academicism in art for all it was worth. During his *Phalanx* period, Kandinsky worked in a variety of styles. Influenced by *Jugendstil*, he produced a number of woodcuts, with strong black-and-white contrasts, mostly of subjects related (80—2) to fairy tales: horsemen, ladies in crinolines and Russian Orthodox monks (Kandinsky was steeped in the colourful and weighty ritual of the Russian Orthodox Church). Paintings which relate to these woodcuts are very flat, highly colourful and imaginative, also of fairy-tale subjects At the same time, however, he painted small landscapes from nature. The paint is applied thickly with a palette knife and bright accents of colour contrast strongly with the predominating sombre tones.

This work was not strikingly original, although it must have seemed fairly advanced in Munich at the time. Nevertheless, even from a comparatively restrained and convential Impressionist exercise like *Beachbaskets in Holland*, an interest in colour for its own sake is very much in evidence. Original or not, Kandinsky achieved a measure of success. In 1904 he exhibited in Paris, in several cities in Russia, in Poland, Italy and Berlin.

Phalanx was more important for the exhibitions it organised than for the work its own members were producing. From the first it was a very open group, always aware of developments abroad and always anxious to

97

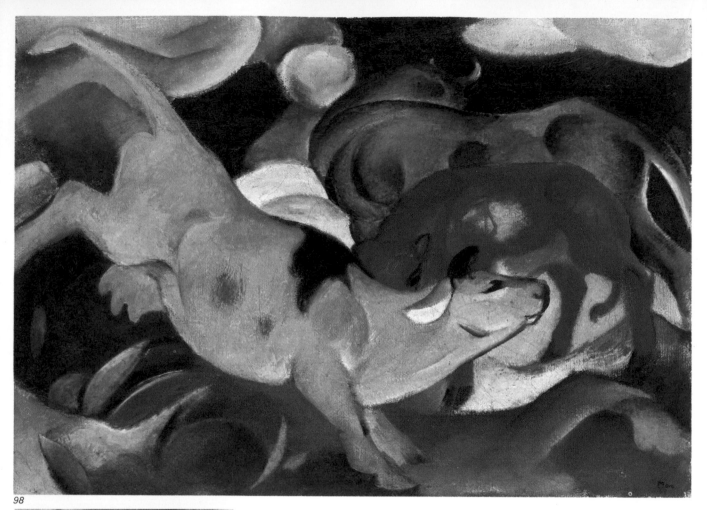

98

99

100

98. *Franz Marc* Yellow, Red, Green Cows,
1912, oil on canvas,
24.5 × 34.5 in. (62 × 87.5 cm.),
Städtische Galerie, Munich

99. *Franz Marc* Nude with Cat,
1910, oil on canvas,
33 × 24 in. (85.5 × 81.5 cm.),
Städtische Galerie, Munich

100. *Franz Marc* Fate of the Animals,
1913, oil on canvas,
6 ft. 4.75 in. × 8 ft. 7.75 in.
(1.95 × 2.63 m.), Kunstmuseum, Basel

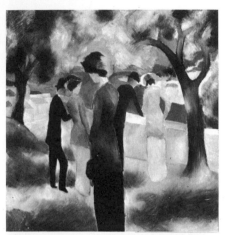

101

102

101. *August Macke*
Woman with Green Jacket, *1913, oil,
19.37 × 16.87 in. (49.2 × 42.9 cm.),
Wallraf-Richartz Museum, Cologne*

102. *August Macke* Satire on the Blue
Rider, *1913, watercolour and gouache,
9.75 × 13.62 in. (24.6 × 34.5 cm.),
Städtische Galerie, Munich*

103. *August Macke*
Landscape with Cows and Camels, *1914,
oil on canvas, 18.5 × 21.25 in.
(47 × 54 cm.), Kunsthaus, Zurich*

bring foreign artists to the attention of the Munich public. In 1904, for example, the ninth *Phalanx* exhibition showed a large number of French Neo-Impressionist canvases and in the same year the Munich artists' association put on an exhibition which included paintings by Cézanne, Gauguin and Van Gogh. Kirchner was one of the visiting artists who took back home with him impressions and ideas which were to be crucial in the development of the *Brücke* style. These exhibitions also gave Kandinsky the courage to brighten his palette still further and gradually to expel colours in the darker range from his compositions.

Murnau

In 1908 Kandinsky discovered a small isolated village in Upper Bavaria, called Murnau. Exasperated, probably, by the art politics in Munich and perhaps aware that he was on the threshold of an important break-through in his art, Kandinsky decided to find a house there and settle down. It was as though he had a clear idea of what he wanted to do and needed to be free from outside influences in order to realise his ideas.

Almost immediately his work began to change. Initially painting village scenes from nature, his colours became brighter and more arbitrary, what we now recognise as typically Expressionist. Instead of smoky blues, sweet yellows and pastel greens, he used penetrating reds, harsh greens and brilliant yellows and arranged them so as to look brighter and more powerful by clever juxtaposition. Black disappeared almost completely, and the colours, now applied with a brush, were placed in more or less regular blocks, in an extension of the Neo-Impressionist manner, although Kandinsky, like Kirchner, was not interested in 'scientific' fidelity to nature.

Using elements from the village of Murnau —streets, houses and trees—Kandinsky, having withdrawn into his studio, then composed from his imagination, taking liberties with space and perspective and removing his palette still further from nature. Blocks, spots, and whirls of red, yellow and blue dance across the surface of the picture in a riot of harsh colour and large areas are completely unrecognisable in terms of the natural subject. In flattening his compositions, Kandinsky also found that he could exaggerate the rhythms inherent in his motif and powerful curves, vertical lines and vortexes complement the violence of his colours. (94)

Common to almost all Expressionist artists was an interest in the primitive. Kandinsky

had been spell-bound by the folk art he had seen in remote parts of Russia and the way everything, from ploughs to entire houses, was covered with bright and complicated patterns and the peasants themselves were dressed in colourful costumes. Taken together, these impressions had given him the feeling of walking around inside an enormous three-dimensional picture. Such experiences of colour and pattern further liberated his painting. He was equally enthusiastic about Bavarian folk art around Murnau. What impressed him above all (84) were Bavarian glass-paintings. Mostly of religious subjects, these were painted in reverse on one side of a sheet of glass to be looked at from the other, the glass surface adding richness to the colours. Looked at against the light, they look like stained glass. As with most primitive art, the idea, the religious moral or the essence of the drama of a situation is expressed directly and boldly, without realistic colour or any attempt to describe space or perspective.

As colour became increasingly important in his work, disassociated more and more from the 'natural' subject, the same was happening with form and Kandinsky came closer to banishing realistic subject-matter altogether from his work. Returning one day to his studio, he saw an easel picture of astounding beauty. What bewildered him was that 'the painting lacked all subject, depicted no recognisable object, was entirely composed of bright colour patches'. Finally he saw what it was: one of his own figurative works standing on its side. He had reached a stage in Murnau where the subjects derived from the village provided him with a number of basic shapes, lines and arrangements of forms around which he could construct near abstract paintings. He was on the threshold of what he called 'absolute' or abstract painting.

Franz Marc

Born in Munich in 1880 and the son of a painter, Franz Marc received a complete academic training and his work was dull and unoriginal for a considerable period. Animals soon appeared as subjects, perhaps as a result of a friendship with the Swiss animal painter Jean Niestlé, and Marc painted them in a sentimental style often emphasised by titles to do with death.

After several trips to Paris his colours lightened somewhat and his technique loosened. Animals remained his prime (91) concern and he began to study animal anatomy seriously in order to make his paintings as realistic as possible. His own melancholic frame of mind together with his

103

104

105

106

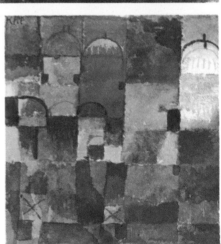

107

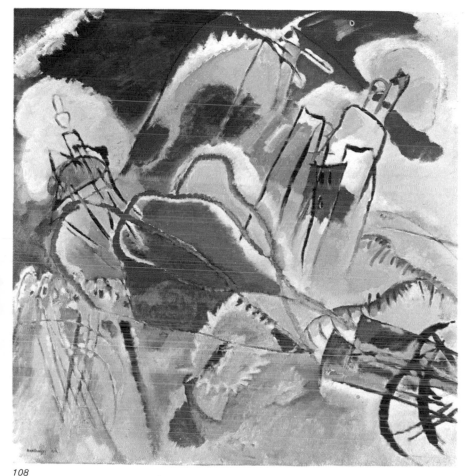

108

104. *August Macke* Turkish Café,
1914, oil on wood,
23.5 × 13.75 in. (60 × 35.5 cm.),
Städtische Galerie, Munich

105. *August Macke* Corner of the Living
Room by Lake Tegern, *1910, oil on canvas,*
16.25 × 18.5 in. (41 × 47 cm.),
Städtische Galerie, Munich

106. *Paul Klee* Little Port,
1914, watercolour,
6.12 × 5.5 in. (15.6 × 14 cm.),
Felix Klee Collection, Bern

107. *Paul Klee* Red and White Domes,
1914, watercolour, Kunstsammlung
Nordrhein-Westfalen, Düsseldorf

108. *Wassily Kandinsky* Improvisation 30,
1913, oil on canvas, 43.62 × 43.62 in.
(110 × 110 cm.), Art Institute of Chicago

109

110

109 *Paul Klee* Self-portrait, *1919, ink*

110 *Paul Klee* Two Men Meeting,
Each Supposing the Other to Be of
a Higher Station, *1903, etching,
4.62 × 8.87 in. (11.6 × 22.4 cm.),
Paul Klee Foundation, Kunstmuseum, Bern*

111

interest in the animal world persuaded him to see Nature in a deep philosophical way, to seek what he believed to be the universal truths underlying all creation: 'I try to intensify my feeling for the organic rhythm of all things; I seek pantheist empathy with the vibration and flow of the blood of nature —in the trees, in the animals, in the air ... I see no happier medium for the *Animalisation* of art, as I would like to call it, than the animal picture ...'

Kandinsky was in complete agreement with Marc when it came to the painting of spiritual values and the Russian taught Marc the importance of brighter, anti-naturalistic colour. (77, 98)

Marc himself wrote: 'Don't we all believe in metamorphosis? Why do all we artists, why do we always search for the metamorphic forms? The thing as it really is beneath its superficial appearance?'

By 1910, Marc had succeeded in using colour in a completely arbitrary fashion. He was still obsessed with animals, but now the emphasis was not on anatomical accuracy but on his emotional sympathy for his subjects. Horses became red, blue or yellow, depending on the mood and a fragmentation of the entire picture-surface into Cubist-derived prisms of colour unite the composition and express the union of all life with a common environment. In one picture, *Yellow, Red and Green Cows* (1911), three types of cow, stylised in a flat way clearly derived from Cubism, merge into their surroundings, become one with Nature. In another, *Nude with Cat* (1910), the (99) influence of Fauvism is apparent. The red contours of the figure contrast with the green of the cushion and the yellow cat.

By 1913 Marc's work had begun to move farther from Nature. Many of his subjects were visionary, appearing to deal with universal states of flux, with the continual ordering of chaos. It has been said that *Fate of the Animals* is a vision of the (100) Apocalypse which directly anticipates the war.

In 1914 Marc took the next logical step and began a series of abstract lyrical canvases like *Forms in Combat*. Clearly (96) Kandinsky's abstract work inspired Marc to remove natural references from his painting, although his style is quite different. Also in 1914 Marc joined the army and two years later fell at Verdun.

111. *Paul Klee* Virgin in a Tree,
1903, etching,
9.25 × 11.75 in. (23.6 × 29.6 cm.),
Paul Klee Foundation, Kunstmuseum, Bern

112. *Paul Klee* Garden Picture,
1905, watercolour on glass,
5.5 × 7.25 in. (14 × 18.5 cm.),
Felix Klee Collection, Bern

112

August Macke

Macke, who had been a friend of Marc's since 1911, was almost as influential as Kandinsky in brightening Marc's colours. Younger, than Marc, Macke was considerably more advanced in his technique. In 1907 he had written: 'My entire joy is now searching for absolutely pure colours. Last week I attempted to put together colours on canvas without thinking of objects, like people or trees, rather like sewing. That which makes music so puzzlingly beautiful also works magically in painting. Only a superhuman power is needed to bring colour into a system like musical notation. In colour there is counterpoint, violin, ground bass, minor, major as in music'. This essay at abstraction was, in 1907, still very much an experiment. A painting of 1910, *Corner of the Living Room,* shows that Macke's approach (105) at this time was still conventional, although the contrast between the reds and greens betrays a Fauvist influence and is similar in effect to Marc's *Nude with Cat* of the same year.

Macke was born in 1887 and spent his early years and studied in the Rhineland. After trips to Paris, Italy and Berlin (where he was taught for a year by Lovis Corinth), he settled in Bonn. He met Franz Marc in 1910 during a visit to South Germany. They became friends and went together to Paris in 1912 where they met Delaunay. In 1914, Macke went to North Africa with Klee. Returning to do his military service, he did not outlive the year, getting killed in action in September, 1914.

Successive visits to Paris leave their mark on successive stages in his paintings. In the space of a few years he passes naturally from Impressionism, through Fauvism to Cubism. He is, however, nowhere just imitative and entirely under the spell of French ideas. In his later work he achieves a genuine synthesis between the brilliance of Fauvist colour and the tight form of (101–4) Cubism. This can be seen in *Turkish Café* of 1914, for example. The composition is flat, there are no outlines and the colours are juxtaposed to enhance their brilliance rather than to express form or space. Delaunay's personal version of Cubism and Futurism lie behind such work, although the feeling for air and light is Macke's own.

Alexei von Jawlensky

Jawlensky, born in Russia in 1864, came to Munich in 1896, the same year as Kandinsky and first exhibited with the Secession in 1903. His development, like that of most of the other artists to be

113

associated later with the *Blaue Reiter*, was also largely in terms of a greater simplification of form and brightening of colour. Unlike the others, he never flirted with Cubist or Futurist ideas. Like Kandinsky, Jawlensky had learned a great deal from Russian folk art, and the paintings in his mature style, with its brilliant areas of colour enclosed by heavy contour lines, (95) which set up a rhythmical balance across the picture surface, are often reminiscent of peasant-produced icons, particularly those of heads, which were always to remain one of Jawlensky's preferred subjects. After (97) the war, he became interested in mysticism, expressed much later, towards his death in 1941, in abstract motifs.

Paul Klee

Klee was born in 1879 in a suburb of Bern. He was naturally gifted in two fields. From an early age he drew well but seems to have been even better musically. As a violinist he was superb, played in an orchestra at the age of ten and was never sure whether he should have become a soloist. (109, 113)

Having decided to become an artist he studies in Munich, working slowly and deliberately at subjects which are both literary and symbolic, enigmatic and often uncanny. These highly worked and intricate drawings have titles like *Two Men Meeting, Each Supposing the Other to Be of a Higher Station, Virgin in Tree* and *Victory of Wit Over Suffering*. (110–11)

Eventually Klee's style became more open and, influenced by the exhibition of modern art he saw in Munich, he began to introduce bright colour into his work and to tend towards lines and forms which existed in their own right, apart from any 'naturalistic' subject. (106–7, 112)

In 1912 he became associated with the artists around the *Blue Rider* and began a friendship with Kandinsky which was close and fruitful for the rest of their lives. Both artists were interested in the theoretical side of art and both concerned with the 'inner world' of the emotions and how they might describe this in their compositions. Klee's close collaboration with Kandinsky continued after the war when they both taught at the Bauhaus under Walter Gropius' direction. He died in 1940.

Kandinsky's Break-through

In 1910, Kandinsky produced a water-colour which was nothing more than an arrangement of coloured areas criss-crossed by irregular lines. He was not the first artist to paint an abstract picture. Others, in Russia and elsewhere, seem to have

114

113. *Paul Klee, Sketch for a self-portrait, 1909, woodcut, 5.12 × 5.75 in. (13 × 14.5 cm.), Felix Klee Collection, Bern*

114. Wassily Kandinsky Riders in the Ravine, *1910, woodcut, 6.37 × 8.25 in. (16.3 × 21 cm.)*

115

115. *Wassily Kandinsky*
Study for Composition II, *1910, ink*

116. *Wassily Kandinsky,*
pen drawing, 1912

116

produced abstract compositions, independently and earlier. But Kandinsky had already formulated the reasons for the necessity of abstract art long before he put his theories into practice.

He made the transition to abstract painting with the greatest caution. It took four years for him to go over completely to non-figurative work—he was still painting landscapes as late as 1913. The abstract forms he developed derive from motifs in earlier landscapes and narrative paintings. Simplifications become paraphrases until a complex of lines derived, for instance, from the horse and rider motif, emerges in his *Compositions* as an image in its own right. His compositions were carefully considered and calculated arrangements of shapes and colours, which attempt to communicate a definite feeling to the spectator. His *Improvisations* on the other hand were painted more freely and were intended to be spontaneous expressions of experiences or feelings. (108,114—16)

The names Kandinsky chose for these two types of composition are intended to call music to mind because music, up to that point, had been the only art-form which did not rely on references to the real world to put its message across. The analogy with music was emphasised by a further distinction between what Kandinsky called the 'melodic' and 'symphonic' sorts of composition. In the melodic, the composition is based on a single form; in the symphonic, on several forms subordinated to an overall design.

'Concerning the Spiritual in Art'

What Kandinsky was trying to express in his compositions and why he believed that abstract art was the only truly modern form of art is set out in his great theoretical work, *Ueber das Geistige in der Kunst (Concerning the Spiritual in Art)*, 1912, the result of notes, drafts and essays over many years.

The book, which is difficult to read, often infuriatingly obscure and at times suspect logically is based on Kandinsky's wide knowledge of science, philosophy and psychology. For Kandinsky, the reality of the 'soul' was an indisputable fact, and the first part of *Concerning the Spiritual* deals with the importance to art of the expression of inner truths, the 'inner necessity' of the artist. The second part deals with the formal conditions of creation: how the artist's 'inner necessity' might be communicated in visual terms.

Kandinsky makes out a case for colour as the basis for the expression of emotions. It is the most powerful medium in the painter's hands and for the sensitive spectator can have an enormous effect on his eyes, ears and feelings. He speaks of yellow, for example, as a 'strident trumpet blast' and has similar musical associations for other colours. Moreover, certain colours are related to certain shapes, and lines also have an emotional correlative.

In its insistence on the importance to art of the spirit, on the emotional effect of colour and in its fundamental approach to the whole problem of what art is, *Concerning the Spiritual* can be regarded as the most important single Expressionist theoretical statement.

Berlin

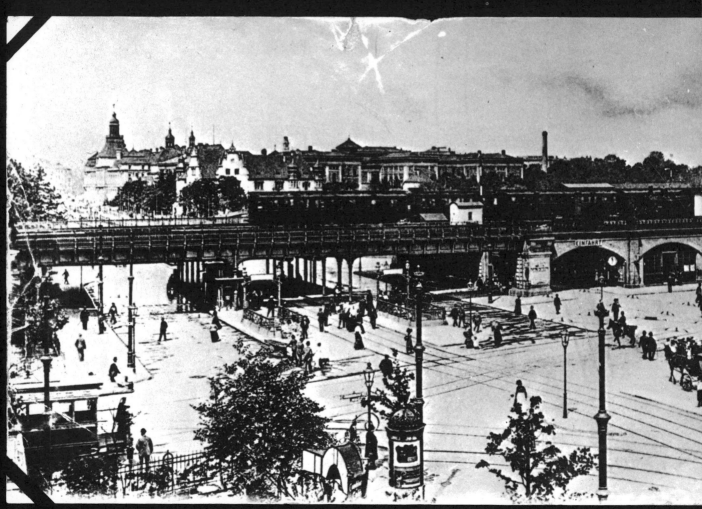

118

117. *Railway Station, Berlin, c.1900*

118. *Potsdamer Platz, Berlin, 1904*

119. *Interior view of timber works, Berlin, c.1900*

119

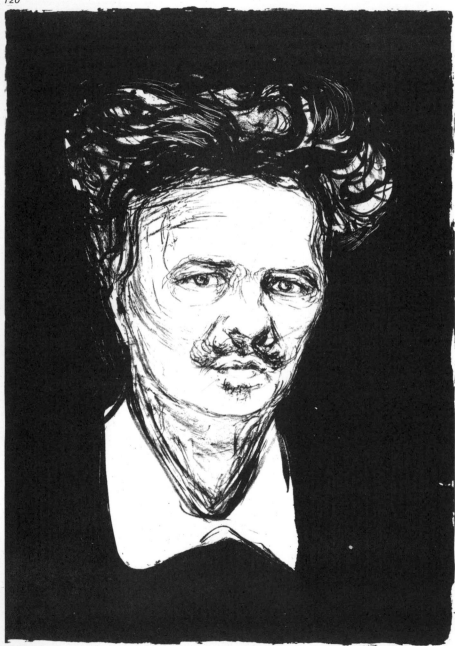

By 1900 Berlin, political capital of Germany since 1871, had become the most vital, and potentially the most powerful city in (118) Europe. Far from beautiful, it was the most thickly populated city in the world, with a population of 2.4 millions. A seventh of all German industry was situated here (119) and Berlin's wealth was reflected by the new underground railway and one of the most advanced surface suburban railway systems anywhere. Since 1870 Berlin (117) had grown from a condition of provincial narrowness to become the sparkling focal point of bourgeois German culture, and that meant music and the theatre above all. The Kaiser had been anxious to improve the quality of the university, named after him, and the natural science faculty soon began to flourish. With the arrival of Einstein, whose *General Theory of Relativity* was published in 1905, the university became the centre of modern scientific research.

In the museums, the collections grew fourfold in the space of fifty years, particularly of Mesopotamian and Egyptian art. The General Director, Wilhelm von Bode, appointed in 1906, both bought and managed to persuade people to give large numbers of paintings. His assistant, Hugo von Tschudi, who was sacked in 1909, largely because he championed the moderns, broadened the collection of the National Gallery and began to systematise it.

When a new art gallery was opened in 1898 by Bruno and Paul Cassirer, a fresh wind blew through the conservative artistic corridors of the capital. Paul Cassirer, the most active of the two brothers, was a champion of French art, and particularly of Impressionism and Post-Impressionism. Between 1901 and 1914 he organised no fewer than ten exhibitions of Van Gogh's work. He became very active in art politics and, always on the side of Liebermann and those artists interested in French painting, was one of the founders of the breakaway Berlin Secession.

Menzel, Slevogt, Liebermann and Corinth were all very successful in the first decade of the century. Menzel, the chronicler of the life and times of Frederick the Great, died in 1905 and was given a State funeral, an almost unprecedented privilege for an artist. The Kaiser was represented by an empty coach. When Liebermann and his friends disassociated themselves from the Academy, and founded their own organisation, the Secession, they were openly attacked by the Kaiser, who described what they were doing as 'gutter art'. When a group of artists, led by

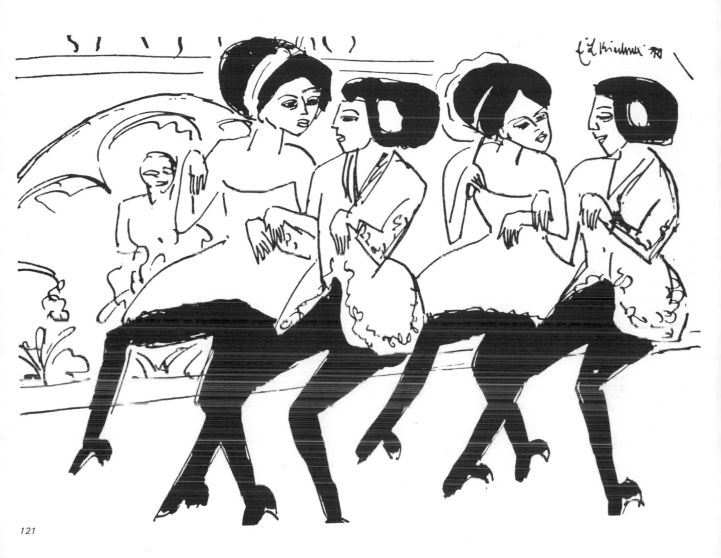

121

122

Pechstein, broke away from the Secession in 1910 to found their own, more liberal 'New Secession', the Kaiser and others with his taste in art, were more shocked than ever.

Despite all this activity in the visual arts, when Berlin was referred to as an 'art metropolis', the visual arts were certainly not included. What was meant was the theatre and concert hall. Both were among the best in the world. Richard Strauss was Director of the Royal Opera and this was just one of six Opera houses. In 1910 there were thirty theatres of all kinds, extending from the most primitive variety hall to the *Deutsches Theater*, where, from 1905, one of the few undisputed geniuses of the modern stage, Max Reinhardt, was changing the (200) entire concept of stage direction. He (120) put on Strindberg, Wilde and Wedekind, at that time all highly controversial writers. The best-known artists designed sets and costumes, among them Munch, Slevogt and Corinth. Thomas Mann described Reinhardt's presentations as 'the experience of art as magical fascination, the interplay of colours, dance, sound and dream'.

On a more popular level, one of the standard pastimes was the circus, presented with a verve and magnificence unknown today. Berlin had two circuses, Busch and Schumann, both near the centre. The march craze, and at its head the music of Sousa, came over from America, and one of the most popular variety acts were the Six Sisters Barrison from England who later renamed themselves the 'Tiller Girls'. (121–2)

Then there was the cult of the dance. First Loy Fuller took the city by storm with her free interpretations of modern music, and then, in 1904, the renowned Isadora Duncan moved to Berlin and opened a school in the polite villa quarter of the city in the south-west. (123)

The Secession

Towards the end of the nineteenth century, artists in all the major European cities became impatient with the official artistic bodies. They had been stifled by reaction too long. Things came to a head first in Vienna. A group of artists resigned from the official artists' association and founded their own, which they called the Secession (from the verb 'to cede'), intended to organise exhibitions of modern work including their own painting without staid and old-fashioned juries. Munich soon followed suit. In 1899 the Berlin Secession was founded.

The reasons behind its inception are interesting. In 1892, Edvard Munch had been invited to show his work at the official

exhibition of the Berlin Artists' Association. Munch was already painting his disturbing studies of extreme states of mind and when the show opened it drew a strong protest from the president of the Academy. Bowing to official displeasure, the exhibition was closed a week later. It was not surprising that Munch's work met with such stormy protest. At a time when even Impressionism had not been fully accepted in the capital, his work must have seemed close to (152) sacrilegious daubing. However, a group of artists, led by the Impressionist, Liebermann, left the Association as a protest and organised their own group, 'The Eleven' and then, taking a leaf out of the book of their colleagues in Munich, named themselves 'Secession'. (124, 126)

At first Liebermann and his friends pursued a very liberal policy and accepted the work of many artists, more modern than themselves, for their exhibitions. But by 1907, when the catalogue of Liebermann's 60th birthday exhibition spoke of the revolutionaries of yesterday becoming the classics of today, the liberal had already become an arch-conservative. By 1914, the Secession had become almost a dirty word in progressive art circles and Ludwig Rubiner allowed himself a sarcastic purple passage in the newspaper *Die Aktion*: 'In Germany a milk-bar is called a 'drinking hall'. Just as pompously the old Secession of Liebermann calls itself a *Free* Secession . . . just as appositely the people from Alsace whom Police Minister Dallwitz brings forward call themselves a free people'.

This hostility to the younger painters, who were now infinitely more advanced than the Impressionists, came to the surface in 1910 when the Secession jury rejected all the more modern exhibition entries lock, stock and barrel, even paintings by those artists who had shown regularly at Secession exhibitions in the past. A characteristic of the 1910 Secession exhibition was that the featured painting was the Mannheim version of Manet's *Execution of the Emperor Maximilian*. Liebermann had a field day during the jury sessions and when his caustic wit seemed to have no effect, he threatened those who wanted to accept the advanced work with his resignation.

The New Secession

The rejected artists, under the leadership of the Brücke artist, Max Pechstein, (125) immediately came together and organised their own exhibition. They called themselves the New Secession, emphasising the sad fact of revolutionaries growing old, by

123

124. *Max Liebermann* Self-portrait
(detail), National Gallery, Berlin

125. *Max Pechstein in 1931 (with a
painting of his wife in the background)*

126. *Photograph of Edvard Munch*

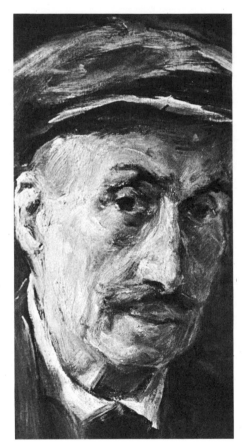

124

125

126

127

making history repeat itself. Some of the reviews of this show are very revealing. Several recognised that the dominant (150) influences were Gauguin, Van Gogh and Munch and continued by observing that the younger painters were on the threshold of an important break-through to something new and exciting. All the reviews claimed that Pechstein was the major talent. Although they were not all approving, all the papers mentioned the exhibition and it was the first time that the younger artists had come to the attention of the public as a body, and with the *Brücke* at their head.

Soon after the first exhibition, the New Secession organised a second show, and then a third in 1911. This was as important as the first, for it brought together for the first time the Dresden *Brücke* and the Munich Expressionist Group, known as *Der Blaue Reiter*.

By this time all the *Brücke* artists were in Berlin. Although they at first entered into the spirit of the New Secession, they began to fear that regular exposure with other artists, and in their opinion for lesser talents, would be damaging. Indeed, up to then, they had always exhibited as a closed group and it was probably only because of the connection with Pechstein that they had exhibited with the New Secession at all.

Die Brücke in Berlin

It was in Berlin that all the Brücke artists reached the climax of their careers. Whereas they had aimed at and achieved a communal style during the early years in Dresden, in Berlin they grew apart and began to go their own ways, pursuing individual styles.

In 1912 the group was given an important exhibition at the Gurlitt gallery, and this had the biggest success of any of the shows so far. Once again, although the reviews were generally favourable, Pechstein was raised to the position of leader of the group. This was reflected not only by one-man exhibitions in several leading provincial museums but also by articles on him in the specialised art magazines. The group as a whole profited from the success. Taken up by the Frankfurt dealer Ludwig Schames, they managed to sell so much of their work that by 1919 their prices had increased ten-fold.

Pechstein, who concentrated on landscapes with figures, was preferred by the majority of critics because his work was closest of all the members to the acceptable French style. Many of his paintings call to mind the Matisse of *La Ronde* and *Joie de Vivre*, although the colours are much harsher, the brushwork far less sophisticated

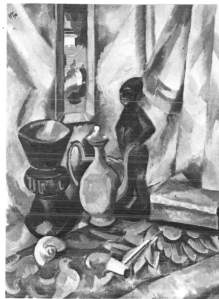

128

129

127. *Max Pechstein*
Fisherman's Head VIII, *1911, woodcut*

128. *Max Pechstein* Still-life with
Bowl, Jug and Wooden Figure, *1913,
oil on canvas,
39.37 × 29.37 in. (100 × 74.5 cm.),
Staatliche Kunsthalle, Karlsruhe*

129. *Max Pechstein* Bathers,
c.1911, woodcut

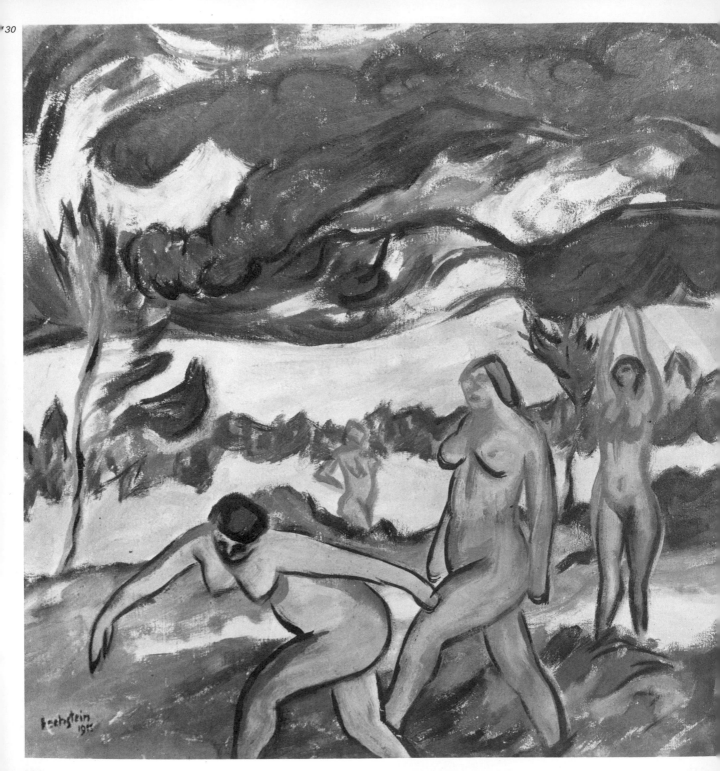

and his feeling for line nowhere near as well developed. (129–30, 149)

Schmidt-Rottluff had gradually brought his work to an impressive degree of (131–2) simplification and sophistication. He filled large, more or less regular forms with predominantly rich, dark colours which (156) he then brought to life with one or two very bright accents. He had also abandoned his earlier practice of juxtaposing equally bright and unstable colours and was now separating the major elements with thick black lines. His work from this period positively shines with direct and even light. His paintings look clean and translucent, in some cases like stained-glass work. (158) The flatness of his compositions and the solidity with which the forms are related one to another give his paintings an authority and an almost classical degree of balance far different from the work of his fellow-members. (133–5)

Kirchner's paintings from his Berlin period are also strikingly different from the work he had done in Dresden. Instead of expressing his subjects in terms of flat areas of bright colour, described by relatively soft contours, he now introduced a sharp angular line, which split and fragmented the outlines and activated every part of the picture. This line was echoed by the acutely angled 'V' forms which predominate and interlock, to send the eye restlessly backwards and forwards in search of a point of balance. (157, 159–60)

These canvases are not composed in the traditional way. Here, the forms and colours do not balance one against the other and the eye is not led around the composition in a calculated and inevitable manner. With his broken lines and sharp, straight brushwork, Kirchner succeeds in every picture in setting up a number of complex and jarring rhythms, which disturb and frustrate any attempt at comprehending them all together.

It is a technique ideally suited to the expression of the high-powered enervating life in the city. Indeed, Kirchner in Berlin applied himself to the city as the preferred subject for his paintings. On those rare occasions when he had painted parts of Dresden, he had interpreted the city in terms of colour and outline and seen only streets, railway lines and houses. Almost all are devoid of figures. Berlin he sees almost exclusively in terms of figures, of claustrophobic groups which blot out their surroundings.

Like the Futurists, the Expressionists were fascinated by city-life, enthusiastic about the size, the speed and the force with which

130. *Max Pechstein* Under the Trees, *1913, oil on canvas,* Detroit Institute of Arts

131

132

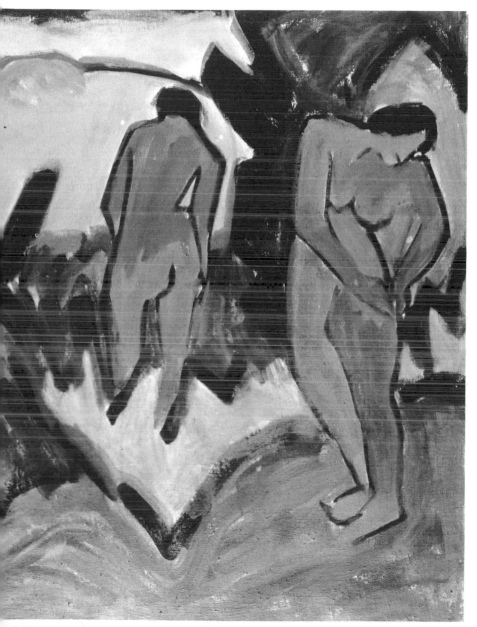

131. *Karl Schmidt-Rottluff*
House with Tower, *1911, woodcut*

132. *Karl Schmidt-Rottluff*
Self-portrait, *1913, woodcut*

133. *Karl Schmidt-Rottluff* Summer Nudes
in the Open Air, *1913, oil on canvas,
Landesmuseum, Hannover*

134

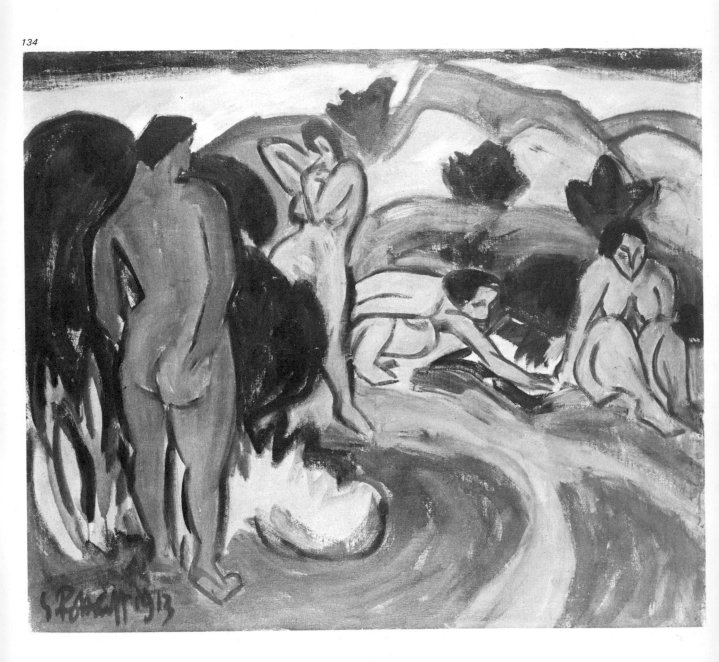

everything in the city is characterised, and Kirchner was no exception. Unlike the Futurists, however, the Expressionists did not look at the city with unmitigated enthusiasm. They also saw it as a black, huge and unnatural environment, which perverted and depraved.

Some aspects of Berlin Kirchner loved, but others he hated, and his city subjects have an unsettling, foreboding atmosphere which contrasts strongly with the idyllic quality of his figure and landscape compositions which he continued to do at the same time. Indeed, he seems to have seen the countryside as a very real antidote to the pressures of city life. The deep personal involvement with the city and all its implications is doubtless responsible for the success of these Berlin compositions. They are among the finest things he ever painted. Of the members of the *Brücke*, Kirchner was alone in making the city a major theme. (137)

Heckel continued to pursue the problems of figure composition, often in the country. Like Kirchner's, his brushwork became sharp and angular, but even more nervous and disjointed than Kirchner's. The best picture of this period is undoubtedly the *Day of Glass* (1913), where the angularity of the forms and the interest in light recall the work of Feininger, whom Heckel got to know at this time. Heckel's interest in primitive art can be seen in the stylised figure in the water. In other paintings of the period he includes pieces of primitive wood-carvings, and produced several carvings of his own in the primitive manner. (137–43, 151)

Break-Up

The *Brücke* began to break up when Pechstein was expelled, or resigned (whichever was the case) in 1912. According to Kirchner, they asked him to leave because he refused to abide by the *Brücke's* decision not to exhibit with the New Secession, of which he was a leading member. Pechstein's own explanation was that he disagreed with Kirchner's egocentric judgements and attempts to force all his colleagues to follow his line. Clearly Kirchner resented Pechstein's growing public acceptance and success.

In 1913, the artists had planned to publish a group history which was at the same time to be a new manifesto. It was to be illustrated with prints and photographs and to have a longish text by Kirchner. The text turned out to be a highly coloured statement, underplaying the achievements of his friends and exaggerating his own. Schmidt-Rottluff and Heckel objected and demanded

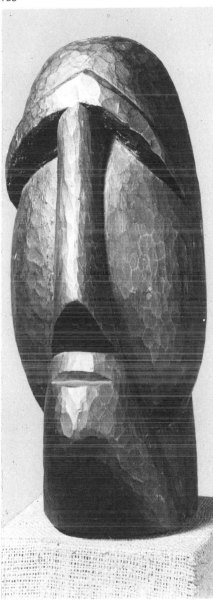

135

that it should not be published. Kirchner later managed to bring out a few copies on his own in Switzerland and these show that the objections of his fellow-members were justified.

This *Chronicle of the Brücke* was the immediate cause of the group's break-up. Even if Kirchner had been more generous and honest, however, there is no doubt that the *Brücke* would either soon have been dissolved anyway, or would have assumed a new and far less rigid form. The individual members had grown away from each other in Berlin; they were living apart and saw each other infrequently. (144–5)

Kirchner reacted with customary bitterness to the decision of the others and cut himself off from them. He became something of a solitary, isolating himself from the art world and devoting himself to painting and writing about his work. In any case, the war was soon upon them all, and Kirchner departed for Switzerland. In a moment of nostalgia in 1925, he painted a large picture, *The Painters of the Brücke,* from (146) memory. The nostalgia did not extend to Pechstein, who does not appear in the group portrait.

Heckel, Pechstein and Schmidt-Rottluff remained friends, however, and frequently exhibited together. After the group's break-up, and particularly after the war was over, none of them managed to regain the power and originality of the earlier period. They were a spent force, condemned either to fruitless recapitulations of earlier styles or, in Kirchner's case, to dangerous experiments with other styles which he did not fully understand. The impetus of the Expressionist movement had passed to others.

It would be a pity if the circumstances of the *Brücke's* dissolution were to detract from the contribution the group made to modernism in Germany. Before the *Brücke* there was nothing but half-hearted imitations of French painting and half-baked Naturalism and Romanticism. The *Brücke* brought Germany up-to-date with the most advanced painting being produced elsewhere and then took what they learned further to create a genuinely original and, most important, a genuinely German avant-garde movement. Their belief in the emotional power of colour and their largely successful attempts to introduce an entirely new kind of subject-matter in painting, had an enormous influence even outside Germany. Of equal importance was the confidence the Group gave to other artists who, without the example of Kirchner and his colleagues, would never have gained the courage

136

necessary to break with tradition.

Many critics, most often non-German, are disturbed by many aspects of *Brücke* painting and are inclined to write it off as crude and immature, the result of a serious lack of talent. This is understandable. The *Brücke* painters were not natural virtuoso performers in the French sense. Indeed, our tastes have largely been educated by French examples and our preferences are for those qualities which the French seem best at achieving most naturally. There is a direct and powerful emotionalism about all *Brücke* work which many foreigners either cannot recognise or find unseemly. Sophistication was not their aim, nor did they seek for a form of painting which would be easy on the eye. If the style is accepted on its own terms, then the full extent of the *Brücke's* achievement becomes apparent.

Der Sturm

When the *Brücke* artists arrived in Berlin, they discovered many artists and writers and a number of engaged and outspoken journals and newspapers where they could publish their views. The most interesting and influential newspaper was *Der Sturm* (*The Storm*), founded by Herwarth Walden in March, 1910. Walden, himself a writer, but with a shrewd business brain, had the makings of what can only be called a great art impresario. At first, *Der Sturm*, with a newspaper format, was a weekly concerned only with literature. (147–8)

Walden, whose real name was Georg Levin, galvanised almost all the advanced artists and writers in Berlin into action. He organised them, sold and printed their work and looked after their affairs. One of his artists, Lothar Schreyer, later wrote of Walden: 'Here was a magnet, which irresistibly attracted all those artists who were decisive in bringing about the change in direction during the first decades of the twentieth century. Expressionists, Cubists, Futurists from all countries trusted him with their work, knowing that he sincerely recognised them, sensing that he was gifted with boundless energy, not only to get these artists and their work across to the public, but to lead them on to victory. Walden dedicated his life's work to this aim until it had been achieved'.

Der Sturm, which at first published verse, criticism and essays, was an immediate success. To begin with it appeared simultaneously in Vienna and Berlin and in March, 1910, not long after the first issue, it had achieved the outstanding circulation of 30,000 copies and had attracted some of Germany's leading writers to its pages.

137

136. *Ernst Ludwig Kirchner* View from
the Window, *1912, oil on canvas,*
47.25 × 25.5 in. (120 × 90 cm.),
Morton D. May Collection, St Louis

137. *Erich Heckel* Canal in Berlin,
1912, oil on canvas,
25 × 39.37 in. (82 × 100 cm.),
Wallraf-Richartz Museum, Cologne

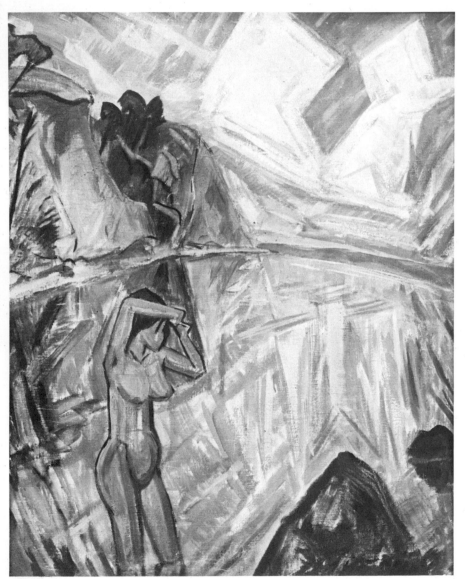

138

139

138. *Erich Heckel* Day of Glass,
1913, oil on canvas,
47.25 × 37.75 in. (120 × 96.2 cm.),
Private Collection, Germany

139. *Erich Heckel* Walk on
Lake Grünewald, *1911, oil on canvas,*
27.87 × 31.62 in. (70.8 × 80.3 cm.),
Folkwang Museum, Essen

140. *Erich Heckel* Self-portrait, *1913,*
lithograph, Kunstarchiv Arntz, Haag

140

To begin with Walden was little interested in the visual arts but in 1910 he was introduced to Oskar Kokoschka, who had broken through to an Expressionist style in Vienna, and brought him to Berlin to do regular illustrations for his newspaper. Kokoschka, who will be discussed later, was a formidable personality, extremely versatile and with a boundless energy which immediately appealed to Walden. Working in an editorial capacity, as well as that of an illustrator, Kokoschka began to influence the policy of the *Sturm* and its scope expanded to include discussion of painting and graphic art, as well as the reproduction of original graphics.

At first Kokoschka monopolised the illustration side of the *Sturm*, but then the *Brücke* took over, taking it in turns to design covers and do illustrations on the inside.

It was through the influence of the *Sturm* that the term 'Expressionism' began to filter through to the public at large. Walden, whose qualities as publicist, impresario and business manager were always more in evidence than his own abilities as a writer, decided to use the word as a slogan. According to him, 'Expressionism' was anything he held it to be: 'We call the art of this century Expressionism in order to distinguish it from what is not art', and then, with a characteristic lack of charity, 'We are thoroughly familiar with the fact that artists of previous generations also sought Expressionism. Only they did not know how to formulate it.'

In 1912, *Der Sturm* published an essay by P. F. Schmidt, who was bold enough to suggest that there was little in common between all the artists described as Expressionists: 'the common name is the product of a dilemma. It signifies little.' The artists, who fought shy of such slogans, agreed with him, but allowed Walden to handle their work under whatever names he thought fit. It was good for business. In the same year Walden decided to launch out into exhibitions and organised the first *Sturm* show, which was to present the public with the work of the Expressionists from all European countries and included the French Fauves, Kokoschka, Munch, and the *Blue Rider* from Munich.

He then discovered the work of the Futurists, and published the *Technical Manifesto of Futurist Painting* for the first time in German. The *Futurist Manifesto* followed and then came a full-scale Futurist exhibition in the Gallery. It was one of the decisive influences on German painting of the period and few artists proved insensitive

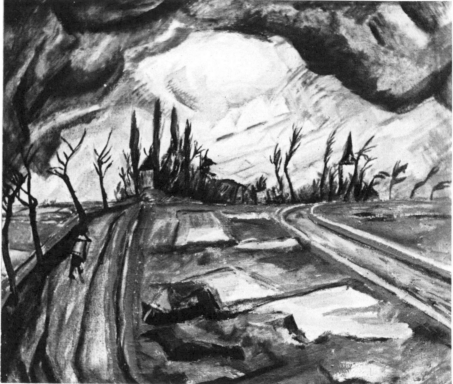

141

142

143

141. *Erich Heckel* Spring in Flanders,
1916, oil on canvas,
32.5 × 38.25 in. (82.7 × 96.7 cm.),
Karl-Ernst-Osthaus Museum, Hagen

142. *Erich Heckel* Self-portrait, *1919,*
woodcut, Kunstarchiv Arntz, Haag

143. *Erich Heckel* The Madman,
1914, oil on canvas,
27.75 × 31.75 in. (70.5 × 80.6 cm.),
Städtliche Kunstsammlung, Gelsenkirchen

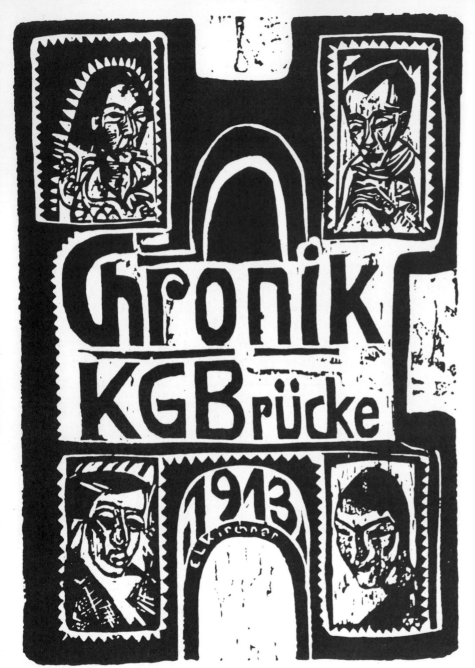

144

144. *Ernst Ludwig Kirchner, Title-page of the* Chronicle of the Brücke, *1913, woodcut*

145..*Ernst Ludwig Kirchner, Page one of the* Chronicle of the Brücke, *1913*

Im Jahre 1902 lernten sich die Maler Bleyl und Kirchner in Dresden kennen. Durch seinen Bruder, einen Freund von Kirchner, kam Heckel hinzu. Heckel brachte Schmidt-Rottluff mit, den er von Chemnitz her kannte. In Kirchners Atelier kam man zum Arbeiten zusammen. Man hatte hier die Möglichkeit, den Akt, die Grundlage aller bildenden Kunst, in freier Natürlichkeit zu studieren. Aus dem Zeichnen auf dieser Grundlage ergab sich das allen gemeinsame Gefühl, aus dem Leben die Anregung zum Schaffen zu nehmen und sich dem Erlebnis unterzuordnen. In einem Buch "Odi profanum" zeichneten und schrieben die einzelnen nebeneinander ihre Ideen nieder und verglichen dadurch ihre Eigenart. So wuchsen sie ganz von selbst zu einer Gruppe zusammen, die den Namen "Brücke" erhielt. Einer regte den andern an. Kirchner brachte den Holzschnitt aus Süddeutschland mit, den er, durch die alten Schnitte in Nürnberg angeregt, wieder aufgenommen hatte. Heckel schnitzte wieder Holzfiguren; Kirchner bereicherte diese Technik in den seinen durch die Bemalung und suchte in Stein und Zinnguss den Rhythmus der geschlossenen Form. Schmidt-Rottluff machte die ersten Lithos auf dem Stein. Die erste Ausstellung der Gruppe fand in eigenen Räumen in Dresden statt; sie fand keine Anerkennung. Dresden gab aber durch die landschaftlichen Reize und seine alte Kultur viele Anregung. Hier fand "Brücke" auch die ersten kunstgeschichtlichen Stützpunkte in Cranach, Beham und andern deutschen Meistern des Mittelalters. Bei Gelegenheit einer Ausstellung von Amiet in Dresden wurde dieser

145

146

Umfang acht Seiten · Einzelbezug 40 Pfennig

DER STURM

WOCHENSCHRIFT FÜR KULTUR UND DIE KÜNSTE

Redaktion und Verlag	Herausgeber und Schriftleiter	Ausstellungsräume
Berlin W 9 / Potsdamer Straße 134 a	HERWARTH WALDEN	Berlin W / Königin Augustastr. 51

DRITTER JAHRGANG · BERLIN MÄRZ 1913 · NUMMER 150/151

Für Kandinsky

Protest

Das „Hamburger Fremdenblatt" vom 15. Februar 1913 veröffentlicht folgende Kritik: **Kandinsky** Zur Ausstellung bei Louis Bock & Sohn, Hamburg

„ Bei Louis Bock & Sohn hat wieder einmal einer jener unglückseligen Monomanen ausgestellt, die sich für die Propheten einer neuen Malkunst halten. Wir sind schon mehrfach mit guten ästhetischen Gründen gegen die unsinnige Theorie dieser Leute und gegen ihre ganze Pfuscherei zu Felde gezogen, daß wir heute diesen Russen Kandinsky rasch und ohne Aufregung erledigen können.

Wenn man vor dem greulichen Farbengesudel und Liniengestammel im Oberlichtsaal bei Bock steht, weiß man zunächst nicht, was man mehr bewundern soll: die überlebensgroße Arroganz, mit der Herr Kandinsky beansprucht, daß man seine Pfuscherei ernst nimmt, die unsympathische Frechheit, mit der die Gesellen vom „Sturm", die Protektoren dieser Ausstellung, diese verwilderte Malerei als Offenbarungen einer neuen und zukunftsreichen Kunst propagieren, oder den verwerflichen Sensationshunger des Kunsthändlers, der seine Räume für diesen Farben- und Formenwahnsinn hergibt. Schließlich aber siegt das Bedauern mit der irren, also unverantwortlichen Malerseele, die, wie ein paar frühere Bilder erwiesen, vor der Verdüsterung schöne und edle malerische Formen schaffen konnte: gleichzeitig empfindet man die Genugtuung, daß diese Sorte von Kunst endlich an den Punkt gelangt ist, wo sie sich glatt ad absurdum, bei dem sie notwendig landen und stranden mußte, als den Idiotismus.

Man wird vielleicht finden, daß seien harte und ungerechte Worte. Ich finde, es sind die einzig möglichen. Der Versuch einer ernsthaften Kritik würde in diesem Falle, meine ich, ein bedenkliches Licht auf den Kritiker werfen. Die bloße Konstatierung der Existenz einer solchen Pseudokunst ist eigentlich schon zu viel.

Kurt Küchler

Den letzten Teil dieser Kritik lasse ich fort, weil er wesentlich neue Beschimpfungen nicht mehr bringt. Herr Kurt Küchler braucht nicht widerlegt zu werden. Man ist auch weniger empört über die Dreistigkeit eines Possenautors, als über die Tatsache, daß einem Unwissenden von einer großen Tageszeitung die Gelegenheit gegeben wird, sich an dem hochbedeutenden Künstler Kandinsky so zu vergreifen. Dieser Protest richtet sich innerlich mehr gegen den Mißbrauch, daß solche Leute auf Künstler losgelassen werden. Dieser Protest soll aber zugleich für Kandinsky eine Ehrung bedeuten und ihm zeigen, welche Achtung und Anerkennung seine Kunst bei künstlerischen Menschen findet. Ich bewundere ihn und sein Werk.

H. W.

Dr. Heinz Braune / K. B. Direktion der Staatlichen Galerien

. . . Immerhin bin ich der Meinung, daß durch solche Art von „Kritiken", mehr der Schreiber gebrandmarkt wird, als der Künstler. Wer mit Kot wirft, beschmutzt zunächst sicher seine eigenen Hände; der andere aber wird gewöhnlich so wenig getroffen, wie in diesem Fall Kandinsky, dessen lauteres, ernstes und unerschrockenes Vorwärtsstreben dadurch nicht zu irritieren sein wird.

Aus einem Schreiben an den Herausgeber der Zeitschrift

Richard Dehmel

Sehr geehrter Herr Walden

Wenn ich gegen die Dummheit des Federviehs jedesmal „etwas schreiben" wollte, wäre ich längst am Schreibkrampf verreckt. Lassen Sie dieses Kurt Küchlein doch piepsen; für solche Hühnergehirnchen zerbricht sich Kandinsky wohl nicht den Kopf.

Besten Gruß
Dehmel

Karl Ernst Osthaus

Museum Folkwang / Hagen i/W

Es verlohnt wohl nicht auf die Ausführungen des Herrn Küchler näher einzugehen. Die Tatsache, daß sich Arbeiten von Kandinsky im Folkwang-Museum befinden, wird Ihnen zur Genüge sagen, was ich von dem Künstler halte.

Hochachtungsvoll
Museum Folkwang
Hagen i/W
Osthaus

W. Steenhoff Stellvertretender Direktor des Reichsmuseums zu Amsterdam

Sehr geehrter Herr

Ich ließ Ihnen ein Exemplar meines Essays über Kandinsky in der Zeitschrift „De Amsterdammer, Weekblad voor Nederland" zusenden. In einigen Tagen erscheint eine zweite Besprechung dieses sehr bedeutenden modernen Malers in der Wochenschrift „de Ploeg", herausgegeben von de Wereldbibliotheek, Amsterdam. Ich höre, daß Albert Verwey, einer der ersten holländischen Autoren in der Wochenschrift „de Beweging" ein Gedicht über Kandinsky veröffentlichte. Uebrigens ist Kandinsky auch hier viel durch die Kritiker beschimpft worden. Aber was macht das!

Hochachtungsvoll
W. Steenhoff

Swarzensky

Der Direktor des Städelschen Kunst-Institutes / Frankfurt am Main

Sehr geehrter Herr

Wir leben in einer Zeit, wo jeder alles sagen kann; so ist also ganz selbstverständlich, daß Ansichten jeder Art gedruckt werden und ganz zwecklos, dagegen mit dem gleichen Mittel einer öffentlichen literarischen Gegenäußerung zu protestieren.

Empörend finde ich es, daß es möglich ist, daß jemand, der berufsmäßig in einer angesehenen Zeitung Kritiken schreibt, eine derartige Expektoration als Kritik herausgibt. — daß er die Sache, die er beurteilen soll in Grund und Boden verdonnert und dabei ungeniert eingesteht, daß er von dem „Versuch einer ernsthaften Kritik" absieht, — ohne seine Ansicht als eine rein subjektive Äußerung zu charakterisieren. Ich kenne die Persönlichkeit des „Kritikers" nicht, und weiß deshalb nicht, ob und inwieweit diese seine rein persönliche Meinung als solche Ihre Entrüstung recht-

147

to it. Cubism had never caught on to such an extent in Central Europe, probably because it was not, at that time at least, accompanied by an apparatus of theoretical writing. In this, Futurism was at a distinct advantage and its theories, radical, even revolutionary, prophesied a new society and a new and enlightened type of man.

In 1913, exploiting disagreement in the Berlin Secession, which had originally planned to organise an exhibition along the lines of the Paris *Salon d'Automne,* Walden decided to stage one of his own which would 'present a survey of creative art in all countries'. He then travelled at break-neck speed from Budapest to Paris, from Vienna to London and invited ninety artists from fifteen countries to exhibit. It was an astonishing achievement. The result was, in Walden's view, an Expressionist exhibition. The *Brücke,* however, was noticeable by its absence. This 1913 Autumn Salon was chiefly remarkable for its comprehensive presentation of world contemporary art. Czechs, Turks, Indians, Japanese exhibited with artists from America and almost all the western European countries. Many of the works, moreover, later became some of the touchstones of modern painting. Balla's *Dog on a Leash* was there, for example, as was Marc's *Fate of the Animals.*

The Autumn Salon was, therefore, an unprecedented success and inspired Walden to stage *Sturm* exhibitions in small German towns and in cities abroad. There was even a *Sturm* exhibition in London.

When war broke out, censorship and financial difficulties restricted the publication of the newspaper. After July 1914, it became a monthly. In 1916, Walden started *Sturm* evenings where lectures on art and poetry, recitals and poetry-readings were given. In 1916 a *Sturm* school was opened to teach acting, painting, writing and music, and in 1917 an experimental theatre, also called *Sturm,* was started.

Walden also began to publish books. He published Kandinsky's short autobiography *Rückblicke (Backward Glances)* in 1913, and Guillaume Apollinaire's *Les Peintres Cubistes* only nine months after its first appearance in Paris. Some extremely influential books were published by Walden. Paul Scheerbart's *Glasarchitektur* (Glass Architecture), which appeared in 1914, had a powerful and lasting impact on architectural thinking in Germany and abroad.

It must have been difficult to continue such varied activities while the war was going on. But in 1918 *Der Sturm* was still the centre of Berlin's advanced artistic activity.

According to a handout of 1918, the *Sturm* had succeeded in presenting to the public 'the most significant cross-section of German and European culture. Those who want to understand the birth of Expressionism, its nature and its significance, must consult the material that the *Sturm* has to offer. The magazine is of special value in that all the woodcuts are printed *directly* from the blocks and are therefore original graphics. The *Sturm* is the leading Expressionist organ.' Here for once was a hand-out which did not exaggerate the case.

Immediately after the war, the complicated web of contacts which the *Sturm* had created was as tough as ever. Playwrights, film-designers and directors were recruited from people associated at one time or another with Walden and there was almost no-one of any significance, working in any medium, who was not at some time associated with Walden. Soon after the war, however, other galleries and journals began to take the initiative, the initial impetus of Expressionism as a new and urgently modern movement was over and Walden's flair and influence also waned.

Nolde and Independent Expressionists

The history of Expressionism can be related for the most part in terms of groups. The break-through to modernism was largely achieved by artists working closely together, as in Dresden and Munich, or by a loose association as in Berlin with *Der Sturm.* Some account must be taken, however, of a number of artists who were independent of the achievements of their contemporaries and, living in comparative isolation, contributed a great deal to the development of Expressionism.

Emil Nolde

Nolde's work during his brief association with the *Brücke* has already been discussed. By nature, he was essentially an independent, learning little from others and preferring isolation to regular contact with fellow-artists (155)

Leaving the *Brücke* in 1907, he went back to the island of Alsen in North Germany, where in 1909 he radically changed his approach. He now painted from his imagination, concentrated on simplicity and on religious subjects. He was a profoundly religious man, although not in an ecclesiastical sense. For him, the Bible and his personal relationship with the idea of Christ were closely linked with childhood memories and his feelings for the North German landscape. He was a pantheist: the smallest corner of Nature was, for him, filled

146. *Ernst Ludwig Kirchner*
The Painters of the Brücke *(Otto Mueller, Ernst Ludwig Kirchner, Erich Heckel, Karl Schmidt-Rottluff),* 1925, oil on canvas,
65.75 × 49.25 in. (167 × 125 cm.),
Wallraf-Richartz Museum, Cologne

147. *The front page of* Der Sturm
for March 1913
carrying a defense of Kandinsky

148. *Oskar Kokoschka*
Portrait of Herwarth Walden, *ink*

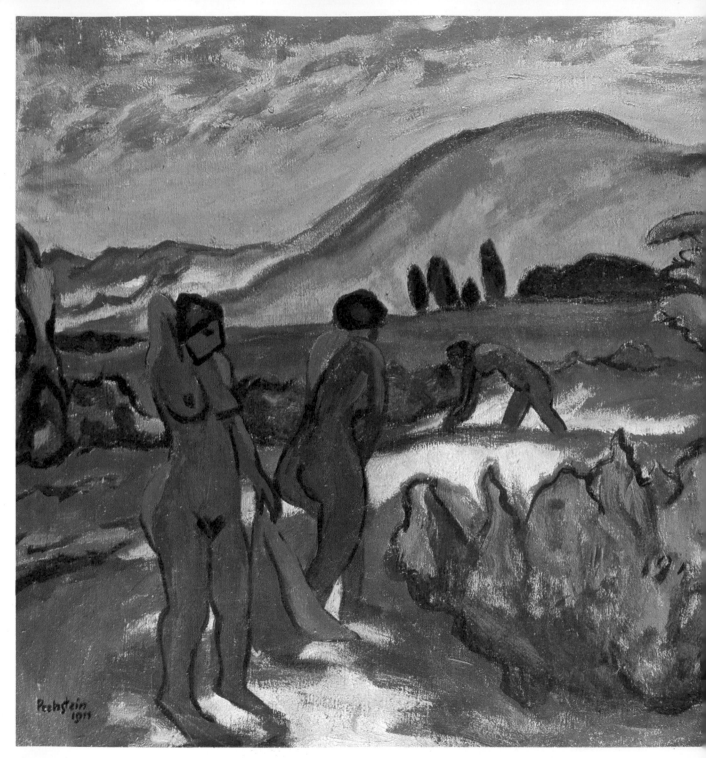

149

150

151

152

149 *Max Pechstein* Summer in the Dunes,
1911. oil on canvas,
29.5 × 39.37 in. (74.9 × 100 cm.),
National Gallery, Berlin

150. *Max Pechstein* Indian and Woman,
1910, oil on canvas,
32.25 × 25.25 in. (81.9 × 64.1 cm.),
Morton D. May Collection, St Louis

151. *Erich Heckel* Bathers,
1913. oil on canvas,
32.5 × 37.5 in. (82.6 × 95.3 cm.),
Morton D. May Collection, St Louis

152. *Edvard Munch* Jealousy, 1896–7,
oil on canvas, 26.5 × 39.37 in.
(67 × 100 cm.), Billedgallen, Bergen

153. *Emil Nolde* The Prophet, *1912,*
woodcut, 12.5 × 8.62 in. (32 × 22 cm.),
National Gallery of Art, Washington D. C.

154. *Emil Nolde* Legend of Maria
Aegyptica *(left wing of triptych),*
1912, oil on canvas, 33.87 × 39.37 in.
(86 × 100 cm.), Kunsthalle, Hamburg

155. *Emil Nolde* Self-portrait
c.1906, woodcut

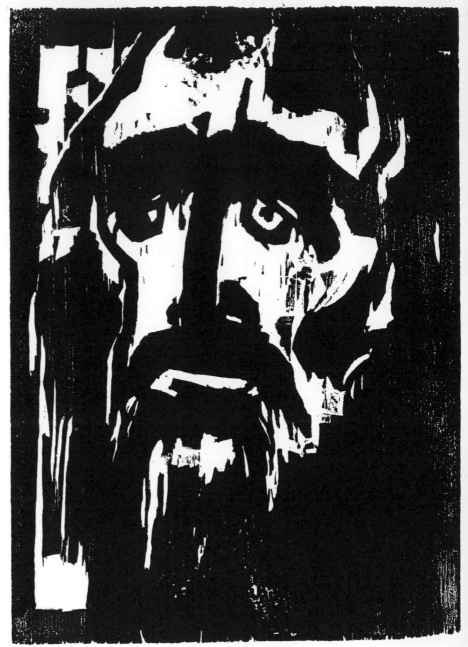

153

155

151

156

158

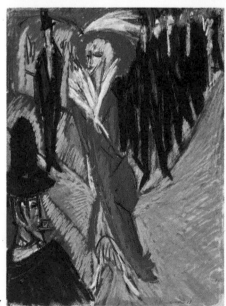

156. *Karl Schmidt-Rottluff* Rising Moon, *1912, oil on canvas,* 34.25 × 37.37 in. (87 × 95 cm.), *Morton D. May Collection, St Louis*

157. *Ernst Ludwig Kirchner* Red Streetwalker, *1914, pastel,* 16.12 × 11.75 in. (41 × 30 cm.), *Staatsgalerie, Stuttgart*

158. *Karl Schmidt-Rottluff* Loftus, *1911, oil on canvas,* 34.25 × 37.75 in. (87 × 96 cm.), *Kunsthalle, Hamburg*

159. *Ernst Ludwig Kirchner* Red Tower in Halle, *1915, oil on canvas,* 47.25 × 35.87 in. (120 × 91 cm.), *Folkwang Museum, Essen*

160. *Ernst Ludwig Kirchner* Five Women in the Street, *1913, oil on canvas,* 47.5 × 12.12 in. (120.5 × 30.7 cm.), *Wallraf-Richartz Museum, Cologne*

157

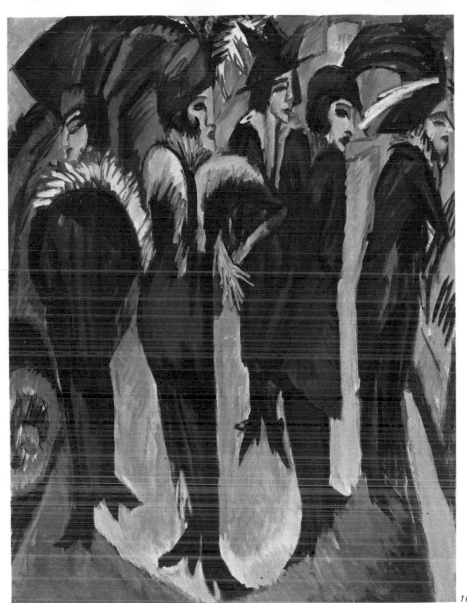

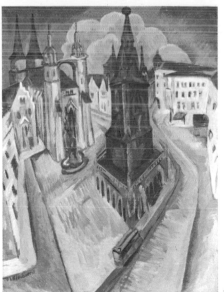

159

160

with the glory of God. He loved Bible stories because he found them intensely human, dramatic and symbolic of the inner truths of life. The immediate reason for an intensified preoccupation with religious subjects seems to have been a serious illness in 1909, although he had already produced a number of woodcuts on Bible themes. The first religious painting was *The Last Supper*, where the lurid brightness of the faces emerges from a sombre background. The paint is thickly applied, and the faces so stereotyped that they are almost caricatures. The face of Christ owes little to tradition. The feeling of suffering and crisis is conveyed by the anti-naturalistic colours, the half-closed eyes, the thinness of the face and the dark, open mouth.

In fact, none of Nolde's religious compositions, which include *The Pentecost*, *Christ Among the Children, Maria Aegyptica* and *The Wise and Foolish Virgins*, owes much to tradition. Colour is used in a completely arbitrary fashion, space disappears and the figures are distorted in the interests of feeling. The shapes and colours dance and flicker before the eyes. They are like the visions of a mystic, always direct and powerful, always disturbed and violent. (153–4, 161, 163)

The Church objected to his highly personalised interpretations of Christian stories, and when he tried to exhibit his *Pentecost* with the Berlin Secession in 1910, the jury agreed with the Church. Together with all the other advanced artists, Nolde's work was rejected and he began a bitter feud with Liebermann and the Secession. A passionate nationalist, he accused the Berlin Secession of 'always emphasising through its exhibitions that the French are the really great painters and that they themselves are merely the half-great.' He attacked Liebermann for being a bad painter and a Jew and the violent anti-semitic outbursts which mar the pages of the first edition of his autobiography have done much to damage his reputation as an artist.

Nolde's dislike of Jews and his association with the Nazis (he was one of the first to join the party in 1920) are no doubt linked with his racialist art theories. He believed that each race had unique characteristics and any artist who denied the facts of blood and history by imitating styles created by other races was to be condemned. Soon after the Nazis came to power, Nolde's work was nevertheless banned as 'degenerate' together with that of all the other advanced artists in Germany.

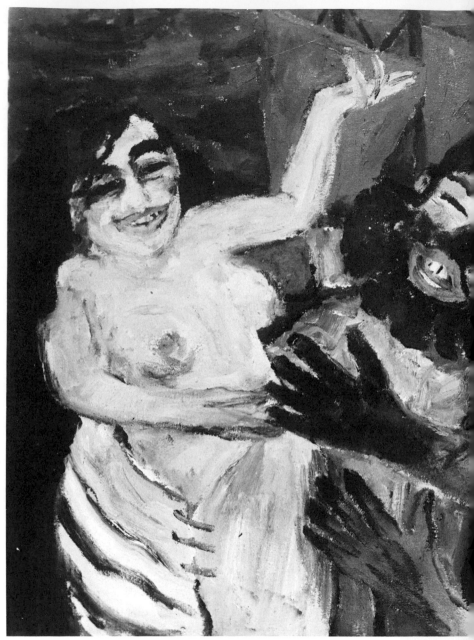

161

136

In his writings Nolde continually made his standpoint clear: 'the great, the really significant struggles were carried on in France. Here in Germany we had only the small fringe effects . . . in Germany now we must create . . . a great German art, a second period—the first was in the days of Grünewald, Holbein and Dürer—the great struggle forward. I feel part of this struggle and hope that the second great period of German art will come.'

Nolde's interest in primitive art, in what he believed to be the direct expression of race, is illuminating in this respect. No doubt he owed much of his knowledge of primitive art to the *Brücke*. The painting, *Masks*, of 1919 clearly shows the influence of exotic art. It is also evidence of the influence of a little known but thoroughly remarkable painter, James Ensor. (165, 167, 173)

Ensor, who lived in seclusion in Ostende, concentrated on weird, allegorical subjects, on pictures which frequently included skulls and masks. He used the masks and their stylised expressions to satirise society and to embody human virtues and vices, in a way similar to the use of the mask in Classical drama. Unlike Nolde's masks, however, Ensor's were not from primitive sources, but from carnivals. His best-known painting, *Entry of Christ into Brussels*, executed as early as 1886, is an astounding tour de force, an attempt to describe symbolically what sort of reception Christ would have been given by modern man. It shows how Ensor, in his isolation anticipated important aspects of Expressionism by several decades.

Nolde, who had already seen primitive masks in the ethnological museums, visited Ensor, whose name was a byword in advanced artistic circles, even though few artists had met the Belgian personally, and spent several hours talking to him. Nolde's own involvement with primitive art was such that in 1912, he even wrote the introduction to a book on the subject in which he favourably contrasts the work of 'natural' peoples with Greek and Renaissance art. In 1913, he was asked to join an ethnological expedition to the South Seas. He travelled overland, through Siberia and China, sketching all the time, and his watercolours of the people and scenes that he saw are among some of the best things he ever produced.

In North Germany, Nolde had continued to paint his broad, dramatic landscapes. (166) It was, however, in his religious compositions that Nolde is at his most Expressionist. The distance from the

162

161. *Emile Nolde* Legend of Maria Aegyptica *(centre panel of triptych), 1912, oil on canvas, 41.4 × 47.25 in. (105.1 × 120 cm.), Kunsthalle, Hamburg*

162. *Emil Nolde* Slave, *1912, woodcut*

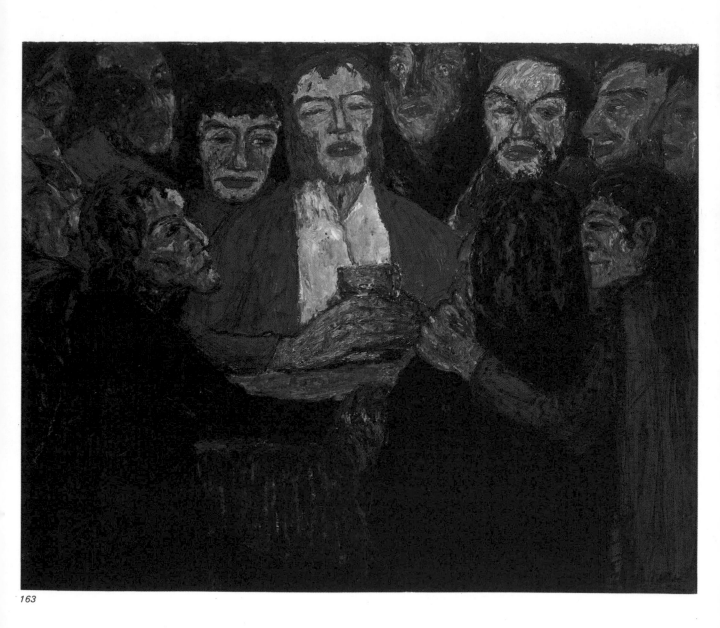

163

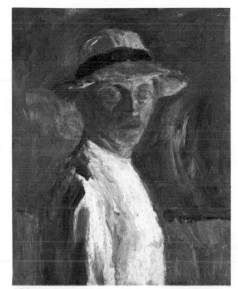

164.

165

166

163. *Emil Nolde* The Last Supper,
1909, oil,
33.87 × 42.5 in. (91.1 × 107 cm.),
Ada and Emil Nolde Foundation, Seebüll

164. *Emil Nolde* Self-portrait,
1917, oil on canvas,
32.62 × 25.5 in (87.9 × 64.8 cm.),
Ada and Emil Nolde Foundation, Seebüll

165. *James Ensor* Intrigue,
1890, oil on canvas,
35.5 × 59 in. (90.2 × 149.9 cm.),
Musée Royal des Beaux-Arts, Antwerp

166. *Emil Nolde* Marsh Landscape, *1916,*
oil on canvas, Kunstmuseum, Basel

167. *Photograph of James Ensor many years later with one of his early paintings from 1888 on the wall*

168. *Gustav Klimt* The Kiss,
1908, oil on canvas,
71 × 71 in. (180 × 180 cm.),
Österreichische Galerie, Vienna

169. *Oskar Kokoschka* Still-life
with Sheep, *1908, oil on canvas,*
34.25 × 44.87 in. (87 × 114 cm.),
Österreichische Galerie, Vienna

170. *Oskar Kokoschka* The Tempest,
1914, oil on canvas,
71.25 × 86.25 in. (181 × 219 cm.),
Öffentliche Kunstsammlung, Basel

171. *Arnold Schoenberg* The Red Gaze,
oil on cardboard,
12.62 × 9.75 in. (32.2 × 24.6 cm.),
Städtische Galerie, Munich

168

169

171

170

143

172

172. *Emil Nolde* Three Russians,
1914, oil on canvas,
27.12 × 34.87 in. (69.5 × 89 cm.),
Ada and Emil Nolde Foundation, Seebüll

173. *Emil Nolde* Masks and Flowers,
1919, oil on canvas,
35 × 29 in. (89 × 73.5 cm.),
Ada and Emil Nolde Foundation, Seebüll

173

174

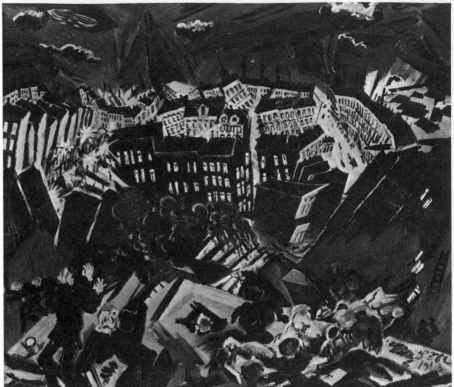

175

176

superficial appearances of Nature, the powerful feelings expressed through colour and distorted form are at once personal and far in advance of anything that his former associates from the *Brücke* had succeeded in achieving. His desire for a new faith, independent of churches and inspired by a deep involvement with life, close contact with Nature, belief in the importance of direct and unselfconscious emotion and honest approach to the business of painting are characteristic of the entire Expressionist movement. (164)

Ludwig Meidner

Meidner (1884–1966), born in Silesia (174) in the Eastern part of Germany, has never been given his due as one of the most typical Expressionist painters and one of the most talented. Partly because of his independence from the major groups and his highly personal style, he has remained relatively unknown, particularly abroad.

Meidner moved to Berlin in 1905 and immediately fell in love with city-life. In Paris for a short time, he discovered the work of Van Gogh and became friends with Modigliani. Already he was convinced of the need for more power and emotion in painting and of the necessity for making the city in all its aspects the major field for modern painters.

Meidner was Jewish by birth, atheist by belief, socialist by conviction. Although an atheist, his mysticism and political sympathies affected his choice of subject and his attitude to it. Meidner appears literally to have had visions and to have been 'taken over' by an irresistible power, which virtually painted for him. His political engagement began to be expressed most powerfully after the war when he was a member of the Communist part and a protagonist of Socialist art.

In 1912, he helped found a group of painters which called itself *Die Pathetiker*, a name intending to signify the antithesis of Impressionist objectivity. Meidner and the group's two other members exhibited at Walden's first *Sturm* exhibition, and through Walden Meidner got to know the *Brücke* painters and the work of the Futurists. It is of interest that Meidner considered *Brücke* work to be half-hearted, lacking all evidence of that spirituality and frenzy that he felt necessary to any work of art. It is clear that the Futurists impressed him greatly. Their attitude to the city was the same, and their political involvement was sympathetic to him, even though it was anything but Socialist.

In 1912 Meidner reached a turning-point

in his art. He produced a series of apocalyptic visions of the city. The paintings show vast areas of concrete breaking up, exploding, the city being destroyed by earthquakes, flames and superhuman forces. (175)

The way in which some of these pictures came to be painted was once described by Meidner: 'In December, 1912, I had a thorough-going religious experience for the first time. Suddenly, while I was painting one evening, I noticed that I could get nothing right. I just couldn't paint. Then all at once I succeeded to such a degree that I actually watched myself as I painted. I painted. My arm was writing on its own and I was taken by surprise completely. Then something came over me: The Holy Ghost . . . I noticed that it was what people call ecstasy'.

The cataclysmic subject-matter evidences the influence of the Futurists, especially in the dynamism, the violent movement which fills the canvas. That Meidner was disturbed (Chagall said that he was talented but mad) is clear from all his paintings. There is no doubt that the apocalyptic townscapes sprang directly from premonitions and later events make them even more remarkable. They are some of the most typical Expressionist paintings ever produced.

Christian Rohlfs

Rohlfs (1849–1938) was, like Nolde, older than the majority of Expressionists and also from North Germany. Like Nolde again, he lived mostly in isolation, was middle-aged before adopting modernist ideas and developed very slowly, his work passing through many stages before reaching a brilliant and colourful climax, as powerful as any produced by much younger artists.

In 1901, Rohlfs went to Hagen, near Essen, patronised by the great collector, Karl Osthaus. Here he discovered Neo-Impressionism and, later, Van Gogh. Under the influence of these artists, his work changed beyond all recognition. His colours became brighter, his brushwork freer. (176)

During the summer of 1905 and in 1906 he painted at Soest with Nolde, who, although a little younger, encouraged Rohlfs to be bolder and move further away from Nature. Rohlfs also began to paint religious pictures and visionary subjects at this time.

174. *Ludwig Meidner* Self-portrait, *1916, ink, Kestner-Gesellschaft, Hannover*

175. *Ludwig Meidner* Burning City, *1913. oil on canvas, 66.5 × 78.5 in. (168.9 × 199.4 cm.), Morton D. May Collection, St Louis*

176. *Christian Rohlfs* Beech Forest, *1907, 43.25 × 29.5 in. (110 × 75 cm.), Folkwang Museum, Essen*

177. Franzensring, Vienna

Vienna

178. Ringstrasse, Vienna, 1891

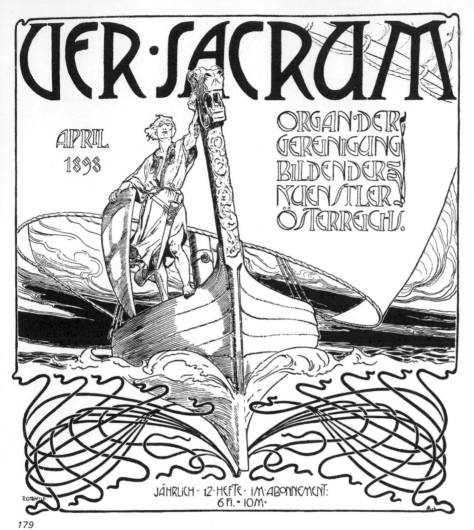

179

Austrian Expressionism

During the long years of German disunity, Vienna was regarded as the cultural capital of all German-speaking people. Although the city's significance had declined by the turn of the century, it was nevertheless extremely important as a musical and literary centre. Later, Viennese artists were to make a highly original, and crucial contribution to the development of Expressionism. (177—8)

Sigmund Freud was once asked about his time in Vienna and he replied that he had spent half his life there and had never come across an original idea. This does no justice to the capital of the Austro-Hungarian Empire around the turn of the century. It was the undisputed musical capital of the world, its theatre was renowned and there were many writers with deserved reputations. Freud himself wrote one of this century's most important books, *The Interpretation of Dreams*, in Vienna and people like Krafft-Ebing and Weininger were investigating various aspects of the subconscious in their own ways.

In the visual arts, however, Austria was even more backward than Germany. Her artists, untouched by the advanced and exciting developments abroad, continued to work in a tradition directly descended from the Baroque. Painters like Makart and Romako turned out large, bombastic history paintings and allegorical compositions which show an obsessive love for sumptuousness and sensuous decoration. Until 1897, Vienna can be said to have been a provincial city, unaware of developments abroad.

In 1897, a group of younger artists decided that the situation was intolerable and resigned from the official artists' association which, they felt, was responsible. Followed soon by young artists in Munich, the breakaway artists called themselves the Secession and organised exhibitions. In 1898 they also brought out a magazine, which they called *Ver Sacrum (Sacred Spring)*. The name was intended to signify the blossoming of art in the capital after the winter of the 19th century. (179)

Generally speaking, the Secession's artists had been converted to the programme of the International *Art Nouveau* movement, believing that fine art and applied art were one and the same activity. By association, the Viennese version of *Art Nouveau* quickly became known as the 'Secession Style'.

Gustav Klimt

Because of its emphasis on applied art, architecture and design, this *Art Nouveau* phase in Vienna did not produce many major painters. The greatest exponent of the style in

179. *Cover illustration of* Ver Sacrum, *April, 1898,*
Victoria and Albert Museum, London

180. *Egon Schiele Self-portrait, 1913,*
pencil, Private Collection, Vienna

painting was undoubtedly the first President of the Secession, Gustav Klimt, who had begun as a conventional academic painter and was, in 1897, beginning to introduce flat, curvilinear patterning into his work.

Klimt, born in 1862 near Vienna, soon established himself as a painter of society portraits, in which wealthy women, dressed in the most extravagant gowns, confront the spectator with their self-conscious grace and haughtily assert their social stature. As Klimt began to embrace the flowing forms and flat patterns of *Art Nouveau* more completely, these portraits became exercises in decoration. The rich patterning of the clothes begins to merge with the extravagant designs of the background and the poses begin to become more theatrical. The faces also become more stylised, less the depictions of individuals than celebrations of the contemporary Viennese idea of what was beautiful. Klimt's faces became as much of a convention as the Pre-Raphaelite expression or the look of the Gibson girl.

As Klimt's interest in flat composition and intricate surfaces grew, he began to make the surfaces of his work still richer, partly by the use of abstract patterning borrowed from a multitude of sources, and partly by incorporating exotic materials. In some of his murals, for example, he used gold leaf and semi-precious stones. His most famous painting, *The Kiss*, is a good example of the way in which Klimt enlivened his surfaces, flattened his compositions and brought his style to the threshold of abstraction. (168)

At first, Klimt's work was a phenomenal success. He and the Secession had managed, in a few short years, to supersede the style that had been popular in Vienna for so long. Eventually, however, Klimt went too far. His large decorations for public buildings, filled with his own personal symbolism, met with scorn and he began to make enemies within the Secession. He resigned from it with a number of other artists in 1905 and they formed themselves into a group, inevitably known as the 'Klimt Group'.

For all his brilliance as a painter and in spite of the many innovations Klimt made as an artist, his work nevertheless belongs more to the spirit of the 19th century than to our own. His love for sumptuous decoration and his interest in the decoration of buildings makes him the legitimate heir of the Austrian Baroque. His eclecticism, interest in and use of style drawn from the past and from oriental art, ultimately label him as an historicist. Klimt was, however, interested in the past for Romantic reasons and not concerned with matters beyond what can be seen on the

180

181

182

181. *Egon Schiele* Sitting Nude,
with her Arm leaning on her right Knee
*1914, pencil and watercolour,
Albertina, Vienna*

182. *Egon Schiele* Nude, *1914, pencil*

183. *Egon Schiele*
Portrait of Arthur Roessler,
1909, chalk, Albertina, Vienna

184. *Egon Schiele* Portrait of
Eduardo Kosimak, *1910, oil on canvas,
Österreichische Galerie, Vienna*

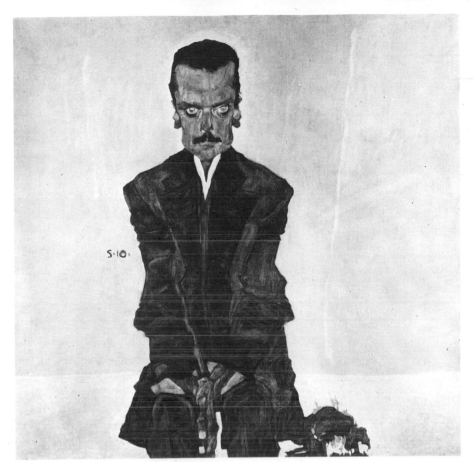

184

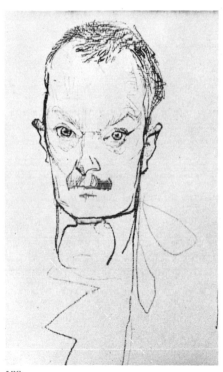

183

185

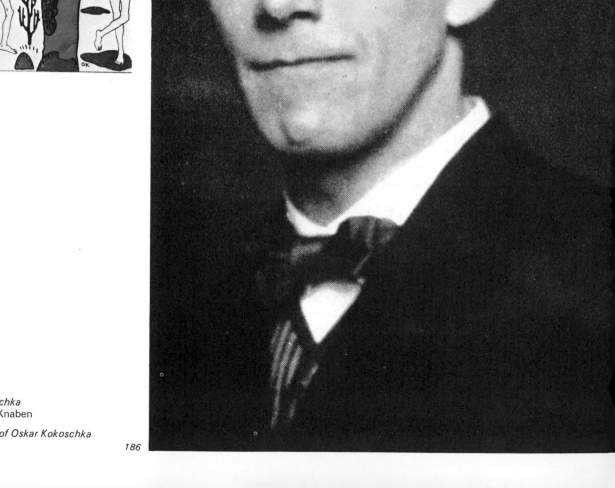

185. *Oskar Kokoschka*
Die Träumenden Knaben

186. *Photograph of Oskar Kokoschka
later in life*

186

154

surface of the picture itself.

Klimt's importance lies in his attitude to modern art. While he was President, the Secession organised several exhibitions of French and German art which brought the Viennese public once again into the mainstream of modernist thinking. Exhibitions of the Impressionists and Post-Impressionists even had an effect on Klimt's own work, particularly on his landscapes, where something of the manner of Signac and Seurat is preserved. For the first time for years Viennese artists could look at and try to understand the work of artists outside their own city and this was to be of great importance for artists of the next generation.

Egon Schiele

The way in which some Viennese artists developed Klimt's style and made it into a tool with which they might express modernist ideas can be seen clearly from the work of Egon Schiele, one of the most remarkable artists to have come out of Austria at this time. (180)

Schiele, born in Tulln on the Danube in 1890, and like Klimt, a draughtsman of truly astounding natural ability, became friends with the older man and learned a great deal from him: the importance of contour, of linear complexity and of the relationship between the major forms of the subject and the shape of the paper.

Schiele soon went beyond what he had learned from Klimt. The older man's concern for balance and decoration often resulted in a precious sclerosis and precluded the expression of any personal feelings; indeed, Klimt never interested himself in matters deeper than the glittering surface of his paintings. In 1910, in a painting called the *Self Seer*, Schiele began to investigate states of mind, fully in keeping with Freud's analyses of the sub-conscious that had already been published. Although the Secession Style is still in evidence in this painting, the line has become harder, the decoration has disappeared and the strangeness of the subject (in fact, a self-portrait) stimulates thought and emotional projection into a situation which is merely hinted at.

Most of Klimt's work reveals an almost obsessional interest in the erotic. But even in his most explicit pieces the atmosphere is of satisfied relaxation, of tenderness and sensuousness. Schiele was also obsessed by sex, but his drawings suggest something close to perversity. He painted, and above all drew women in obviously suggestive poses, but they are in no way

exciting or sexually stimulating. There is an unhealthy element about all of Schiele's erotic work. The women do not invite or provoke; there is an openness, almost a brazen directness about their hard expressions, as though unconcerned by their bodies, seeing their powerful sexuality as a tool. (181–2)

It is the quality of Schiele's line that denies any potentially erotic content. It attacks rather than caresses, torments rather than arouses and searches out the hard structure of the bone beneath the tautly stretched flesh. His portraits emerge in the same way. He seems to search out the soul beneath the skin, to suggest a lifetime's experience in the eyes and the folds of the flesh. They are worlds away from the stylised faces of Klimt's portraits. (183–4)

Schiele's private life helps us understand his work. Like many of his Expressionist contemporaries, Schiele's world was troubled and guilt-ridden. His childhood had been unhappy and his work was persistently misunderstood. The police even sent him to prison for a few weeks for drawing young girls under the age of consent naked. It was only after he married during the war that Schiele grew more happy, and the change is immediately noticeable in his work, which becomes softer and more restrained. The happiness did not last long. He was conscripted into the Austrian army and died, a few days after his wife, from the Spanish Influenza, in 1918.

Schiele's interest in the personality of his sitters and the feeling of the darker side of human existence which comes out in his self-portraits especially, marks him as an Expressionist, decidedly more modern in tone than Klimt ever was. It is therefore not surprising that real recognition should have come not in Vienna, where the brilliant superficialities of the Secession Style remained the preferred mode for some time after the war, but in Berlin. Here the Expressionist journal, *Die Aktion*, devoted a special issue to his work, and from then on artists in the German capital began to feel his influence.

Oskar Kokoschka

Oskar Kokoschka, four years older than Schiele, was also associated with the group around Klimt for a time. Kokoschka, a self-taught artist and poet from Pöchlarn on the Danube, taught at the Vienna Workshops. This was a school, founded by the Secession to train young artists in the Secessionist ideas of applied art and design. Here Kokoschka produced graphic work which, with its bright colours and thick

187. *Oskar Kokoschka,*
Drawing for Murderer, Hope of Women
which appeared in Der Sturm, *ink*

188. *Oskar Kokoschka*
Portrait of Professor Auguste Forel,
1910, oil on canvas, 27.5 × 22.87 in.
(70 × 58 cm.), Kunsthalle, Mannheim

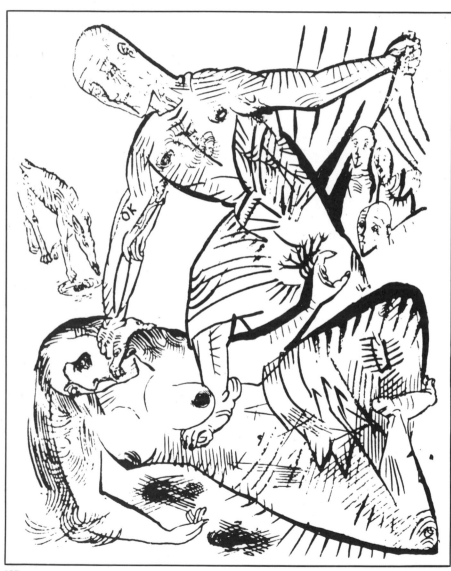

187

contours, was completely in keeping with the contemporary Viennese style, although nowhere near as sophisticated and delicate as the work of Klimt, for example. Kokoschka clearly felt that he owed something to Klimt, for his early illustrated prose-poem *Die Träumenden Knaben* (*The Dreaming Youths*) is dedicated to the Secession's President. The poem reminds us that it was as a poet that Kokoschka first made his name. *The* (185) *Dreaming Youths* is a celebration of horrors and excesses, delighting in gruesome details and expressing a longing for an exquisitely drawn-out death. Based on French models, notably Verlaine and Rimbaud, the poem brought something new to German style: a spare, direct, but emotionally loaded language. The sensitive illustrations are in strong contrast to the poem's content.

Kokoschka's plays are even more radical in language than the prose-poem. By 1908 he had written two of the most important: *Sphinx und Strohmann* (*Sphinx and Scarecrow*) and *Mörder, Hoffnung der Frauen,* (*Murderer, the Hope of Women*). These are among the first Expressionist dramas. In them, almost nothing of the traditional theatrical conventions remains. The characters are depersonalised, ciphers for elemental forces, and the language is intentionally obscure, often reduced to disjointed exclamations, or encrusted with colourful phrases and images intended to affect the senses rather than communicate with the intellect. *Murderer, the Hope of Women* symbolically presents the conflict between male and female. Basing his ideas on Weininger's philosophical investigation of the life-force, Kokoschka created a strange morality play without time or place, an allegory of the universe, impossible to interpret. (187)

Kokoschka's dramatic language shows him as an intensely visual writer. His most powerful images evoke colours or sights and great emphasis is placed on the gesture and costume of the actors. His first important paintings were a series of portraits of (188) Viennese intellectuals, in which he pursues the personalities of his sitters even further than Schiele; his style is completely subordinated to the expression of their inner life. The style that emerges is far from Klimt's: colourful, disjointed, free to the point of wildness and with only a small interest in the linear and an emphasis on the expressiveness of the eyes and hands. Commenting (189) later on these early 'black portraits', as he calls them, of before the World War, the artist said: 'the people lived in security, yet they were all afraid. I felt this through their

cultivated form of living which was still derived from the Baroque; I painted them in their anxiety and pain'.

Kokoschka's disturbing style in these portraits made him unpopular when he first exhibited in 1908 and 1909. This pleased him, because even from an early age he was determined to outrage and disgust, believing that agitation and shock were the most important things an artist could do. By these standards, Kokoschka was an immediate success, although he could never hope to make a living from outraging the public and managed to stay alive only by the generosity of friends and through those who commissioned portraits, paying him with free board and lodging at their houses while he was painting them.

In the winter of 1907—8 he was the guest of Oskar Reichel and paid for his keep with a now famous still-life. The subject is a (169) bizarre collection of objects, a turtle, a mouse, a newt, a skinned sheep and a flowering white hyacinth. Not only is the style, with its arbitrary lighting and liquid brushwork unusual, but the subject itself, with its morbid overtones is unique. Not only are the objects themselves physically repulsive, but the hyacinth and the odour we immediately associate with it add a number of unpleasant associations to the other objects. We are forced to think of the smell of the rotting flesh, of the mouse and of the stagnant water in which the newt swims around. The success with which this picture conjures up a multitude of associations is the more remarkable for its date. At a time when the *Brücke* artists in Dresden were still struggling with problems of style, Kokoschka had successfully taken an outmoded convention, the still-life, and had turned it into a medium for the depiction of Expressionist ideas.

In 1909 Kokoschka did the same for the landscape, a genre which, till then, had been left untouched by other Expressionists. *Winter Landscape, Dents du Midi*, was, in fact, his first landscape. Again, the mountains, the bare trees and the unreal disposition of light create a melancholic atmosphere, which becomes the real subject of the painting.

In 1911 Kokoschka met Walden, who was in the process of establishing *Der Sturm* in Berlin and Vienna. Walden took Kokoschka with him to Berlin. Kokoschka thought that the state of his finances might improve in the German capital; it could not become worse than it was in Vienna, and so it was that he became the *Sturm's* first illustrator. These illustrations were usually

189. *Oskar Kokoschka, Detail of hands from* Portrait of Adolf Loos, *1909, oil on canvas, National Gallery, Berlin*

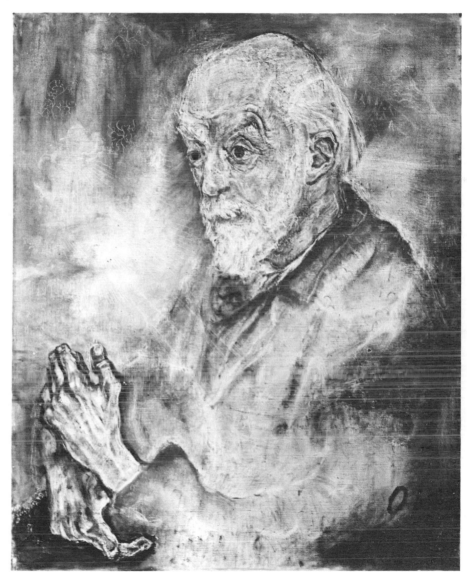

188

190

190. *Richard Gerstl* Two Sisters,
*c.1907, oil on canvas,
59.87 × 59 in. (152.1 × 149.9 cm.),
Österreichische Galerie, Vienna*

pen-and-ink portraits of contributors, astonishingly successful for a young artist of 24.

In Berlin, Kokoschka's hopes were fulfilled: he began to make a name for himself. Paul Cassirer organised an exhibition of his portraits in 1910 and this was followed by an invitation to show substantially the same exhibition at the Folkwang Museum in Hagen. Walden also introduced Kokoschka to the *Brücke* artists, who had by this time all moved to the German capital. He liked and admired the *Brücke* work, doubtless because their attitude was similar to his own, although their solutions of similar problems were very different.

The last great picture painted by Kokoschka before the outbreak of war, and in a sense the summation of all his work till then is *The Tempest* of 1914, which celebrates his affair with Alma Mahler, later to marry Walter Gropius, founder of the Bauhaus, and then the Expressionist playwright, Franz Werfel. The colour is limited almost entirely to a range of blues and the indeterminate forms around the central couple flicker and dance like unearthly fire. The feeling is less of a tempest than of the eye of the storm where all is peace. (170)

Kokoschka had a bad war. He was almost fatally wounded at the front: shot in the head, bayoneted in the lung and captured by the Russians. After the war he had to convalesce for many months in a hospital in Sweden and then became Professor at the Dresden Academy. In the opinion of many he never again succeeded in achieving the power and insight of his early work, which made a singular and important contribution to the development of Expressionism. (186)

Richard Gerstl

The portraits of Richard Gerstl are very close to Kokoschka's. Gerstl is one of the most underrated artists of the period and one of the most original. Born in 1883 and therefore of Schiele's and Kokoschka's generation, he died young in 1908 and only painted during the last four years of his life. Unlike the early work of Schiele and Kokoschka, Gerstl's owes nothing whatever to Secessionist modes. It emerged mature from the first, anti-linear, free and restricted in its colours. Gerstl restricted himself entirely to portraits and landscapes. Of these the portraits are the more interesting. Clearly influenced by Munch, whose work had been included in a Secession exhibition in 1903, Gerstl's figures never seem happy, often appearing as sick or diseased creatures, or as (190)

insubstantial spirits. Like Schiele, Gerstl's own troubled personality comes to the fore throughout his work; the feeling is that he is painting himself, no matter what his subject.

Gerstl's style was the opposite of everything that was accepted in Vienna at the time. His paintings often seem unfinished, leaving important details to the imagination of the spectator. The paint is applied as brutally as possible, as though Gerstl is attempting to make the very act of painting say something about his emotional state. For all the limitations of his range of subject-matter, Gerstl's work is among the most remarkable produced during the Expressionist epoch.

The War and After

By the time war broke out, Expressionism had become the most important force in German art. The leading Expressionist painters were well known in every city in the country; some had become secure and respectable. The war disrupted the activities of all those concerned with the movement. When the war was over, Germany itself, and the aims of its artists were changed for ever. Many of the leading members had been killed; others had left the country. Marc, Macke and Schiele were dead; Kokoschka had survived by a miracle. Kirchner was in Switzerland, as was Klee. Kandinsky was in Russia, closely annnointed with official Soviet art circles. None of the groupings now existed, and if they had done, would probably not have managed to cope with the new and difficult problems which the end of the war had brought.

In a sense the war itself fulfilled the demands of some of the Expressionists. They were after nothing short of social revolution, the destruction of the older form of society, and at first it seemed as though the war had succeeded in doing this, if nothing else. Moreover, the war, more complete in its horror and destructive power than anything in history before it, had made many of the Expressionists' visions real. In its excesses it was, in part, an ideal Expressionist act. Its legacy could so easily have been Expressionist as well: the creation of a new social Utopia.

Eventually the German Revolution of November, 1918, was abortive. Begun by sailors of the German Fleet at Kiel, it spread like wildfire throughout the country. Everywhere people were demanding Soviets, or representatives of the People, to set up governments. For a brief period a Soviet Republic was set up in Bavaria, and weeks of rioting, street-fighting and intense political activity in Berlin were brought to a close brutally and finally by army officers returning from the front.

The November Group

Most of the artists in the capital were in sympathy with the aims of the Socialists. They formed themselves into groups proposing new forms of co-operation between the State and its creative and intellectual members. Many joined the Communist party, newly founded, and spoke at meetings, wrote pamphlets and designed posters. If Expressionism had proposed a close and real relationship between the State and its creative and was the chance, and few artists were prepared to let it pass.

Simultaneously with the Revolution, the *Novembergruppe* was founded in Berlin, under the leadership of Max Pechstein and the painter and stage designer, César Klein. The Group established workers' councils for art and attempted to show how Expressionism was the perfect expression of Utopian forms and would be the ideal art for the new Socialist State. Following the pattern of Tatlin, Malevich and Kandinsky in Russia, the November Group attempted to exploit all the new possibilities for co-operation between art and society. As Pechstein wrote: 'We desire to achieve through the Socialist republic not only the recovery of the conditions for art, but also the beginning of a unified artistic era for our time'.

Similar groups then sprang up in many other German cities and all were concerned with the importance of a new form of artistic education which would help mould the new sensibilities necessary for the citizens of the new Socialist state.

The Revolution quickly collapsed. Although the Kaiser had been exiled to Holland, the mediocrity of the Weimar Republic quickly took the place of the pomposities of the Monarchy. But if the Revolution achieved nothing else, it succeeded in creating the atmosphere necessary for a fundamental rethinking of the nature of the artist's role in society and of the importance of a new form of artistic education, quite unlike anything that had so far been attempted. The result of this thinking was the Bauhaus, Walter Gropius' radically new art academy, founded in Weimar. It is significant that Gropius staffed his institution almost entirely with Expressionists, Kandinsky and Klee among them, and that all students found that their basic ground studies were based on Expressionist ideas.

The revolutionaries of yesterday are the reactionaries of today. After the war, Expressionism became respectable. Artists who had fought against society for so long, who had struggled to change the taste of their country, suddenly realised that they had succeeded in achieving what they had set out to do. Many had achieved the ultimate in German respectability: a professorship. Others could settle down to a life devoted to their art, untroubled by financial or other worries. The ideas behind Expressionism were now being applied to other forms.

Expressionism in other Arts

191

191. *Ernst Ludwig Kirchner*
Portrait of Georg Heym, *1923, etching,*
Schiller-Nationalmuseum, Marbach

192. *Hans Poelzig,*
Set for the film Golem, *1920,*
National Film Archive, London

193. *Photograph of Georg Trakl* 192

193

Expressionism in Other Arts

The climate of opinion, the social and artistic forces which led to Expressionism in the visual arts were not basically of a kind that made them applicable to painting alone. They were at once much broader and more embracing. Unlike the ideas behind, for example, Cubism, which were of an almost exclusively visual nature, the Expressionist philosophy was intended to be so universal that it could be applied to life itself. After the painters had taken the lead, artists working in other media began to question the traditional forms and to come up with answers related to the Expressionist point of view in painting. The results, the revolution that was successfully achieved across the broad spectrum of artistic creation, makes it possible to speak of 'Expressionist' poetry, architecture and film.

One of the most striking characteristics of Expressionist artists in general is their interest in and ability in all means of artistic expression. There has been no other period in which so many painters wrote poetry, so many musicians painted and so many film-makers had been associated with other art-forms. A few names will suffice to make this remarkable fact clear. Klee was so proficient a violinist that he almost became a concert artist. Schoenberg produced a remarkable series of paintings. Strindberg painted. (171) Schiele, Kokoschka, Kirchner wrote poetry. Kandinsky wrote a play and based some of his theories on Schoenberg's ideas. The architect, Poelzig, designed the sets for an Expressionist film, as did César Klein, (192) one of the leaders of the New Secession in Berlin, and much of the basis for the new, Expressionist idea of architecture was based on a book written by an eccentric novelist. Alfred Kubin, member of the *Blaue Reiter*, also wrote a weird and wonderful novel, called *The Other Side*. It was a versatile generation and there was a great cross-fertilisation of ideas.

Expressionist Poetry

Like Expressionist painting, Expressionist poetry ultimately derived from French models, and from Symbolism, in particular. Early Expressionist poets explore the same area of subject-matter as poets like Rimbaud and Verlaine, rely on a similar sort of symbolism and attempt to apply, in German, the same attitude to vocabulary and syntax. Certain Expressionist poets took experimentation to the extent that all formal language disappeared, but for the most part the revolution was achieved in terms of traditional forms. Most of Heym's lyrics are tied to traditional subjects and

194

194. *Still from the film*
The Cabinet of Dr. Caligari

195. *Oskar Kokoschka* Pietà
(poster for the Kunsthaus theatre),
Österreichisches Museum für
Angewandte Kunst, Vienna

195

forms, as are Trakl's. Kafka's prose is the
clearest and most regular imaginable. What
they all have in common, however, is a sense
of revolt, a love of excess, a visionary
enthusiasm and spontaneity and a
predilection for the less palatable side of life.

Like other artistic styles which question,
which pose problems rather than suggest
answers, Expressionist poetry is often
tortured and dissonant. Intensity is preferred
to harmony; formal perfection less important
than shock. Ideals of beauty are abandoned
because they lead only to the imaginary; they
have nothing to do with the real and acute
problems that face us all. A brief discussion
of four of the most important Expressionist
poets will suggest the nature of the style.

Ernst Stadler (1883-1914) had a very
strongly developed visual sense, and his
poetic pictures are disturbing, direct and
often very unpleasant. His subjects include
a lunatic asylum and the Jewish quarter of
London, and his early lyrical work *The
Preludes* (1904) derives completely from
French Symbolism.

Georg Heym (1887–1912) also derived
his language from Symbolism and was
concerned with the poetry of horror,
corruption and evil. Unlike other poets who
prophesied the castastrophe of the coming
war, Heym describes it in direct and powerful
terms. Dirty suburbs, corpses, blind men,
poverty and sadness are the constant
subjects of his poetry. He also evolved a type
of landscape poetry, distinguished by its
colour symbolism, in which nature itself is
given human emotions. Here, even the
silence and calm of a landscape, are not seen
as healing or beautiful qualities but as
factors in an oppressive atmosphere,
reflecting a feeling of crisis. (191)

Georg Trakl (1887–1914), whose personal
life was tragically disturbed, is also
concerned with decadence and corruption.
The air is filled with foul smells, the earth
peopled by rats, ravens and flies. The blood
from a million abbatoirs runs into stinking
canals. Like Heym, Trakl is fascinated by the
symbolism of colour. For him, as for many
Expressionist painters, each colour has a
definite meaning, a point where it becomes
typical for a certain kind of experience:
silver is the paleness of death, gold the
glorious reflection of truth. (193)

Gottfried Benn (1886–1956) began life as
an army doctor in Berlin and then became a
specialist in venereal diseases. His first work
was a small volume of lyrics called *The
Morgue* (1912) which takes the form of a
stroll through wards full of cancer victims
where the air stinks of decaying flesh. Later

196

197

196. *Oskar Kokoschka*
Portrait of Paul Scheerbart,
ink, Staatsgalerie, Stuttgart

197. *Erich Mendelsohn, Utopian sketch,*
c.1914, ink

198. *Hans Scharoun, Utopian sketch, 1920*

199. *Hans Scharoun, Study for*
the Chicago Tribune Tower, c.1920

198

199

201

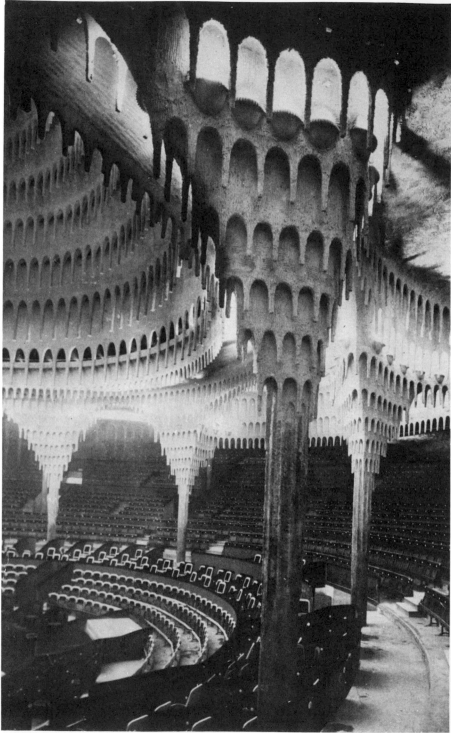

200. *Oskar Kokoschka*
Portrait of Max Reinhardt, *1919,*
lithograph, 24.5 × 18.5 in.
(62 × 47 cm.), Kunstarchiv Arntz, Haag

201. *Hans Poelzig, Interior of the*
Grosses Schauspielhaus (theatre),
Berlin, 1920, (destroyed)

202. *Hans Poelzig, Exterior of the*
Grosses Schauspielhaus, Berlin, 1919

202

poems like *Sons* (1914) and *Flesh* (1917) unmask the banalities of everyday life and present human beings as animals.

About 1910 a whole group of poets began to follow the example set by these four poets, and Expressionism became a literary movement which was both socially and politically committed.

Expressionist Drama

Something has already been said about Kokoschka's early plays and they are indeed typical of Expressionist drama. Plays of this type rejected any claims on reality. The actors appear in a bare space, do not speak everyday language and their actions do not follow the logic of reality. They are often given masks, to make the drama even less realistic, more allegorical, more a drama of types, something like the medieval morality play. Indeed, the comparison is not (195) fortuitous, for authors like Kokoschka, Barlach and Stramm, attempted to revive the universality and elementalism of earlier forms of drama. The idea of drama as symbolic show, representing elemental forces and concepts in a stylised way, was brought to its logical conclusion by Bertolt Brecht, who, although not an Expressionist himself, relied on the Expressionists' success in 'alienating' their audiences, that is, preventing them from becoming emotionally involved in the performance, thereby encouraging them to use their intellects.

Expressionist Cinema

The cinema, for the Expressionists a new art-form, thrilled them all. It appealed to poets, painters and actors alike because it offered an involvement that was more complete and a freedom unmatched by any other art-form. Many writers produced work expressly for the cinema and architects considered that the most challenging commission was cinema design. After the war, many of the factors that had emerged earlier in painting and drama enter German films and contribute to the international success that movies like the *Cabinet of Dr Caligari* achieved. (194)

In *Caligari* we are presented with a world several stages removed from Reality. Lights and shadows are painted on the sets themselves, which are in any case (having been designed by Expressionist painters) distortions of reality. Even the actors' make-up is exaggerated in a way which suggests the theatrical use of masks. One of the film's designers had come to the conclusion that, in his own words, 'a film should be drawings brought to life', and succeeded in making *Caligari* just that, and in a style which recalls the work of Heckel and Feininger. In

Caligari we see an imagined Gothic town with crazily angled windows, bent chimneys and decorated floors. Sometimes the windows are simply drawn on the walls, the bricks on the buildings and the pavements on the ground. Often decorative devices heighten the drama or point to the importance of one or other figure. Abstract patterns are used to heighten the feeling of terror, to reflect the psychological state of the major characters.

Superficially, the plot of the film is about a magician with hypnotic powers who makes a young man under his control commit murder. The story is presented to us through the eyes of two young men in a lunatic asylum who imagine it all. But there can be no doubt that the plot has implications deeper than the vicarious excitement created by the horrific details of the story. At root, it is about the power of strong men over others, and even about the nature of evil itself.

It is interesting that with all Expressionist films to follow *Caligari*, the role of the designer was of great importance. It became customary to invite a painter or architect of standing to work on a film. Thus the architect Poelzig was asked to design the sets for *Golem* and César Klein created the (192) visuals for *Genuine*. Ludwig Meidner was the designer for *Die Strasse* (1923).

This is not the place to go in any detail into the importance of the Expressionist cinema. *Caligari* gave rise to a number of films both at home and abroad and can be regarded as one of the most powerful innovatory films in the history of the cinema.

Expressionist Architecture

In 1919, the Berlin art-dealer, Paul Cassirer, staged an exhibition of drawings which he called *Architecture in Iron and Concrete*. The drawings had mostly been done in the trenches by a thirty-year-old architect, Erich Mendelsohn. While studying in Munich in 1909, Mendelsohn had made contact with the artists who were later to associate with the *Blaue Reiter* and his drawings from the war years have more in common with the free expressive creations of Kandinsky than with conventional and carefully finished architectural sketches. (197)

Loose, dynamic and with a strong sense of the sculptural, Mendelsohn's drawings are at once highly imaginative and futuristic. Each drawing has a dominant rhythm, which Mendelsohn intended to set up a certain emotional tension. 'Certainly the function is the primary element,' he wrote of architecture, 'but function without feeling simply remains construction. . .function plus dynamics, that is our task'. This is a neat description of Expressionist architecture.

But few of the drawings exhibited by Cassirer were capable of being carried out in terms of the materials available at that time. It is significant that Mendelsohn was not alone in creating his paper fantasies. Other architects and non-architects were giving rein to their fantasies at the same time. It was not a moment for building. After the war, there was simply no money available, and consequently the time was ripe for radical and impracticable experimentation. (198–9)

This experimentation eventually left its mark on a small number of buildings which, even today, astound by their modernism and the radicality of their approach. Although the drawings of Mendelsohn and others date from the war, the seeds of the Expressionist approach had been sown at the beginning of the century by Bruno Taut whose book, *The City Crown*, questioned traditional ideas of city-planning, and emphasised the spiritual needs of a town's inhabitants.

Taut then fell under the influence of the Expressionist writer, Paul Scheerbart, who was associated with *Der Sturm* and best known as a writer of science fiction. (196) He believed that glass was the major architectural material of the future and that its use would improve the practical and spiritual life of the people who lived in glass buildings. Taut took the social role of architecture very seriously. In the pages of his magazine, *Frühlicht* (*Early Light*), he stressed the need for a new society and a new architecture and often seems to demand nothing less than a social revolution.

All of Taut's ideas did not remain visionary. In his Glass Pavilion at the 1914 *Werkbund* exhibition at Cologne was a small circular building with a glass dome. On the façade was the legend: 'Coloured glass destroys hate'.

Poelzig was also an architect of great imagination who had an influence before the war. Unlike Taut, Poelzig was not a believer in new materials, but was as convinced of the role of architecture as influence for good in society: 'Architecture is the product of a national state of mind, and the average deplorable architecture of German towns during the last few years was a result of the corruption of a nation, which desired only material gain, a nation which had lost its psychic connection with its native soil. . . our aim is to reconnect them'.

Poelzig, who began his career in Breslau, early demonstrated that his was an original talent. His best-known and most extravagant work was the theatre he designed for Max Reinhardt on the site of the

203. *Erich Mendelsohn, Sketch for the Einstein Tower, Potsdam, c.1918*

204. *Erich Mendelsohn, Einstein Tower, Potsdam, 1921, concrete*

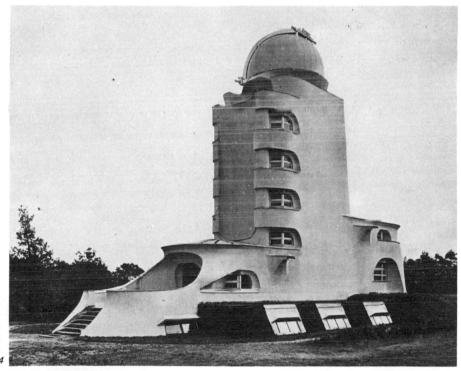

old Circus Schumann. In a sense, a theatre was the ideal project for an Expressionist architect. The theatre is a place of fantasy where the spectator enters a world with different standards of reality. Poelzig saw his task as the creation of a building which would, by its form, isolate the audience from the outside world and introduce them into an unreal environment. It succeeded completely. The inside of the theatre was a huge cavern-like dome covered with hanging, stalactite forms in tiers. The lighting was concealed, emphasising the feeling of unreality. The outside of the theatre with its minimum fenestration and brooding height had the same effect of presenting us with a mysterious, closed world. (200–2)

Mendelsohn's Einstein Tower, built in Potsdam as an observatory and laboratory, is also a strongly personal expression, its powerful rhythms, to which all else is subordinated, determining the plan and elevation of the building. But the Einstein Tower demonstrates the dilemma of the Expressionist architect, for the design proved impracticable, and Mendelsohn had to make many alterations before the building eventually became a possibility in terms of engineering. (203–4)

This is why the most typical pieces of Expressionist architecture, strange though it may seem, remain sketches, free and imaginative on paper, and not actual buildings. But enough plans were carried out and the influence of these buildings and of the sketches was so strong that Expressionism in architecture became a force to be reckoned with, especially when the time came when new materials made many of its ideas possible in real terms.

Post-Expressionist Painting
After the war the Expressionist painters found that they had acquired an enthusiastic public. Their work was bought by museums at home and abroad, articles appeared in the popular press and those bastions of conservative opinion, the Art Schools, offered them professorships. The Expressionist generation had suddenly become a symbol for everything that Germany ought to have become and representative of those who had been sickened and disillusioned by the war.

Inevitably, the style lost its urgency. The movement had lost its point. Not only were the demands for social renewal now being made by people in general, but the excesses and the violence expressed in most of the work of the pre-war period, had been surpassed by the war itself. Life had not only caught up with art; it had made even the

205. *George Grosz* The Workers, *1921,*
Philadelphia Museum of Art

205

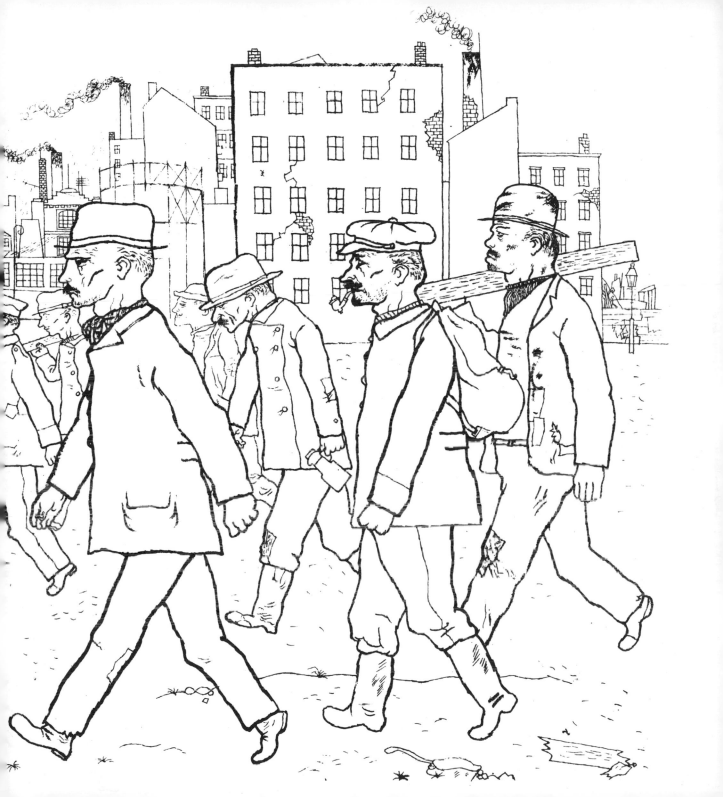

206. *George Grosz,* Portrait of
the Writer Max Hermann-Neisse, *1925,*
oil on canvas, 39.37 × 39.75 in.
(100 × 101 cm.), Kunsthalle, Mannheim

207. *Otto Dix,* Countess Elsa, *1922,*
pencil study for a painting,
17 × 13.75 in. (43 × 35 cm.),
Private Collection, Haag

206

207

most powerful art pale by comparison.

Moreover, the Expressionist demands for a 'new' human being, spiritually aware and in tune with the cosmic realities underlying the superficial appearance of nature, seemed futile in a period of actual physical suffering. What mattered after the war were the social injustices and the social divisions which seemed more acute now that the Monarchy had been overthrown. Several artists extended the Expressionist manner to deal with subjects of direct social relevance.

George Grosz

George Grosz (1893–1959) was one of the leading members of the *Novembergruppe,* and a Communist. His biting drawings, with their taut line, depict the horrors of post-war Berlin with its streets littered with war-cripples and beggars and its bars crowded with perverts and whores. His sense of social outrage emerges most strongly from those drawings which anatomise the other side of the post-war coin: the racketeers, the wealthy entrepreneurs and all those monocled and mustachioed Germans who had grown fat off war-profits and were about to make another killing with the inflation and collapse of money. Stylistically, these propagandist drawings by Grosz stand some distance away from Expressionist practice. Grosz describes and comments on his figures by shrewdly combining details of physiognomy and dress so that his people become symbols of the class to which they belong. The bowler hat, the duelling scar, spats and a gold-watch chain distinguish the over-fed capitalist, while an ex-soldier with tattered medal-ribbons lurches by on crutches. (205–6)

Otto Dix

An eagle-sharp eye for detail also marks the drawings and paintings of Otto Dix (b. 1891), and his insistence on detail and an overall realist clarity make his works often seem super-real, so clear that it is as though we are seeing reality for the first time. Dix also concerned himself with social subjects, the horrors of war, with its victims, and the decline in standards which came after it. Like Grosz, Dix drew and painted prostitutes, beggars and other social outcasts, but unlike Grosz his tendency to caricature is not marked. In the portrait of his parents, for example, there is a compassionate note which is no way muted by those qualities which clearly make of it a sort of generalised symbol of the working-class. (207–8)

A New Objectivity

Shortly after the end of the war, it became clear that artists like Grosz and Dix were at the height of their powers and introducing

new qualities into painting. In 1924, the Director of the Mannheim Kunsthalle, G.F. Hartlaub, wrote an essay in which he claimed to discern a movement, at the head of which were Grosz and Dix. He labelled this movement *Die Neue Sachlichkeit (The New Objectivity)* to distinguish it from Expressionism and organised a large exhibition which would present it to the German public for the first time. This show, which opened in Mannheim in 1925, marks the end of the Expressionist epoch in Germany and the beginning of a new stage in German art history. Of *Die Neue Sachlichkeit* Hartlaub wrote: '...The expression ought really to apply as a label to the new realism bearing a socialistic flavour.
It was related to the general contemporary feeling in Germany of resignation and cynicism after a period of exuberant hopes (which had found an outlet in Expressionism). Cynicism and resignation are the negative side of the *Neue Sachlichkeit;* the positive side expresses itself in the enthusiasm for the immediate reality as a result of the desire to take things entirely objectively on a material basis without immediately investing them with ideal implications. This healthy disillusionment finds its clearest expression in Germany in architecture.'

Max Beckmann

The strongest talent in the *Neue Sachlichkeit* movement (it was never a group) was Max Beckmann (1884–1950) who had begun to paint in a monumental version of Liebermann's and Corinth's Impressionism. He was so tied to a traditionalist attitude that he was, for a time, one of Expressionism's most articulate opponents and found it embarrassing to account for the change in his style after the war. What marks Beckmann's mature style is its powerful emotionalism, its disciplined clarity and its controlled distortions, which emphasise the emotional power of his new subjects. These distortions and the new, shallow type of space depicted in Beckmann's pictures, derive ultimately from Gothic art, but the sense of resignation which emerges is completely contemporary in character. (210)

Beckmann also sought to strengthen the impact of his compositions by resorting to sheer size. He began to paint enormous pictures (*Night,* for example), where (209) more than life-size figures act out night-marish situations on a stage lit by sickly coloured light or in rooms without windows.

Conclusion

According to Virginia Woolf, 'On or about

208. *Otto Dix* Portrait of the Artist's
Parents, *1924, oil on canvas,
45.87 × 51.25 in. (116.5 × 130.2 cm.),*
Städtische Galerie, Hannover

208

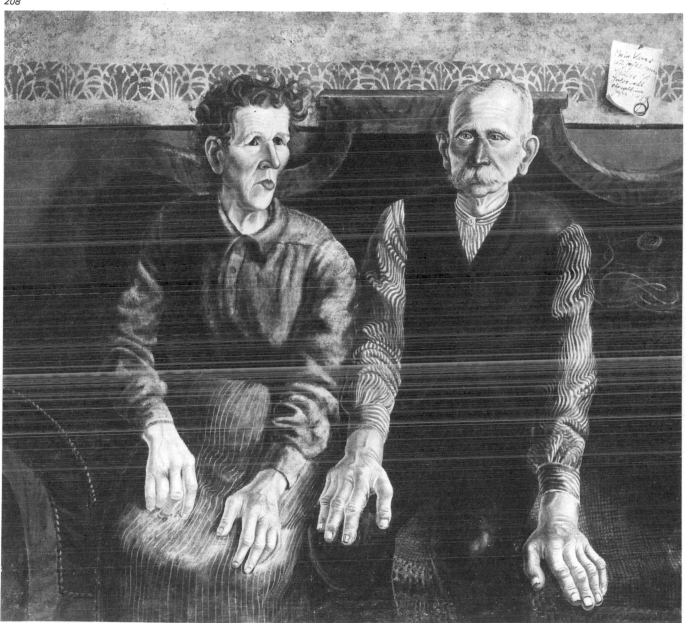

209. *Max Beckmann* Night, *1918/19,
oil on canvas, 52.37 × 60.62 in.
(133 × 154 cm.), Kunstsammlung
Nordrhein-Westfalen, Düsseldorf*

210. *Max Beckmann* Self-portrait,
woodcut

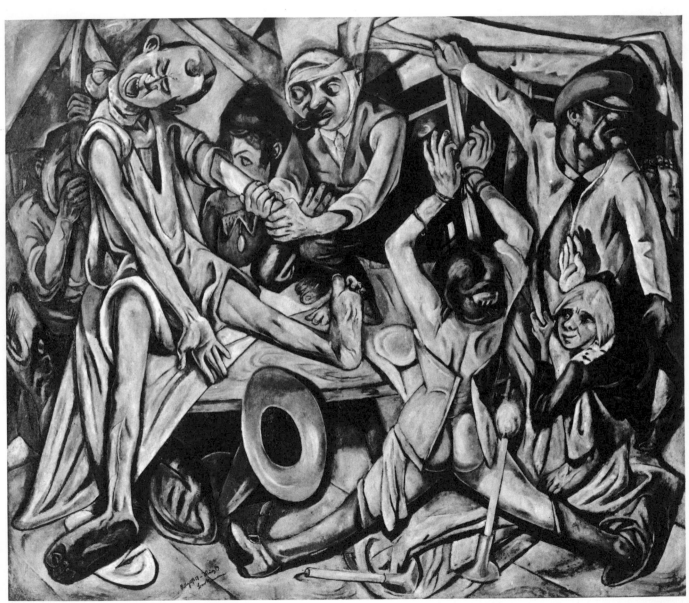

209

December 1910 human nature changed'. Certainly by that time the traditional picture of the world had been destroyed for ever. Scientists had disproved many of the ideas on which nature's laws appeared to have been based and there was a degree of questioning and hypothesising in all areas of human activity unparalleled in history. The new view of the world had begun to be reflected in the visual arts. Many of the modernist styles had already been created: Fauvism, Cubism and Expressionism all put forward their own versions of reality. Each in its own way had questioned the tenets of Impressionism and found them wanting.

In Impressionism everything was suppressed in favour of the eye; the very act of perception was exalted to the substance of reality: I see, therefore I am. In common with the other modernist movements in the arts, the Expressionists believed that there was a reality at once deeper and more significant than the reality pursued so energetically by the Impressionists. As the Expressionist poet, Gottfried Benn, wrote: 'there is no outer reality, there is only human consciousness, constantly building, modifying, rebuilding new worlds out of its own creativity'.

The new reality sought by the Expressionists was to be found, on the one hand, within the artists themselves and, on the other, within the work itself. They therefore elevated the importance of their own emotions and studied their own responses to nature more closely than they studied nature itself. They also recognised that the painting, independent of the outside world, is also a form of reality, obeying its own laws and not the window opening out on to the outside world, as it was for the Impressionists. Just as the Symbolists made the writing of the poem the dominant matter of the poem, the Expressionist painters made the business of painting their pictures a major concern.

For the Expressionist, Nature was not an end in itself but the provider of forms through which he might symbolise his inner conflicts, his spirituality. Nature in an Expressionist painting ceases to be *natural*; it becomes an idea. Moreover, when an Expressionist painted a cityscape, he did not regard it as he would a landscape. Ludwig Meidner, in his essay on the painting of city scenes, stresses that it is the very soul of the city he wishes to portray, not its surface appearances, and Kirchner's Berlin street scenes are less topographical studies than the revelation of what he feels it is like to live there.

The Expressionists were entranced with depths. They wished to go beyond the surface of things, to explore the depths of the city, of the self, to experience the extremes of the senses. In order to do this they often induced extreme states of feeling with drugs, sex and drink. They were fascinated with society's misfits because they loathed the average in all things and the *homme moyen sensuel* above all. This partly explains why Expressionist literature is full of criminals, mad geniuses, whores and lunatics.

In Expressionism primitivism became a major terminus. Any artistic development which grows more and more sophisticated must inevitably narrow into decadence. This had happened with *Art Nouveau* and with Impressionism, where the emphasis on the small, almost imperceptible effect of light or atmosphere was also highly sophisticated. Any situation like this will inevitably lead to a reaction and the reaction is usually primitivistic. The Expressionist search for meaning through extreme states of being reveals a yearning for the primal, the essential, the truly necessary.

Some, or all of these characteristics are the mark of Expressionist art and forge a link between the apparently unrelated figure compositions by Kirchner, for example, and the *Improvisations* and *Compositions* of Kandinsky. Expressionism was an irrational art concerned with mysteries and revelations. As Goethe wrote: 'Painting exhibits what we should and would like to see, not what we usually perceive.'

210

Documents, Extracts and Quotations

DER BLAUE REITER

Inhalt der ersten Nummer.

Vorwort
Geistige Güter F. Marc.
Über moderne Malerei Roger Allard.
Die „Wilden" Deutschlands F. Marc.
Die „Wilden" Russlands D. Burljuk.
Die Neue Secession M. Pechstein
Die Masken A. Macke
Musikwissenschaft N. Brjussow
Anarchie in der Musik . . . Th. v. Hartmann
(Ein Artikel über Musik) . . . Arnold Schönberg
(" " französische Musik.) Martin-Barzun
(Artikel über Litteratur) Alexandre Mercereau
Der gelbe Klang (Bühnenkomposition
 mit Vorwort) Kandinsky
 Bitte wenden

211. *Handwritten List of Contents by Kandinsky for the Blaue Reiter Almanac, 1912, Piper Publishers, Munich*

Chronicle of the Brücke, 1913

'In 1902 the painters Bleyl and Kirchner got to know each other in Dresden. Heckel joined them through his brother, a friend of Kirchner's. Heckel introduced Schmidt-Rottluff to the group. He had known him in Chemnitz. They came to Kirchner's studio to work together. Here they had the chance to study the nude, the basis of all art, naturally. From the drawings of this basic motif arose the general feeling that creative inspiration should come from life and that one should be subservient to experience. The individuals drew and wrote a book together, *Odi Profanum*, which expressed their ideas and compared their individual qualities. Thus a group emerged quite naturally and was given the name *Brücke*. Each member encouraged the other. Kirchner brought the technique of the woodcut from Southern Germany. Having been stimulated by the old woodcuts he had seen in Nuremberg, Kirchner had adopted the technique anew. Heckel made wood-carvings. Kirchner enriched this technique by painting his own carvings and looked in stone carvings and tincasting for the rhythm of closed form. Schmidt-Rottluff did the first lithographs from the stone. The first group exhibition took place on their own premises in Dresden: it met with no recognition. Dresden offered great stimulus in the charm of its landscape and its old culture, however. Here the *Brücke* also found its first foundations in art history: in Cranach, Beham and the other German medieval masters. When Amiet exhibited in Dresden, he too became a member of the *Brücke*. In 1905 Nolde followed him. His individual imagination gave the *Brücke* a new note. He enriched our exhibitions with his interesting etchings and learned how to make woodcuts from us. Schmidt-Rottluff went to Alsen on his invitation. Later Schmidt-Rottluff and Heckel travelled to Dangast. The hard light of the North Sea developed into a monumental Impressionism, particularly in Schmidt-Rottluff's work. Meanwhile Kirchner developed the closed composition. In the ethnographic museum, in Negro sculpture and the wood-carving of the South Seas he found a parallel to his own work. The ambition to be liberated from academic sterility brought Pechstein to the *Brücke*. Kirchner and Pechstein went to Gollverode to work together. Then the *Brücke* exhibition which included the work of the new members took place in the Salon Richter in Dresden. The exhibition made a deep impression on the young artists in Dresden.'

Reproduced in Buchheim, Lothar-Günther, *Die Künstlergemeinschaft Brücke*, Buchheim Verlag, Feldafing, 1956

This extract from the *Chronicle of the Brücke* seems more objective than it is. It is historically inaccurate and there are several misleading emphases, notably on Kirchner's own contribution to the group. Kirchner in fact wrote the Chronicle and presented it to his fellow members for their comments in 1913. They found it biassed and the group split up. Kirchner then cut some woodcut illustrations and had a few copies printed privately.

Letter from Nolde, March 1914

'We live at a time when primitive man and the primitive way of life are becoming extinct. Everything has been discovered and made European. Not one single, tiny spot of virgin, essential nature inhabited by primitive people has been retained for the future. In twenty years everything will have been lost. In three hundred years the researchers will dig around and labour in the hope of uncovering something of those costly things which have about them the primeval spirituality that we once possessed and that we are now destroying so stupidly and shamelessly. The primitive people live together with Nature, are at one with it and are part of all creation. I often have the feeling that they are the only real human beings alive, while we are like puppets, manufactured and full of conceit. I paint, draw and try to hold fast something of this essential being. . .am of the opinion that my pictures of primitive peoples. . .are so genuine and harsh that it is impossible to hang them in perfumed salons. . .And what have the English destroyed for ever in their great and diverse colonies, without having once done a spiritual deed which might at least have excused the destruction. Like Japan and China they have merely saved a few foreign cult objects by bringing them back to their island. Is this enough, however?'

From Nolde, Emil *Briefe aus den Jahren 1894–1926* ed. Max Sauerlandt, Furche-Kunstverlag, Berlin, 1927.

Nolde went on an ethnological expedition to the Bismarck islands in 1913–14 and had the opportunity to check his theories of primitive art and primitive society against the facts. The belief in the 'uncivilised' and the directness of expression achieved in primitive art was central to most of the Expressionists. Like Nolde, they also believed that European civilisation was decadent

and damaging to the essential nature of man. This letter from Nolde is a plea for less intrusion into primitive societies.

Extracts from Kirchner's Diaries 1923

'I have to write the history of the *Brücke* for the *Kunstblatt*. Good. Once again I'll not make overdue reference to my own work and will describe the events fairly and impersonally. We founded ourselves on tradition. We were German as no other artists. We went back beyond the tenth century and started from there. Don't discount interest in the *Brücke* too soon, the real stuff is being done today. Real art emerges in the 40th year of one's life, before that it's more or less the expression of sensuality, of the erotic in the broadest sense. Where there's only eroticism, there's no art. Look at Munch. . .Nolde is often sick and too primitive. In 1900 I came to Dresden intending to become a painter. To earn money I enrolled as an architectural student. My free time was taken up with painting girls who undressed for me to draw them. At the Academy I learned academic drawing from the nude. I only worked freely at home. . .I got to know another student. . .Erich Heckel. . .Like me he had worked from his imagination at school and painted symbolic subjects with many figures, and heads, but also tried to express his feelings through landscapes. I had perceived that there was not enough sense of form in me for such things. I talked with him and he admitted that he was in the same situation. So we tackled the nature of the girls in my studio and of the men, whom we drew in complete naturalness without posing. . .Pechstein. . .wanted to learn new ideas. . .wanted prescriptions which I was unable to give him. . .the artists of the *Brücke* had nothing but struggle and the poor people fed me and patched my clothes.'

1923

'Schmidt-Rottluff sends me without comment two base articles from the Dresden *Staatszeitung* which is once again completely untrue when it says that Pechstein was leader of the *Brücke*. I have decided to send Westheim an exact history of the *Brücke*. . .Those particularly interested in Kirchner's views are recommended to read the fine and factual book by his friend L. de Marsalle, which will appear sometime this year.'

From Grisebach, Lothar
E.L. Kirchners Davoser Tagebuch, DuMont Schonberg, Cologne, 1968

These two diary extracts show something of Kirchner's attitude to the group when he was living in Switzerland. L. de Marsalle was, in fact, Kirchner's own *nom de plume*. He wrote several pieces of criticism and catalogue introductions, all on his own work, under this name. His diaries are full of derogatory remarks about Pechstein, whom the critics had come to recognise as the group's strongest talent and leader. Kirchner's later life is marked by attempts to redress the balance by publishing articles stressing Kirchner's own importance to the group and to the birth of Expressionism.

1925

'Kirchner's pictures from the pre-1900 period were almost entirely imaginative compositions. Racially a German artist this was thoroughly natural, for the German artist creates from his imagination, from the spirit, unlike the Latin artist who creates from an attitude of mind. German art is religion in the broadest sense of the word, Latin art is reproduction, depiction, description or a paraphrasing of nature. The German paints the 'what', the Frenchman the 'how'. That completely explains the bad technique in German art and the great dependence of the Germans on French technique. There are only very few German artists who have opened new roads in creation, since Dürer almost none. . . Kirchner was able to develop a new, self-sufficient form, which is also recognised abroad as original. For the first time a German painter was again among the technical pioneers of art.'

From Grisebach, Lothar *E.L. Kirchners Davoser Tagebuch*, DuMont Schonberg, Cologne, 1968.

This diary entry is a rough for an article later to be written by 'L. de Marsalle'. Although the last sentence shows Kirchner at his immodest best, what goes before clearly shows what he felt Expressionism needed to be and why he thought it was a thoroughly German style. There is no evidence that any member of the *Brücke* (except Nolde) painted anything before 1900.

1925

'The Zürich exhibition of modern painters from all countries. . .I was very disappointed with the Germans. Kokoschka is a tragic case. He takes pains with colour but never succeeds. . .you just can't look at Dix, cheap and eclectic. . .Beckmann just as pointless and repulsive. . .he stole from

everything available. . .Kandinsky has great taste in colour, a pity that he's abstract. . . Heckel looks bad. There's nothing left of the power there once was, the pictures are not genuine and hateful. He imitates everything, particularly me. . Heckel always imitated . . .Chagall looks bad. . .no power. . .the older he gets the worse he looks, he simply stole what little bit of interest there is from Russian peasant art. He takes nothing from it and adds nothing. He's just a Jew, you can see that only too plainly in him.'

From *Das Kunstblatt*, 1930 (Vol. 14)

The above extract is included here to show Kirchner's ungenerous attitude to the *Brücke* and to other modernists of his generation during his seclusion in Switzerland.

Kandinsky on the Blaue Reiter

'In Munich. . .everybody painted, or wrote music, or poetry, or danced. There were at least two studios in the attic of every house, where people were often less concerned with painting than with constant discussion, philosophising and excessive drinking. (This depended more on the state of the purse than of the morals). . .I lived here for many years and it was here that I painted the first abstract picture. It was here that I carried round with my thoughts about 'pure' painting, pure art. I tried to proceed 'analytically', to discover synthetic connections, dreamed of the 'great synthesis' that would come and felt obliged to communicate my thoughts not only to others on my island, but to people beyond it. Thus, of itself, my first book, *Concerning the Spiritual in Art*, grew out of my hasty notes 'pro doma sua'. I had finished it in 1910 and put it in a drawer because no publisher would risk underwriting the costs which were actually quite small. . .At the same time my desire to edit a book grew — actually a sort of almanac — which would be written entirely by artists. Above all I dreamed of artists and musicians. The damaging separation of one art from another, of 'art' from folk and child art, or 'ethnography',* the strong walls between phenomena which to my mind are so related, often identical, with one word the synthetic relationships refused to leave me in peace. . .almost on the same day (1911–12) two great 'streams' of painting were born: Cubism and Abstract Art. Simultaneously Futurism, Dadaism and Expressionism quickly triumphed. . .Atonal music and its master Arnold Schoenberg, who was at that time being booed off everywhere, invited scorn as often as those painting 'isms' I have already mentioned.

I got to know Schoenberg and immediately recognised an enthusiastic believer in the *Blaue Reiter* idea. . .And then Franz Marc from Sindelsdorf arrived. We understood each other absolutely. In this unforgettable man I found a (for the time) very rare type of artist (are they any less rare today?) who could look far beyond the limits of a 'co-operative dairy', who was not outwardly, but inwardly against tying down, restricting traditions. . . . I thank Franz Marc for the publication of *Concerning the Spiritual* by Piper: he smoothed the way. . .Marc brought in the then very young August Macke, a helpful strength. We gave him the task of getting the ethnographic material together. . . I got hold of the Russians (painters, composers, theoreticians) and translated their articles. . .my neighbour in Schwabing was Paul Klee. At that time he was still very 'small'. I can however state with justifiable pride that I sensed the later, great Klee in the very small drawings he was doing at the time (he hadn't then begun to paint). There is a drawing by him in the *Blaue Reiter Almanac*. . .my plan for the next volume was to place art and science side by side: origins, process of development in the manner of working, purpose. . .but then the war came and brushed such modest plans aside.

*My first enthusiasm for ethnography came many years ago. As a student at Moscow University I recognised, actually rather unconsciously, that ethnography is as much art as science. The decisive fact, however, was the shattering impression that the ethnographic museums made on me much later.'

From *Das Kunstblatt*, 1930 (Vol. 14)

Kandinsky's interesting recollections of the artists who came together to work on the *Blaue Reiter Almanac* emphasise his belief in the universality of all human activity and the fallacy of dividing activities up and giving them separate names. At that time the value of, for example, child art had been by no means recognised and even 'primitive' art was only considered interesting for the light it shed on 'uncivilised' societies. Also interesting are Kandinsky's unrealised plans for the second volume of the Almanac. Only comparatively recently have artists and scientists attempted to work together for their mutual benefit and enlightenment.

Klee on Kandinsky, Diary entry, Autumn, 1911

'Kandinsky. . .who lives next door, this Kandinsky whom Uncle Louis calls

Schlabinsky, has a great influence on him. Luli often drops in for a visit, takes things by me to show him and often brings back pictures without a recognisable subject by the Russian for me to look at. Very interesting pictures. This Kandinsky wants to form a new group of artists. I have grown to trust him implicitly after having met him personally. He really is someone and has an unusually fine, clear mind. . .in the course of the winter I then joined his *Blaue Reiter*.'

From *Paul Klee: Tagebücher*, edited by Felix Klee, DuMont Schonberg, Cologne, 1957

Letter to Marc from Kandinsky, 1911
'Now! I have a new plan. Piper must take care of the publication and we two must be the editors. . .A sort of Almanac (annual) with reproductions and articles. . .and *chronicle*!! that is reports of exhibitions, criticisms, all written by artists. The entire year must be reflected in the book and a chain to the past and a beam into the future must give full life to this mirror. The authors will probably not be paid. Perhaps they must even pay for their own blocks, etc. etc. . . . the book can be called *The Chain* or something else. . .Don't talk about it. Or only if it can benefit us directly by doing so. In such cases "discretion" is very important.'

Reprinted in the catalogue of the *Blaue Reiter* collection in the Städtische Galerie, Munich, 1963

Kandinsky. From a letter, 1930
We invented the name *Blaue Reiter* at the coffee-table in the summerhouse in Sindelsdorf: we both loved blue, Marc—horses, me—riders. The name sprang from itself, helped on by Mrs Maria Marc's wonderful coffee.'

Idem

Foreword to the Almanac of the Blue Rider by Kandinsky and Marc. 1912.
' ''Everything that grows can only begin on earth.'' This sentence of Däubler's can stand over all our work and ambitions. A fulfilment will come, at some time, in another new world, in another existence. On earth we can only determine the theme. This first book is the indication of a new theme.'

From *Der Blaue Reiter*, new edition of the Almanac edited by Klaus Lankheit, Piper and Co., Munich, 1965

Kandinsky. From a letter, 1935
'In reality there never was a '*Blaue Reiter*' Association, never a 'group', as it is often falsely described. Marc and I took what seemed to us right and we chose it freely without troubling our heads over any opinions and wishes. Thus we 'decided to lead our *Blaue Reiter* like dictators. The 'Dictators' of course were Franz Marc and I.'

Reprinted in the catalogue of the *Blaue Reiter* collection in the Städische Galerie, Munich, 1963

Two Extracts from Kandinsky's Autobiography
'The horse carries the rider with power and speed. But the rider controls the horse. Talent carries the artist to great heights with power and speed, but the artist directs his talent. That is the element of 'consciousness', of 'calculation' in the work or whatever else one chooses to call it.'
'In many ways art is similar to religion. Its development consists not in new discoveries which invalidate the old truths (as is obviously the case with science). Its development relies on sudden illuminations like lightning, in explosions which burst in the sky like fireworks. . .this illumination shows with blinding light new perspectives, new truths, which are basically nothing but the organic development of earlier wisdom. . .'

Idem

Macke. From 'Die Masken' (Masks), 1912 (published in the Blaue Reiter Almanac)
'Incomprehensible ideas express themselves in comprehensible forms. Comprehensible to our senses as a star, thunder, a flower. As form. The form is mysterious to us because it is the expression of mysterious forces. Only through them do we sense the secret forces, the 'invisible God'. The senses are the bridge from the incomprehensible to the comprehensible. To look at plants and animals is to feel their mystery. To hear the thunder is: to feel its mystery. To understand the language of forms is: to come closer to the mystery. To create forms is: to live. Have not children, who create directly out of the mystery of their perception more worth than the imitators of Greek form? Are not the wild artists, who have their own form as strong as the form of thunder? . . . the relationship between the several and various forms allows us to recognise the individual form. Blue is first made visible by red, the greatness of the tree by the smallness of the butterfly, the youth of the child by the age of the old man. One plus two is three. The formless, the infinite, the nought remains incomprehensible . . . the joys, the sorrows of men, of peoples stand behind the texts, the pictures, the temples, the cathedrals and masks, behind the musical works, the dramas and dances. Where they are not, where forms are made empty without basis, there is no art.'

From *Der Blaue Reiter*, new edition of the Almanac edited by Klaus Lankheit, Piper and Co., Munich, 1965

August Macke's contribution to the *Almanac of the Blue Rider* highlights some of the ideas central to Kandinsky's and Marc's conception of painting, of giving the invisible finite and comprehensible form. It also stresses the importance in art of relative qualities, without which we cannot perceive at all.

Kandinsky. From 'Problems of Form'
'The practical-functional is foreign to a child which observes everything with unaccustomed eyes and yet possesses the pure ability to comprehend the thing in itself . . . Thus there is revealed in every child-drawing without exception the inner sound of the object itself.'

Extracts from: Franz Marc: 'The New Painting'
'Who believes that he is closer to the heart of nature, the Impressionist, or the youngest of today's artists? There is no rule that we use to measure here; but there is the fact that we believe we are as close to the heart of nature as Manet when he tried to reproduce the outer appearance of the colour of the peach or the rose, the scent, to recreate its scent and make its inner secret tactile.

Today we seek things in nature which are beneath the veil of surface appearances, and these seem more important to us than the discoveries of the Impressionists. They simply ignored these things. And it's not temperament that makes us search for and paint this inward, spiritual aspect of nature, and it's not because we want to be different either. It's because we actually *see* it in the same way that artists previously 'saw' violet shadows and atmosphere more clearly than anything else. We are able to explain why we see what we do as unsatisfactorily as they could explain what they saw. It has to do with the times.

Nature is everywhere, within us and without us. Something exists that is not completely concerned with nature, but reaches beyond it and interprets . . . this is art. Art was and is at every period the boldest departure from nature and 'naturalism', the bridge into the world of the spirit . . .'

From *Pan*, 1911

Karl Jaspers on the 1912 Sonderbund Exhibition in Cologne

'In this exhibition . . . Expressionist art, which was strangely homogeneous and came from all over Europe, was to be seen with magnificent Van Goghs. One frequently felt that Van Gogh was sublimely the only artist mad against his will among so many who wished to be mad but were only too healthy.'

Quoted in Peter Selz *German Expressionist Painting* University of California Press, Berkeley, 1957.

Karl Jaspers, an eminent German philosopher with a great enthusiasm for art, wrote this comment about an exhibition which marked the absolute highpoint of Expressionist painting and was as important for the development of modernism in Germany as the Armory show in 1913 was for its awakening in America.

Kandinsky. 'Painting as Pure Art', 1916

Extracts from this important piece of theoretical writing are included here because many of Kandinsky's basic notions about art are summarised in it.

In the first part, *Form and Content*, which is a good example of Kandinsky's manner of argument and mixture of sound sense and transcendental musings, he defines what he considers to be the essential 'construction' of a work of art. He then goes on to describe the progression from figurative to abstract art.

'Form and Content

The work of art consists of two elements: the inner and the outer.

The inner element, seen on its own, is the emotion of the soul of the artist. This emotion has the ability to call forth a basically similar emotion in the soul of the spectator. As long as the soul is bound to the body it can as a rule only receive vibrations through the medium of feeling. Feeling is therefore the bridge from the immaterial to the material (artist) and from the material to the immaterial (spectator). Emotion—feeling—work—feeling—emotion. *The inner element of the work is its content*. Thus the vibrations from the soul must be there. When this is not the case, no work of art can come into existence. That is, only the appearance of one. The inner element, created by the soul's vibrations is the content of the work. Without content no work can exist. So that the content which at first lives only in the 'abstract can become the work of art, the second element—the outward—serving to embody it. Thus the content searches for a

means of expression, for a 'material' form.

Thus the work is an inescapable, indivisible fusion of the inner and outer elements, i.e. content and form.

The decisive element is the content. Just as the word does not determine the concept, but the concept the word, so the content determines the form: *The form is the material expression of the abstract content*.

The choice of form is therefore determined by the *inner necessity*, which is in effect the only immutable law of art.

A work which has been created in this way is 'beautiful'. Thus a *beautiful work is a marriage of the inward and outer elements in terms of the law*. This marriage gives the work unity. The work becomes the subject.

As painting is a spiritual organism which, like every material organism consists of many single parts, isolated, these single parts are lifeless, like an amputated finger. The life of the finger and its functional effect is determined by its controlled interaction with the rest of the body. *This interaction is the construction*.

The work of art is governed by the same laws that govern the work of nature. The single parts only gain life in terms of the whole?

Development

'Clearly nature is seen entirely as a point of departure, as an excuse to give the spiritual content expression. In any case this standpoint was already recognised and proclaimed by the Impressionists as part of their 'credo'.

However, this 'credo' is in reality only a *primum desiderum* of the painting of the second period.

If the choice of object (nature) for this painting were unimportant, then the artist would not need to search for 'motifs'. Here the object determines the treatment, the *choice of forms is not free*, but dependent on the object.'

Final Stage

'If we cut out the figurative (nature) from a picture of this period and leave the purely artistic *alone* in the picture, we see immediately that this figurative construction breaks apart from lack of form. Or it happens that only completely indeterminate, accidental artistic forms (in embryo) not fit for existence remain after this cutting on the canvas. Thus *nature* (the 'what' in the sense of this painting) is not incidental but *essential*.

This cutting out of the practical elements, the figurative (nature) is only possible where this essential part is substituted. And that is the pure artistic form which can endow the picture with the power of self-sufficient life and raise the picture to spirituality. It is clear, that this essential part is the construction which is described and defined above' (under *Form and Content*).

From *Expressionismus, die Kunstwende*, published by *Der Sturm* in 1918. Reprinted in Kandinsky: *Essays über Kunst und Künstler*, G. Hatje, Stuttgart, 1955

Ludwig Meidner: To all Artists, Poets and Musicians

'It can no longer be permitted that a powerful majority must live in the most shameful, dishonourable and inhuman conditions, while a tiny majority gorges itself from an overfilled table. We must choose Socialism: choose the general and complete socialisation of the means of production, which afford every person work, spirit, bread, a home and the sense of a higher objective in life . . . we painters and poets join with the poor in a holy alliance. Have not many of us known poverty, the shame of hunger and of material dependence? Do we stand any firmer or surer in society than the proletariat? Are we not like beggars, dependent on the moods of the art-collecting bourgeoisie? If we are young and unknown, they wither, throw us alms or let us die quietly.'

From *Das Kunstblatt*, 1919

Ludwig Meidner: Introduction to the Painting of Cityscapes

'We must eventually begin to paint our home, the big city, which we love so completely. On countless canvases, large as frescoes, our trembling hands should splash down all the marvellous and strange, monstrous and dramatic aspects of the avenues, stations, factories and towers. We remember individual pictures from the '70s and '80s which show city streets. They were painted by Pissarro or Claude Monet, two lyricists who came from meadow, bush and tree. The sweetness and blossoming of their agricultural landscapes is also there in their cityscapes. Can you really paint monster houses softly and transparently like you paint brooks, can you paint boulevards like turnips?

It is no longer possible to solve our problem with the technique of the Impressionists. We have to forget all the earlier methods and tricks and discover a new form of expression.

The first essential is: that we learn to see, to see more intensely and correctly than our predecessors. The Impressionist lack of clarity, their blurring, is of no use to us. The lack of perspective cannot interest us and restricts our impulsiveness. 'Tonality', 'coloured light', 'coloured shadows', 'dissolving the outline', 'complementary colours' and whatever else there is—have become phrases for the schoolbook. The two of us—and that is not least important—must begin to work. We can't take out easels out into the tumult of the streets in order to read off 'tonal values' while squinting. A street does not consist of tonal values but is a bombardment of rows of windows, rushing balls of light between roads and alleys of all sorts and of thousands of hopping spots, groups of people and of threatening, formless masses of colour. Painting in the open air is completely wrong. We can't put on canvas the chance, the disorder of our subject in a trice and make a picture of it . . . the point here . . . is not a purely decorative filling of the picture surface à la Kandinsky or Matisse, but life in all its richness: space, life, light and dark, weight, brightness and the movement of things. Simply: a deeper penetration of reality.'

From *Kunst and Künstler* Berlin, Vol. 12, 1914

Typical of Meidner's impassioned prose, this praise of cities illustrates the Expressionists' interest in crowds and buildings and how their attitude to painting was consciously anti-Impressionist. The vocabulary and sentiments of this passage recall something of the Futurist manifestoes, which Meidner had read. His style had also been formed partly under the Futurist influence. Also interesting is Meidner's rejection of Kandinsky, whom he saw as a purely decorative artist. Meidner's 'inner reality' was not spiritual or transcendental, but was made up of the powerful forces underlying all human activities.

Max Liebermann. From an 'Artistic Confession'. 1922

'And so we read that until now art had reduced seeing to 'mechanical photography', and that Expressionism was the first to replace the painting of the eye by the painting of the imagination. But isn't every painting, as long as it's a work of art, a painting of the imagination? . . . Courbet, or Leibl, Menzel or Manet painted representations of reality that are their own subjective reality as they see it. It is one of the most serious and hence least excusable

errors to assume that the more faithfully a painter represents reality, the less visionary he is, that the Realist or Impressionist merely copies nature, while the Idealist or the Expressionist gives his interpretation of it. To make visible the invisible: that is what we call art. The artist who renounces attaining to the invisible, that which lies behind appearances—whether we call it soul spirit or life—through his representation of reality, is no artist. But the artist who would like to sacrifice the representation of appearances in favour of a stronger expression of his feelings is an idiot. For how would we be able to understand the supernatural without the natural? . . . The musician alone is independent of nature . . . and herein lies the limit which neither the plastic arts nor poetry can cross with impunity: they must never distort the original image of nature to the point of unrecognisability.'

Originally published in *Kunst and Künstler*, Berlin, Vol. 22, 1922

This attack on the Expressionists, is interesting because Liebermann has adopted certain important Expressionist notions in order to defend his belief in Impressionism. 'To make visible the invisible', the reference to 'soul' and 'spirit' are conscious references to concepts first given currency by the writings of Klee and Kandinsky. Elsewhere Liebermann refers to the 'hieroglyph', one of Kirchner's favourite terms. Liebermann, President of the Berlin Secession, and one of the most respected figures in the German art world, was writing at a time when Expressionism was at the height of its influence and Liebermann's own version of Realism/Impressionism was on the wane. It would have been impossible to have written about art in these terms fifteen years before and no-one would have dreamed of suggesting that the Impressionist was interested in 'that which lies behind appearances'.

To the November Group, Berlin. 1918

'Expressionists, Cubists, Futurists! Your fame rests in having prepared the way for the greater part of the Revolution. Later, other groups will come to recognise this. For you shouted while others were still fidgeting. Now they are trying to water down this revolution of yours . . . Expressionists, don't allow yourselves to be led by people who, as 'intellectuals' try to put over the pseudo-cultural benefits of capitalism into the new freedom. You are the leaders. Stand firm on the absolute basis of Socialism, destroy the old, so that you can rebuild

without hindrance. Don't be only Expressionists in art, but Expressionist human beings. Cubists, down with capitalist forms of art!'

From a letter from the painter, Curt Stoermer, published in *Zehn Jahre Novembergruppe*, Berlin, 1928

This part of an appeal to the artists of the November Group perfectly illustrates how Expressionism and the other forms of modern art had become linked in the Socialist mind with the aims of the Revolution and parallels the situation in Russia where, during the early years of the Revolution, the most avant-garde artists were encouraged because it was felt that their work was so new and original that nothing of the traditional forms of 'capitalist' or bourgeois art remained in their work. Those Expressionists who had joined the November Group did so in the same belief and saw the Revolution as the climax of their artistic activities.

Georg Heym, Diary Entry, 1911

My God I am suffocating . . . in these banal times . . . I hoped at least for a war. But that too is nothing . . . if only I had been born during the French Revolution I would have known at least where I might decently depart from this life: at Hohenlinden or Jemappes . . . I, however, the man of things; I, a torn ocean; I, always a storm; I, the mirror of the external, as wild and chaotic as the world, I unfortunately so made up that I need an enormous, appreciative public to be happy, sick enough never to be satisfied just with myself. If I heard a storm-bell ringing somewhere I would be suddenly cured; if I saw people running around with fear-ridden faces; if the people were to rise up; if a street were bright with helmets, sabres, enthusiastic faces . . .

Published in *Expressionismus 1910–1923*, catalogue of an exhibition, in German Literature Archive, 1960

Heym here begs for excess in anything to drag him out of what he feels are banal times. This was a common Expressionist sentiment, and partly explains why some artists welcomed, to begin with at least, the war. Here at least was something that would engage their personalities entirely.

Theodor Däubler. From 'Im Kampf um die moderne Kunst', 1919.

'Today we have our own truly significant artists in Germany once again. Schmidt-Rottluff probably has the strongest

temperament of them all. If Pechstein's talent is described as vital and completely decorative it is by no means completely described. It can be assumed that he may do his best work when commissions for stained glass or mosaics bring out the best in him. Kirchner is one of the most genuine and spontaneous artists. Heckel, a very serious visionary expresses himself best in the spiritual landscape. . .Emil Nolde beat an entirely new. . .path in art. In a sense he stands at the opposite pole to Matisse. Both discovered the most natural element in modern painting: the creation of a picture entirely in terms of colour. Nolde is the stronger, rougher personality: Matisse is an incomparably fine and highly cultured artist. But he proves how firmly nature and culture must be bound together. Ludwig Meidner cannot be overlooked. His explosive power, his rebellious temperament have made it possible for him to create genuine, thoroughly personal works of art.'

Published in *Expressionismus 1910–1923*, catalogue of an exhibition, in German Literature Archive, 1960

The view of a contemporary writer on the Expressionist artists and his attempt to make them known to a wider public.

From the Foreword to the First Performance of three plays by Kokoschka in 1917 in Dresden

'A drama by Kokoschka is simply a variation of his pictures and vice versa. Sound, melody, rhythm and gesture in his words are parallel to those in his pictures. Again, the chaos of the world he observes as though he were the first man and, as though he were the first artist, he invents. . .technique and style. The people in his dramas are large and simple, like the colossus of a mountain and so natural as though they were a landscape. . . Kokoschka's people express themselves not only through the word, but above all through gesture and movement; for the word reveals the content of the speaker, the gesture reveals his spirit, as in opera melody and sound sing of the eternal, the word only of its shadow: the event and the earthly man. We sense a new stylistic possibility, perhaps a new art-form, which indeed comes closest to opera: a pantomime resting on the word.'

Paul Scheerbart: Extract from 'Glasarchitektur', 1914

'We live mostly in closed rooms. These create the milieu from which our culture grows. Our culture is to a certain extent the product of our architecture. If we want to

raise our culture to a higher plane we are for better or worse therefore obliged to change our architecture. And this will only be possible when the rooms in which we live are no longer closed. We can only do this by introducing glass architecture which lets in the light of the sun, moon and stars, not only through windows but through as many walls as possible which are completely of glass— of coloured glass. The new milieu that we create in this way must produce a new culture for us.'

Published by *Der Sturm*, Berlin, 1914

The visionary writer Scheerbart, who in some ways can be regarded as the writer of science-fiction, had an enduring influence on the thinking of German architects before and after the first world war. This representative passage from his best-known work, *Glass Architecture* (first published by *Der Sturm*) illustrates his ideas and gives the reasons for the introduction of vast areas of glass into the buildings of Taut and others. It also shows how, during the Expressionist period, all artists were concerned above all with the social and cultural implications of what they were doing.

From: Herbert Kuehn. 'Das Gegenständliche des expressionistischen Dramas', 1919

'The revolution in painting and lyric poetry was greater than the revolution in drama. The picture had previously been regarded as the reproduction of things seen. When Kandinsky and Picasso destroyed the object in order to paint the infinitely pure, the absolute, they were understood by very few at first. The object disappeared, their subject became line, colour. . .In drama, we were already accustomed to seeing the performance as a symbol, as a representation, for a performance without representation is worthless.
For this reason artists looked at drama from the Expressionist viewpoint much later. Like music, the very nature of drama is more Expressionist. Thus the change was not so great. But the intensity of the change was all the stronger. . .The performance was the figurative, the representation. As a third, exterior component came the means of representation: the material. In drama, word, actor, scene.
The new art seeks the cosmos, seeks the law not outside man, but within him. It sees the awakened being as its fulfilment.'

In short Herbert Kuehn is here saying that the drama, like music, was already, by its

very Nature, Expressionist, because it deals directly with symbols and never sought to represent the real world like poetry and painting. Interesting is the statement that Picasso 'destroyed the object', a widespread belief at the time. In fact, for all their difficulties, even the most complex of Picasso's Cubist compositions were never abstract, nor has Picasso ever produced an abstract composition.

Max Pechstein: 'Expressionism Lives!'

'Expressionism is an historically determined phenomenon and its birth was conceived by an inner necessity. It is the habit of limited intellects to make an artistic movement more important by showing how it superceded the values of another movement. But I must say that eighteen years ago Impressionism had nothing further to say to us. A few great artists and some masterpieces of that style were held in awe but by and large it was a spent force by the time we entered artistic spheres with fire in our hearts. They seemed to us so empty. It was as though we were offered stones instead of bread. The Impressionist style was content with its *valeurs* alone while we once again demanded that a painting should have content. The shine on the nose and the brushstroke were the most important things to them. They reproduced nature as it appeared to look in a certain light and a certain air at the expense of all feeling. They didn't reproduce nature as it was. During the rule of the Impressionist painters had completely forgotten how to construct a picture, how to weigh its masses, how to distribute its weights and counterweights. What mattered was the motif and not the life in the picture. . .we recognised once again the importance of line and colour and concentrated especially on colour, in order to determine the harmony of the picture. We therefore painted red, green, blue, sad and happy pictures without worrying about the mundane demands of those who wanted to be true to nature. This offended the masses whose taste had been formed by Naturalism, but we also had our authorities, painters like Giotto for instance who put a pink donkey in front of a violet wall on an olive-green floor and put a sky-blue Christ on the donkey. . .Most important for us however was the inner experience of the cosmos and the burning ambition to transmute this in its many parts in the artist's soul and then to recreate it in its greatness and simplicity. A sea wave, as we try to paint it, is all the oceans, which angrily destroy people and all human

works but, at the same time, serve man...
this wave is an eternal rhythm. The wave as
seen by the Impressionists is only an
excuse for the painter to put down a painterly
piece of bravura. The human being, man and
woman, stand alone in the world. Their
environment is threatening and they
themselves fight each other... in the same
way we stand in conflict with the world and
create it afresh, feel the secret threads of
life and let them guide the brushes in our
hands while we watch. We are only the
harps on which the wind plays its melodies.
We search for and have a philosophy of life
and express it in our paintings without
drowning the poet in technique. We are not
content with the cabbage patch and bunch
of asparagus of the Impressionists... not
the ambition to be noticed because of
unusual forms but the burning desire to give
form to a full life.'

From the *Berliner Tageblatt* 21-12-1922.

Pechstein wrote this essay for publication in
a popular newspaper at a time when
Expressionism was an accepted art-form
and when the general public wanted to
know more about its aims. The artist makes
his objections to the Impressionists clear
and explains as best he can what the real
subjects of Expressionist paintings are,
where his 'inner realities' lie. Interesting is
the extent to which Pechstein uses the
pieces of art jargon which had quickly
caught on. 'Inner necessity' occurs at
several points, for example.

Reading List

I: Books

Buchheim, L.G.: *Der Blaue Reiter und die
 Neue Künstlervereinigung München,*
 Feldafing, 1959
Buchheim, L.G.: *Die Künstlergemeinschaft
 Brücke,* Feldafing, 1955
Edschmidt, Kasimir: *Ueber den
 Expressionismus in der Literatur
 und die neue Malerei,* Berlin
Eisner, Lotte: *The Haunted Screen,*
 London, 1969
Grisebach, L. (ed): *E.L. Kirchners
 Davoser Tagebuch,* Cologne, 1968
Grohmann, Will: *Das Werk Ernst Ludwig
 Kirchners,* Munich, 1926
Grohmann, Will: *Karl Schmidt-Rottluff,*
 Stuttgart, 1956
Haftmann, Werner: *The Mind and Work of
 Paul Klee,* New York, 1954
Hoffmann, Edith: *Kokoschka, Life and
 Work,* London, 1947
Kandinsky, W.: *Concerning the Spiritual
 in Art,* New York, 1947
Kandinsky, W.: *Essays über Kunst und
 Künstler,* edited by Max Bill, Bern, 1955
Kandinsky, W. and Marc, F.: *Der Blaue
 Reiter,* new and documented edition
 edited by Klaus Lankheit, Munich, 1965
Kracauer, Siegfried: *From Caligari to
 Hitler,* Princeton, 1947
Myers, Bernard S.: *The German
 Expressionists,* London, 1957
Samuel, Richard & Thomas, R. Hinton:
 *Expressionism in German Life, Literature
 and the Theatre,* Cambridge, 1939
Sauerlandt, Max: *Die Kunst der letzten
 30 Jahre,* Berlin, 1935
Sauerlandt, Max: *Emil Nolde,* Munich, 1921
Selz, Peter: *German Expressionist
 Painting,* Berkeley, 1957
Sharp, Dennis: *Modern Architecture and
 Expression,* London, 1966
Whitford, Frank: *Kandinsky,* London, 1967

II: Catalogues

Der Blaue Reiter, the permanent
 collection of the Städtische Galerie,
 Munich.
*Expressionismus, Literatur und Kunst
 1910–1923* exhibition of the German
 literature archive in the Schiller-
 Nationalmuseum, Marbach A.N., 1960

Acknowledgements

Colour Illustrations
Art Institute, Chicago 108; Billedgallen, Bergen 152; Ernst Bührle, Zurich: Photo Drayer 86; Courtauld Gallery, London 3; Folkwang Museum, Essen 159; Hessisches Landesmuseum, Darmstadt 58; N. Ketterer, Lugano 48; Paul Klee-Stiftung, Bern 106, Kunstgewerbe Museum, Zurich 8; Kunsthalle, Bielefeld 156; Kunsthalle, Bremen 57; Kunsthalle, Hamburg: Photo Farbfotodienst 62, 64, 158, back of jacket; Kunstmuseum, Basel: Farbfoto Hinz 100, 166, 170; Kunstsammlung Nordrhein-Westfalen, Düsseldorf: Photo Klein 59, 107; Morton D. May Coll., USA 150, 151; R. Meyer Coll., Bergen 7; Musée Royal des Beaux-Arts, Antwerp 165; Nationalgalerie, Berlin 56, 63, 149; National Gallery, London 47; National Gallery of Scotland 2; Rotterdamsch Trustee's Kantoor N.V. Rotterdam 46; Staatsgalerie, Stuttgart 157; Städtische Galerie, Munich: Photo J. Blauel front of jacket, 85, 87, 88, 92, 93, 94, 95, 98, 99, 104, 105, 171; Stiftung Seebüll Ada und Emil Nolde 1, 50, 53, 54, 163, 164; Wallraf-Richartz Museum, Cologne title-page, 160.

Black-and-White Illustrations
Arts Council, London 138; Bayerische Nationalmuseum, Munich 84; Bayerische Staatsgemäldesammlungen, Munich 96; Hannes Beckmann, New York 83; Bildarchiv Felix Klee, Bern 109, 112; Gertrud Bingel, Munich 122; British Museum, London 18, 20; Detroit Institute of Arts, Michigan 130; Dyckerhoff and Widmann K.G., Berlin 204; Hugo Erfurth, Archiv Günther Franke, Munich 186; Folkwang Museum, Essen 136, 137, 176; Galerie des 20 Jahrhunderts, Berlin 60; Giraudon, Paris 14; Hamlyn Group Photo Library 12, 13; Hawksley Studio, London 179; Hessisches Landesmuseum, Darmstadt 4; Von der Heydt Museum, Wuppertal 97; Karl-Ernst-Osthaus Museum, Hagen 37, 141; Walter Klein, Düsseldorf 209; Kunstarchiv Arntz 140, 200, 207; Kunstinstitut, Frankfurt 24; Kunsthaus, Zurich 103; Kunsthalle, Bielefeld 68; Kunsthalle, Hamburg 120, 154, 161; Kunsthalle, Mannheim 188, 206; Kunstmuseum, Bern 110, 111; Landesmuseum, Hannover 133; Landesmuseum, Munster 66; Mansell Coll., London 15, 27, 125, 177, 178; Bildarchiv Foto Marburg 32; Morton D. May Coll., USA 175; Munch Museet, Oslo 17; Musée d'Art Moderne, Paris 76; Musée Unterlinden, Colmar 23; Museu de Arte, São Paulo 16; National Film Archives, London 192, 194; Nationalgalerie, Berlin 11, 124, 189; National Gallery of Art, Washington 153; Öffentliche Kunstsammlung, Basel 6; Österreichische Galerie, Vienna 184, 190, 195; Philadelphia Museum of Art, USA 205; Piper Verlag, Munich 211; Prestel Verlag, Munich 126, 167; Cora Pongracz, Kunsthistorisches Museum, Vienna 185; Radio Times Hulton Picture Library, London 61; Rheinisches Bildarchiv, Cologne 40, 101, 137, 146; Dr. Ing. Rauert, Hamburg 39; Dr Bernard Sprengel, Hannover 134; Staatliche Kunsthalle, Karlsruhe 128; Staatsgalerie, Stuttgart 196; Städtische Galerie, Munich 73, 74, 82, 91, 102; Städtische Kunstsammlung, Gelsenkirchen 143; Städtisches Museum, Hannover 208; Städtisches Museum, Wiesbaden 75; Stiftung Seebüll Ada und Emil Nolde front endpapers, 172, 173; Tate Gallery, London 10, 135; Ullstein, Berlin 26, 71, 72, 89, 117, 118; Walker Art Center, Minnesota 77; Frank Whitford, London half-title, contents page, 5, 9, 19, 21, 22, 25, 28, 29, 30, 31, 33, 34, 35, 36, 38, 41, 42, 43, 44, 45, 51, 52, 55, 65, 67, 69, 70, 78, 79, 80, 81, 90, 113, 114, 115, 116, 121, 127, 129, 131, 132, 142, 144, 145, 147, 148, 155, 162, 174, 180, 181, 182, 183, 187, 197, 198, 199, 202, 203, 210, back endpapers.

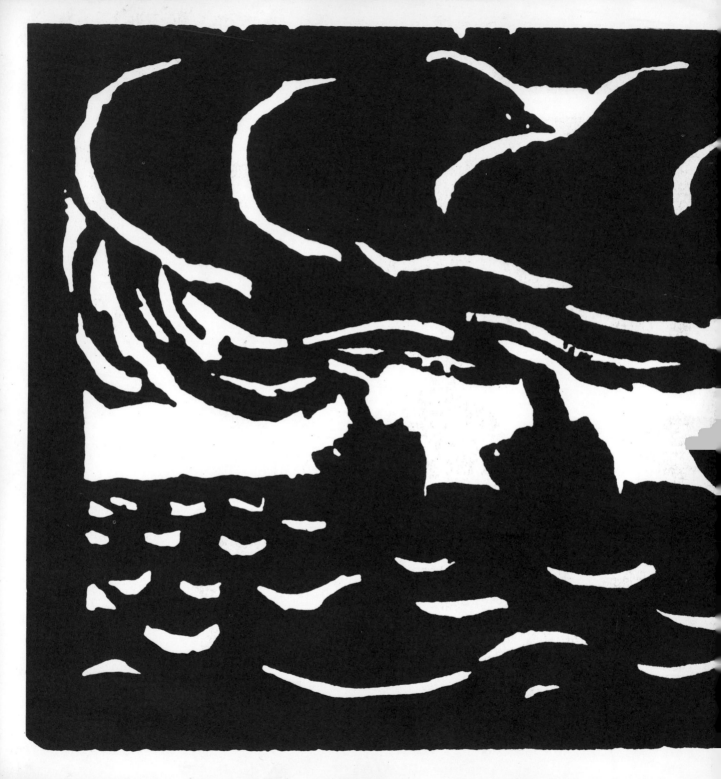